Publisher's Acknowledgements
We would like to thank the following for their kind permission to reprint texts: **Hudson**, New York; **Robert Storr**, New York; **New Falcon Publications**, Tempe, Arizona; **Suhrkamp Verlag**, Frankfurt, and the following for lending images: **John Baldessari**, Santa Monica, California; **Castelli/Sonnabend Tapes & Film**, New York; **Paula Cooper Gallery**, New York; **Feature Inc.**, New York; **Feigen Contemporary**, New York; **Stephen Friedman Gallery**, London; **The Estate of Douglas Huebler**, Valencia, California; **Wolfgang Liab**, Hochdorf, Germany; **Richard Long**, Bristol; **The Museum of Jurassic Technology**, Culver City, California; **PaceWildenstein**, New York; **Adrian Piper**, New York; **Robert Rauschenberg**, New York; **Charles Ray**, Los Angeles; **Saatchi Gallery**, London; **William Wegman**, New York.
We would like to thank the following for their assistance: **James Pedersen**, Feature Inc., New York; **Stephen Friedman**, London. Photographers: **James Dee, Robert Friedman, Julie Lichtenberg, Charles Long, Peter Muscato, Enzo Ricci, G. Schiavinotto, Tom Scott, Oren Slor, Orcutt and Van Der Putten, Donald Waller, Ben Watkins, Joshua White, Stephen White, Dorothy Zeidman.**

Artist's Acknowledgements
I would like to thank Gilda Williams for initiating this project; Stephen Friedman for his enthusiasm and support; John Stack at Phaidon who has been a pleasure to work with; also Clair Joy, Veronica Price, Stuart Smith and Adam Hooper; Jim Pedersen at Feature Inc. for his fantastic detective work; Dennis Cooper, Bruce Hainley and Adrian Searle whose writings send my mind reeling, and especially to Hudson and Julie Lichtenberg for their profound insight.

Descriptive captions of works are by the artist.

All works are in private collections unless otherwise stated.

Phaidon Press Limited
Regent's Wharf
All Saints Street
London N1 9PA

Phaidon Press Inc.
180 Varick Street
New York, NY 10014

www.phaidon.com

First published 2001
Reprinted 2002, 2003
© 2001 Phaidon Press Limited
All works of Tom Friedman are
© Tom Friedman

ISBN 0 7148 3986 8

A CIP catalogue record of this book is available from the British Library.

Designed by SMITH
Printed in Hong Kong

cover, front, **Untitled** (detail)
1995
Toothpicks
66 × 76 × 58.5 cm
A starburst construction made with thousands of toothpicks.

cover, back, **Untitled** (detail)
1998
Polystyrene insulation, polystyrene balls, paint
45.5 × 45.5 × 179.5 cm
Polystyrene insulation is cut into 2.5 cm square sections of varying lengths and connected at right angles. The resulting network is covered with Styrofoam balls and hangs from the ceiling by monofilament.

page 4, **Untitled** (detail)
2000
Ink on paper, monofilament
76 × 99 cm
A drawing made by tracing the projected images from a variety of sources onto paper with an ink pen. The resulting linear enclosures were cut out leaving only the lines. The drawing is hung by monofilament from the ceiling.

page 6, **Tom Friedman**
1998

page 44, **Untitled (All My Work)**
(detail)
1996
Ink and coloured pencil on paper
28 × 21.5 cm

page 86, **Untitled** (detail)
1993
Plastic cups
h. 9 cm, ⌀ 101.5 cm
A continuous ring of plastic drinking cups, one inside the other.

page 96, **Untitled**
1999
Paper
h. 23 cm, ⌀ 12.5 cm
A paper construction hangs by monofilament from the ceiling.

page 102, **Notebook Selection**
(detail)
1994
Ink on paper
26.5 × 20 cm

page 144, **Tom Friedman**
1975

Bruce Hainley Dennis Cooper Adrian Searle

Tom Friedman

Φ

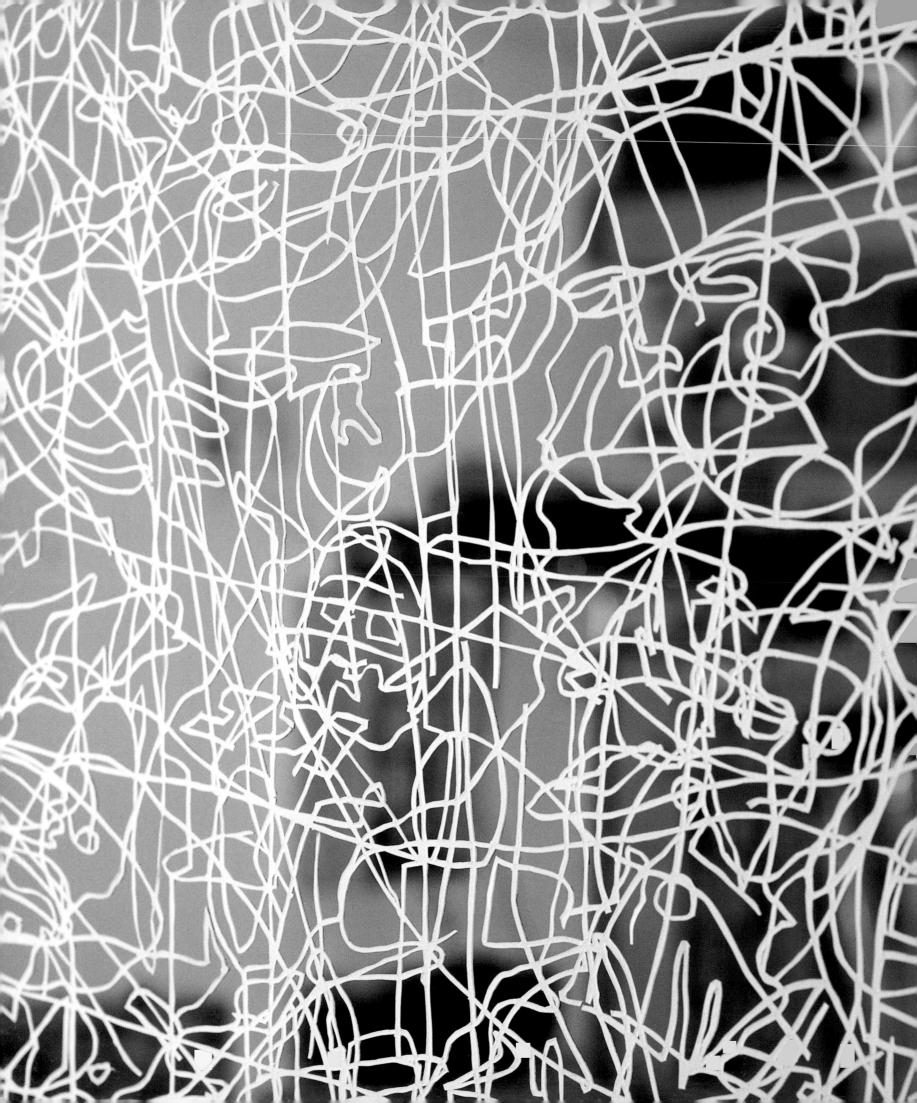

Contents

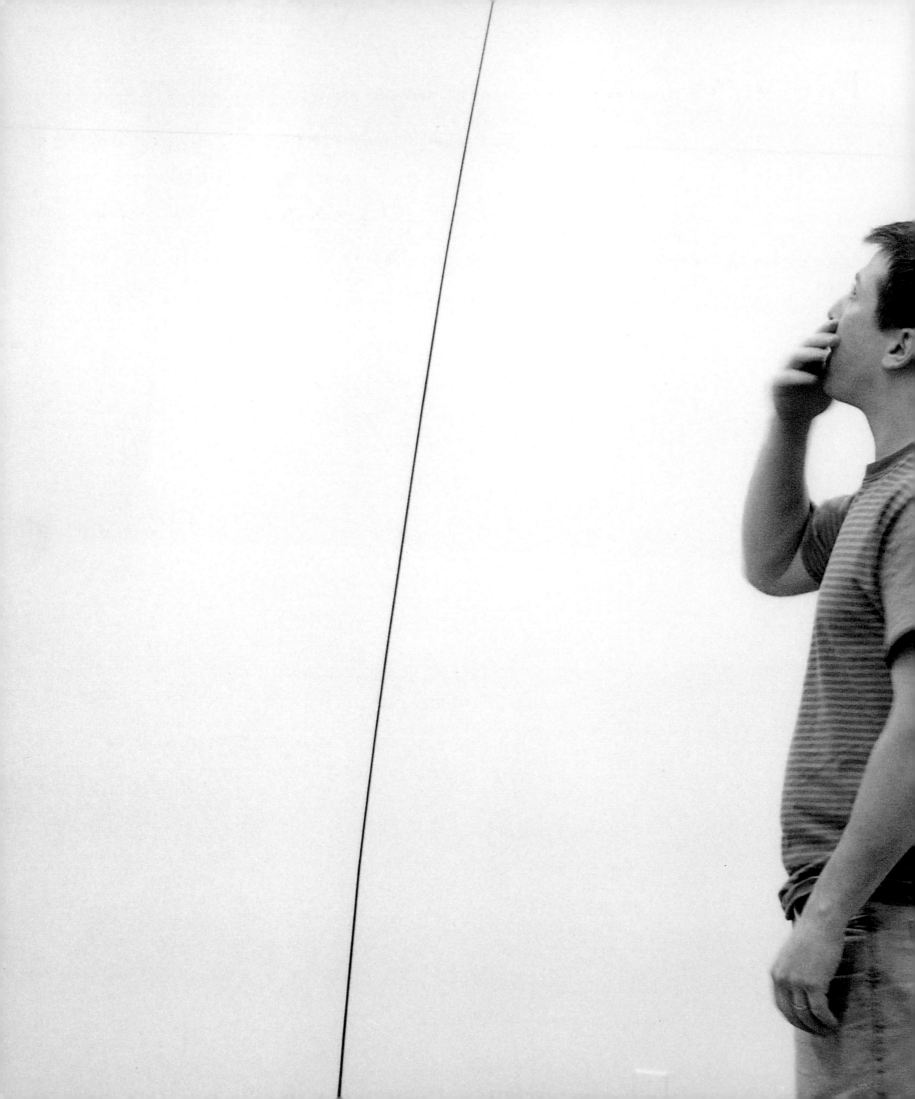

Contents

Dennis Cooper When did you decide to be artist?

Tom Friedman **As young as I can remember. I always enjoyed spending a lot of time drawing, focusing my attention on that. I grew up in St. Louis, Missouri, where my exposure to art was limited to the art books my parents had on their bookshelf, on Picasso, Rubens, El Greco, Walt Disney. I looked at them every so often. Art for me kind of began as a skill. But I guess I always knew I wanted to be an artist.**

Cooper You toyed with the idea of being a graphic artist or an architect, right?

Friedman **Yeah. Where I grew up, I had no concept of what an artist was. I assumed you got a job that could earn money. Initially I looked for creative outlets that were more practical, like architecture, graphic design and illustration. Each change was moving towards doing my own art.**

Cooper You didn't find those forms satisfactory?

Friedman **I think I had too much of my own stuff to work through, and they weren't ways to work through that. So I decided to go to graduate school and major in studio arts. I went to the University of Illinois in Chicago. I entered this program doing large charcoal drawings that were like Thomas Hart Benton. At the time, the program was very conceptually based, and this language being used to talk about art was so foreign to me. I was forced to address why I was doing these drawings, and it paralyzed me.**

Cooper How did you proceed?

Friedman **Being so confused, I tried to find something incredibly basic and simple. I wanted to gain a grasp of what I was communicating, because the way my work had been read was so far from how I was thinking about it. That was the first year – it's a two-year program. The next year when I returned, I**

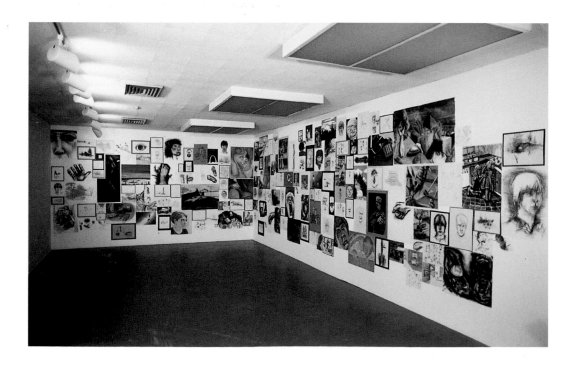

Early Work
1974–94
Mixed media
Dimensions variable
Installation, Artist's studio,
Middletown, Connecticut, 1994

decided to take everything out of my studio, remove all the stuff that was there. I then boarded up the windows and the closets, painted the entire space white, and made this obscenely white, empty space. There were fluorescent light fixtures on the ceiling that cast a diffuse light, so you really couldn't see the edges of the walls. Did you see the movie *THX 1138*?

Cooper Yeah.

Friedman **You know the prison? That's what it was like.**

Cooper Scary.

Friedman **At this point I sort of dropped the idea of making art; it was more about discovering a beginning. Everyday I would bring an object from my apartment and place it somewhere in the space. The first day I placed a metronome on the floor, and it just clicked back and forth. Or I would sit the whole day, on the floor, looking at it and thinking about it, and asking questions about my experience of it. There was something about this space … I didn't know at this time the significance of the 'white cube'. For me, this was more like a mental space that had been cleared away.**

Cooper A blank?

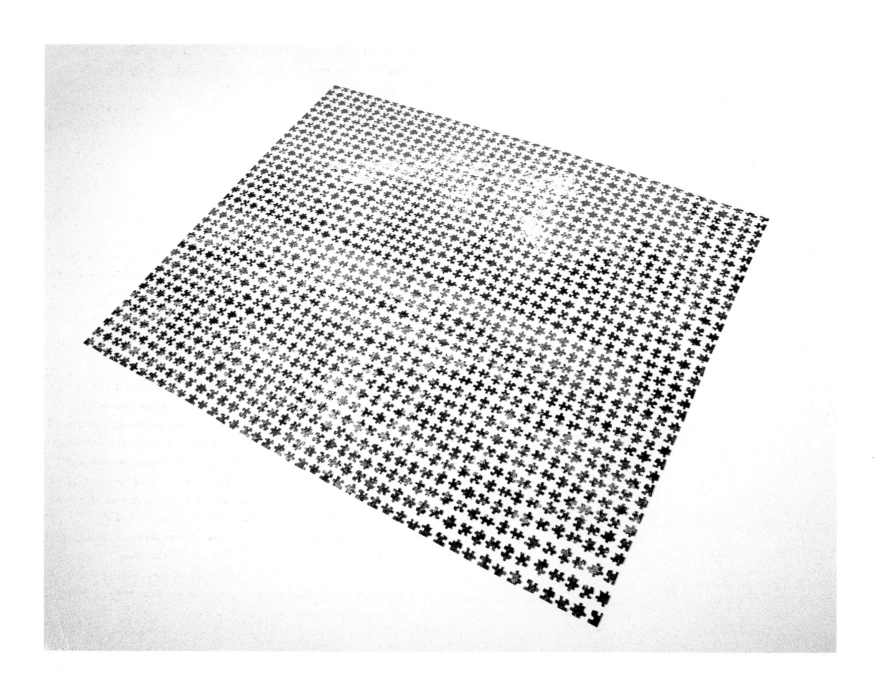

Friedman **Right. A way of trying to understand silence, or nothing.**

Cooper That was a fairly radical shift from Thomas Hart Benton.

Friedman **Well, there were stages towards that simplification. It needed to be radical. I didn't really know what I was doing at the time, but one day I poured honey on the floor, and when I was away from this space someone asked me if I had urinated on the floor. They thought the puddle of honey looked like urine. This incident enabled me to see the potential meaning of this experiment. I started to think of something I could do in the space that related in a way to this activity. I thought about putting together a jigsaw puzzle, as a metaphor for what I was trying to do: to piece something together.**

Cooper Was this an intentionally pure investigation? I mean, you didn't go comparative idea shopping in Chicago's galleries and museums?

Friedman **No. I went to the store and bought a jigsaw puzzle. I think the faculty was beginning to worry about me. But when I got to a point of almost finishing the puzzle, I thought what I'd do is separate the pieces, like three-quarters of an inch apart from each other (*Untitled*, 1990). So they were in the right order … as if the puzzle was stretched apart. This seemed to redefine the puzzle in a way. You had to look at each piece to construct the total image. That was the beginning, for me, of thinking about using these materials and manipulating them.**

Cooper Can you define how you knew this piece was a success?

Friedman **I think in the way it was read by people, which was very similar to the way I was thinking about it. There was something irrefutable to me about it. It wasn't about a particular thing, but it seemed to branch off into possibilities of meaning. And these possibilities didn't limit it.**

Cooper Which de-paralyzed you?

Friedman **I had found a clear point of departure. I then started to look for other metaphors to describe my process. At this time I was involved in meditation, so I thought about a process that could somehow describe that. I thought about erasing, so I started to collect eraser shavings. I wasn't familiar with Wolfgang Laib's pollen pieces until people mentioned them to me as I was erasing. But there was something interesting about the romantic aspect of his work versus the mundane, and the meaning of erasure seemed to have a similar significance. And the gesture of erasing … the repetition of it became almost like a mantra. After spending hundreds of hours collecting eraser shavings, I sprinkled them onto the floor of this studio space in a soft-edged circle (*Untitled*, 1990). And that seemed to take me to the next level of trying to represent something very specific, striving for clarity and focus … finding something objective, in a way.**

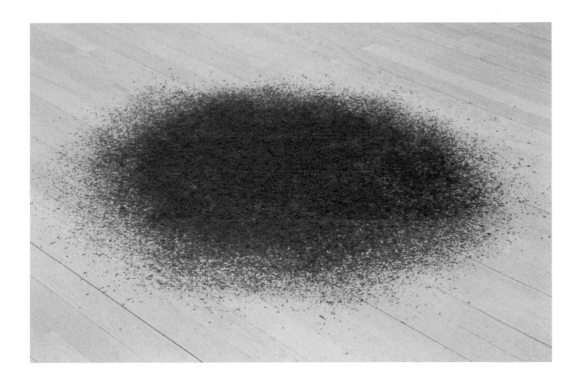

Cooper Clarity in what sense?

Friedman **Through that piece, I identified for myself four basic elements: the material I would choose, the process of altering the material, the form that it would take, and its presentation. I found that there would be an element of logic that would connect them, like the process of erasing with an eraser and achieving this minimal focal point as the idea of erasing.**

Cooper Was the closed-off, hermetic system interesting to you as well?

Friedman **Yeah, I really wanted the logic kind of to circle around itself in a way, always come back to itself, and be about itself. I thought more about this circular logic, and this led me to the next piece. I made a pendulum out of a string and funnel. I filled it with laundry detergent and then swung the pendulum into a circular path (*Untitled*, 1990). The funnel sprinkled the detergent on the floor in a spiral pattern. After it made the spiral, I removed the pendulum. So there was the laundry detergent in relation to its form, like a spin cycle of a washing machine, and gravity in relation to a galaxy. One thing that was interesting about using the detergent was the idea of cleansing. I started to look for other materials that had to do with cleaning, or personal hygiene. Because I was thinking about ritual and process, I liked the**

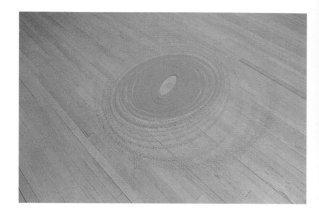

connection these materials made between daily mundane rituals and rituals for spiritual purification.

Cooper What about the chemical aspect? Detergent is an artificial construct.

Friedman **This construct for me would flip-flop from a critique to a celebration of itself.**

With the idea of looking for these cleaning materials on my mind, the next work came from being in the shower and noticing that a piece of my pubic hair had got stuck on a bar of soap. I looked at it as being very beautiful.

It wasn't enough for me to allow it just to be this event that happened. I wanted to ritualize it and incorporate a type of precision that I was investigating and developing in my process. I decided that I would inlay my pubic hair on the soap in a spiral as precisely as I could (*Untitled*, 1990). It was a way to use this circular logic and make something more absolute. I wanted to take this idea further, so I thought about a material that would suggest a process that is as direct as possible, that has a very clear objective. I got a roll of toilet paper and re-rolled it as precisely as I could (*Untitled*, 1990). The ensuing shape was cylindrical like a roll of toilet paper, but without its cardboard tube. And the fact that it was just one roll, the precision, the geometry and the objectivity of the process seemed to make it more absolute.

Cooper Were you sufficiently intuitive about what you were doing at that point for people's responses to function as a kind of language-based, correlative explanation for what you were doing?

Friedman **I was discovering a lot through other people's understanding of it.**

Cooper Were you still in school?

Friedman **I graduated somewhere between the soap with pubic hair and the toilet paper roll. The last piece I did in graduate school was a wall piece where I signed my name on the wall with a felt-tip pen in a spiral (*Untitled*, 1990). I**

opposite, **Untitled**
1990
Laundry detergent
Dimensions variable
A spiral of laundry detergent created with a pendulum consisting of a string and funnel.

right, **Untitled**
1990
Hair, soap
2.5 × 10 × 5 cm
A partially used bar of soap inlaid with a spiral of the artist's pubic hair.

far right, **Untitled**
1990
Toilet paper
h. 12.7 cm, ⌀ 10.2 cm
One roll of toilet paper re-rolled without its tube.

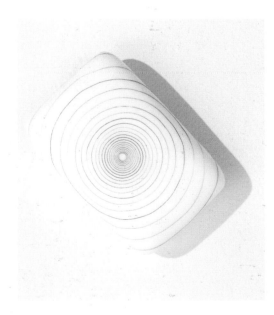

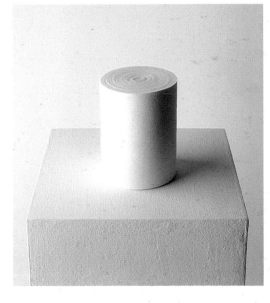

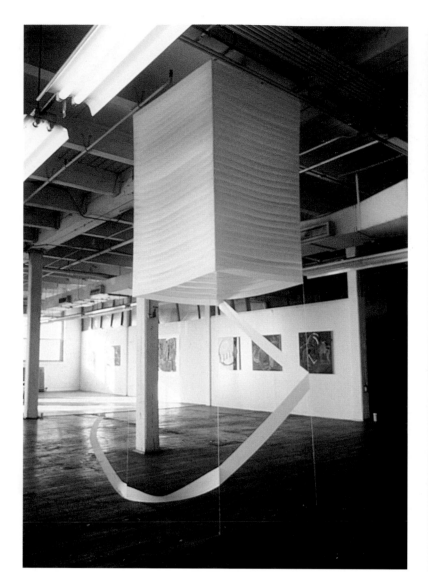

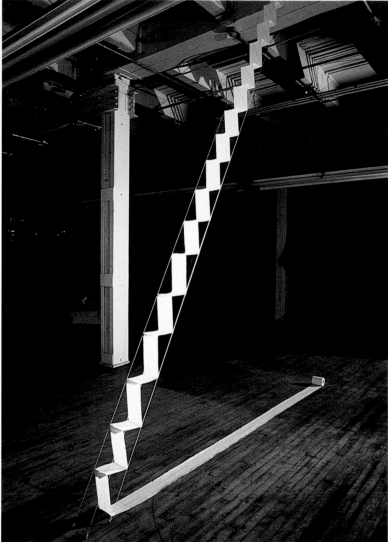

just kept signing it until the pen slowly ran out, so it created this vortex. In a funny way it was a goodbye piece to school. But it's the same type of logic – a type of identity loss in relation to meditation – that was interesting.

Cooper You haven't mentioned the work's comedy.

Friedman **That just sort of happened, because of the nature of these irreverent, dumb materials. They became very beautiful.**

Cooper A comedic tone seems crucial to the work's effect, and that tone's modesty in particular seems key.

Friedman **Right, it's very deadpan, which is one side. The other side is humility or regression.**

Cooper How so?

Friedman **It depends on where the interpretation comes from. If it comes from the mundane becoming art, it's comedic; if it comes from art as mundane, it's humility, or regression as an acknowledgement of its most**

left, **White Cloud**
1989
Toilet paper
Dimensions variable
Installation, University of Illinois at Chicago
Toilet paper wound around a structure of four strings, each extending from the ceiling to the floor.

right, **Untitled**
1989
Toilet paper, string
Dimensions variable
Installation, University of Illinois at Chicago
Toilet paper wound through a structure made of string.

Untitled
1990
Marker pen on wall
⌀ 106.5 cm
The artist's signature written on
the wall in a spiral until the pen
has run out of ink.

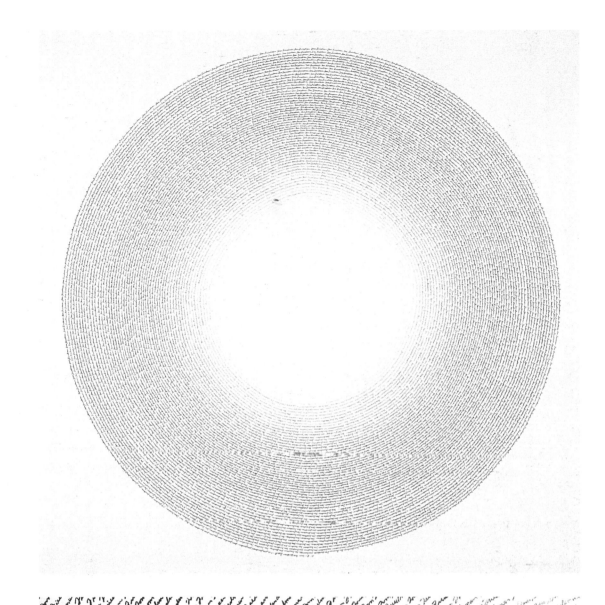

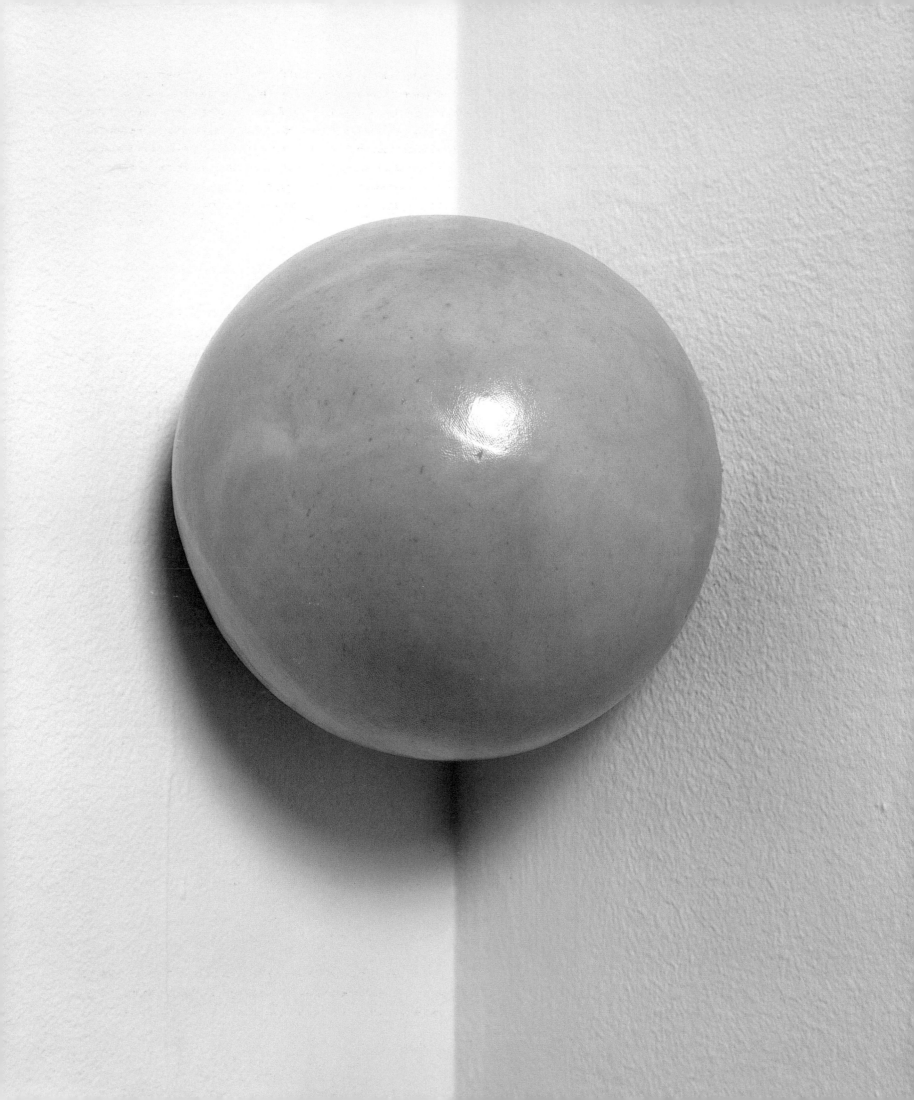

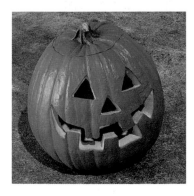

base being. I did this piece where I chewed a bunch of bubble gum, about 1,500 pieces (*Untitled*, 1990), then moulded them into a sphere. I was thinking of how to present it. It didn't seem to make sense to just put it on the ground or on a pedestal. So I thought I'd just wedge it in the corner and let the stickiness of the gum hold it up. I wedged it head height into the corner, and that seemed to make sense – like in school, being punished for chewing gum in class and made to stand in the corner. There was also something about 'bubble-head'. In one respect, bubble-head related to someone who just doesn't have any ideas, there's nothing in there, and also this nothingness in reference to a meditative silence.

Cooper Were you living in Chicago at this point?

Friedman **Yeah; I had just finished graduate school (1990). I needed to make a living. A lot of artists out of school in Chicago would get jobs with the museums as art-movers, or as exhibition assistants at the Field Museum of Natural History, and that's what I did too. I worked there for about a year. I would work nine-to-five, and then come home and do my artwork. You could turn working at the Field Museum into whatever you wanted. If you really put a lot into it, you could eventually design exhibits. But my mind was constantly on my own artwork. So after about a year, I had worked my way down to changing light bulbs in the museum (laughter).**

Cooper Had you already developed a relationship with the gallery Feature Inc.?

Friedman **While I was in graduate school Tony Tasset, one of my teachers, told Hudson – who runs Feature – to look at my work. Hudson did a studio visit and was interested. He put me in several group shows and then gave me a one-person show (1991).**

Cooper Was that a smooth transition, in terms of how showing affected your working process?

Friedman **It seemed like a natural progression for my work, which was about the experience of being with the work. I was interested in making something, and really investigating how its information unfolded to someone looking at it.**

Cooper There was quite a community of vital younger artists in Chicago in the early 1990s. Were you part of the gang?

Friedman **I kind of kept to myself in a way. But I knew people who were there, like Jeanne Dunning, Hirsch Perlman, Judy Ledgerwood, Julia Fish and Tony Tasset. But I didn't consider myself in that group.**

Cooper So you were more interested in the ways in which your work interacted with viewers than in your personal interaction with other artists?

Friedman **Yeah, in fact the next jump with my work in 1990–91 was thinking more specifically about what the viewer brings to an art experience. The idea of expectations stuck in my mind. There was an expectation to have**

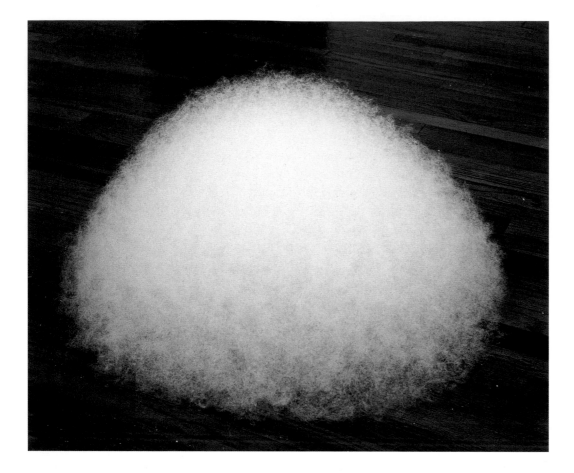

Untitled
1991
Pillow stuffing
45.5 × 76 × 76 cm
Stuffing from a pillow was
separated strand by strand into a
pile on the floor.

something move you, or tell you something you don't know, or generate a thought process.

Cooper Are you talking about generating those things in yourself, or in the viewer?

Friedman The viewer. You know, no one wants to look at art and have it not do anything. I think this came from the unassuming quality already inherent in my work. I thought about the art of downplay which came from my interest in Andy Kaufman's comedy. I had seen his comedy on TV as I was growing up. He did this one performance where he would start telling really horrible jokes. And you could see the audience was thinking, 'Oh, this is so bad!' He would become aware of the audience's disapproval and become almost paralyzed with stage fright. Then he'd start to whimper and cry. The crying would start to slowly take on a rhythm. There were bongos next to him on the stage. And then dancing was added to the rhythm, which led him to the bongos, which he started playing, and then he danced off-stage. It was just unbelievable. After you realized the joke, it just changed your whole perception of what he was doing.

Cooper He played with notions of innocence.

Friedman This innocence seemed to be his point of departure, as if beginning from childhood. But his innocence would always flip-flop and become something else. These ideas sparked my next piece, which was a standard A4 sheet of paper that I poked with a pin as many times as I could without

ripping the paper apart (*Untitled*, 1991). It was displayed on a wall, hung by the pin that poked it. I liked that initially it seemed like this discarded towel, but if you investigated it you would see the pin-holes, and that would change it from this seemingly casual thing to something very laboured. I thought about that type of phenomenon – what happens between the assumption of casualness and the discovery of intensity.

Cooper People have often compared your work to magic tricks, gag gifts.

Friedman **Well, I did magic when I was a kid.**

Cooper Was there something in the formal modesty of the magic trick relative to the grand effect it creates that interested you?

Friedman **Yeah, how the modesty or casualness unfolds into illusion and mystery. The casualness sort of mutated into this idea of fragility, fragility defining a kind of presence. My work was already small and fragile, but I wanted to push this further. I did another piece which was a very thin piece of wire, I think picture-hanging wire, that stood perfectly erect protruding from the floor (*Untitled*, 1992). I made it by initially placing the tip of the wire into a small hole in the middle of the floor. The wire would bend over, so I'd cut it**

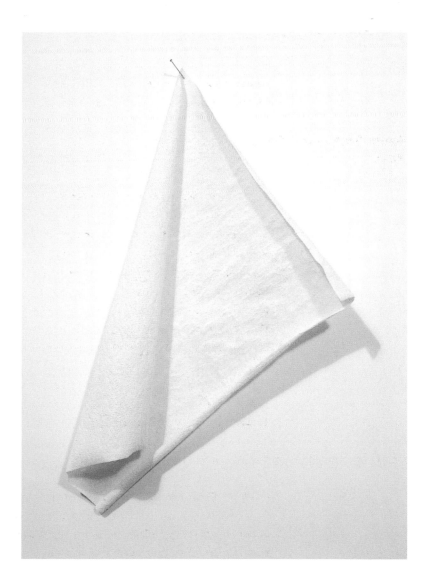

down slightly and straighten it out again. I kept cutting it down and straightening it out to find the exact height at which it could support itself without bending over. It was so sensitive that it would quiver with just the vibrations in the air, and it seemed to be defying gravity. It was almost invisible – you had to be shown where it was. I remember people would come into my studio, and I'd point the piece out to them, and wherever they were, walking around my studio, they'd constantly have to orient themselves in relation to the piece. That's the kind of presence I was thinking about. Because of its fragility, people would have to consider it, hold it in their minds, and be sensitive to it so as not to damage it.

Cooper You generally work on the wall or on the floor. What do you see as the differences there?

Friedman **Whether something was on the wall or the floor was part of the basic elements that I was thinking about from the beginning, in terms of presentation. My decision seemed based on being as direct as I could be. Like the laundry detergent; it seemed like it needed to be on the floor because that was the way it fell. Pinning a piece on the wall, I would think about the line or the direction that someone would travel to see the piece. I didn't want any kinks in that line; I wanted it to be fluid. The decisions seemed based on what was most natural.**

Cooper What about the shit piece, which used a pedestal (*Untitled*, 1992)?

Friedman **I was still thinking about scale and fragility, which led to thinking about the smallest amount of material to present that would have the most significance. So I thought that I would use my faeces, and rolled some of it**

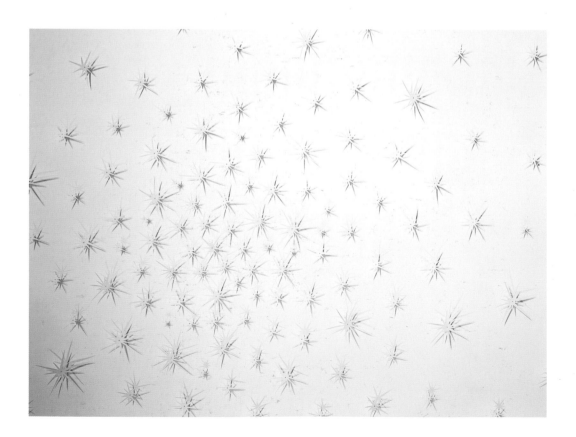

above, **Untitled**
1992
Wire
h. 45.5 cm
A very thin, 45.5 cm-tall wire protrudes from the floor. It was made by alternately straightening and cutting it down to find the exact point that it could support itself without bending over.

left, **Untitled**
1996
Paper, pins
Dimensions variable
A wall installation made with hundreds of stars cut from paper. Each star is affixed to the wall, floating by a pin.

right, above, **Untitled**
1990
Balsa wood airplane model
⌀ 91.5 cm
A balsa wood airplane model
arranged on the floor with
bilateral symmetry, with the
exception of several pieces that
deviate from the airplane's
symmetry.

right, below, **Untitled**
1990
Pick-up sticks
Dimensions variable
Two piles of pick-up sticks; one
strewn on the floor, the other laid
down carefully to duplicate the
first pile.

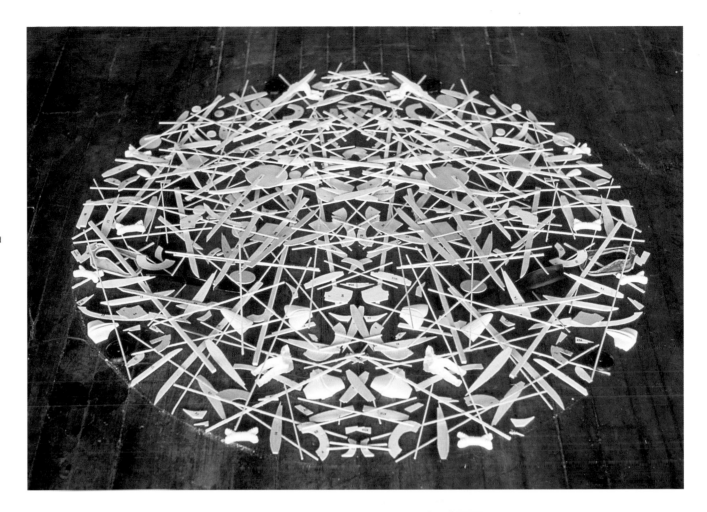

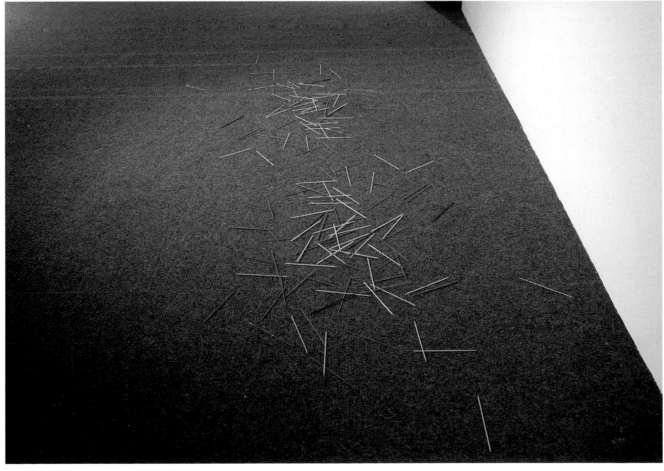

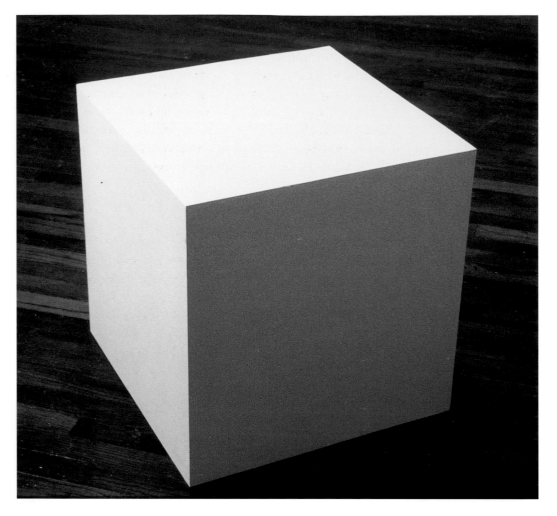

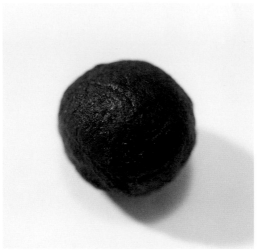

Untitled
1992
Faeces on pedestal
Pedestal, 51 × 51 × 51 cm; faeces,
∅ 0.5 mm
A sphere one-half millimetre in
diameter of the artist's faeces
rests precisely centred atop the
cubed pedestal.

into a ball. I wanted it to be spherical, I wanted it to have a shape, not just be
the material. It was tiny, about half a millimetre in diameter. I presented it on
this pristine white cube/pedestal, because I wanted to draw a relationship
between this minimalist icon and the shit. I really wanted the size of the shit
almost to create some sort of bridge between the idea of it and its physical
presence, to kind of merge the two together. Also I wanted to use the size to
draw one's focus towards an idea, a very potent idea. I saw the cube and the
shit contrast each other but become similar, both requesting a similar
experience.

Cooper Making art out of your shit can be read as a transgressive act. That
might even be the first reading for some people.

Friedman **That was part of compressing the idea. It was like thinking about
shitness through an intense meditative focus.**

Cooper Still, it's a loaded piece, which must have received a loaded response.

Friedman **I think people talked more about the stories around it than about
the ideas. Like at my opening, some guy who I guess was a bit irreverent sat
on the cube, thinking it was an empty pedestal. I saw it happen and ran over
to him. He stood up, and I told him to just stay there, while I proceeded to
look for the shit on his butt. But I couldn't find it! Luckily I had some spare
ones.**

Cooper A multiple! *(laughter)* Was the shit piece shown in Chicago or New York?

Friedman In New York. It was my second show at Feature. Also in that show was a piece titled *Hot Balls* (1992), which was a collection of toy and game balls I stole from various stores in Chicago. I was working on this piece and had 'collected' about two hundred balls over a six-month period. I didn't know what I was going to do with them. I tried to finish the piece by arranging them. Eventually, I decided to steal a really big ball, which sat on top of the smaller balls and became this kind of prize.

Cooper Why steal them?

Friedman I heard something about how the space shuttle on its next trip into space would take these stamps with it. When the stamps returned to Earth, they would be sold as collector's items. It was interesting that you'd have two of the same stamps, and one would have this history attached to it that made it more valuable than the other one which was visually and even subatomically identical. So I was thinking about presenting information in a piece that wasn't inherent to the physical qualities of the piece, but in what you learned about it, and that would change your perception of it. The fact that the balls were stolen was their attached history. Also the stealing related to the tricks and sleight of hand. It also offset the preciousness of my process.

Cooper How would a viewer know they were stolen? I guess the title was a clue.

Hot Balls
1992
Stolen balls
h. 51 cm, ⌀ 91.5 cm
About two hundred balls, stolen
from shops by the artist over a six-
month period, are arranged on
the floor.

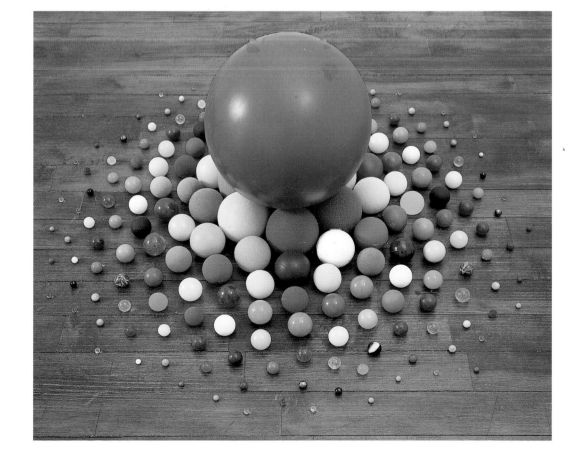

Friedman **For that particular exhibition there was a hand-out with empirical information written about each piece.**

Cooper You say that *Hot Balls* involved about six months of stealing and thinking, whereas I assume the shit piece took much less time to realize. How does this time differential distinguish one piece from another, if at all?

Friedman **I think the time element becomes relative to each piece. Even ones that take a minute or a second seem to compress or expand time in a way whereby they become similar to the more laboured pieces. One's idea of an instant or an eternity takes the same amount of time to think about.**

Cooper You don't speak of your work in relation to other artists' work. Who influenced you? Are there artists with whom you feel a kinship?

Friedman **I think my first art experience was when I was younger; my parents had a lot of Picasso books. They had one book of his etchings. When I would look at them I just saw lines; I didn't really see much more than these interesting lines. Then one time when looking at the etchings, the lines became figures and created these images that seemed housed within the whiteness of the page. It seemed to give the white page this solidity. It was really a profound experience for me to see that happen, that sort of shift in perception.**

When I think about artists who have influenced me recently, I don't distinguish much between one or the other. I think everything I see and consider influences me in some way. It's interesting because art, visual art, doesn't affect me that much for some reason. It could have something to do with the mystery of it, that I feel that I've already gone through it. Music is something that has that mystery for me. It really affects me, and I feel I've been more influenced by music than visual art. It's really odd that I don't get much out of looking at art, because I make objects and I hope people enjoy looking at them.

Cooper It makes complete sense to me. As a writer, I learn much more from visual art than I do from other writing, at this point. So what music have you learned from?

Friedman **Recently I've been listening to a lot of electronic music. Like Richie Hawtin is one of my favourites. And Richard James and Thomas Brinkman.**

Cooper Who's that?

Friedman **I don't really know much about him, but he's collaborated on some things with Richie Hawtin. And Tom Jenkinson, Stereolab. Glitch music, like Oval or Autechre.**

Cooper How have they influenced you?

Friedman **I've always been interested in the idea of quanta, and the quanta of ideas. I think that electronic music begins to investigate these things, the way sounds and rhythms can be broken down and built up from their**

smallest part.

Cooper Do you think about the way their work diverges from traditional musical structures?

> **Friedman** I think of it more as pattern and texture, the way different patterns and textures work off each other. I mean once you start dealing with electricity you begin to enter into thinking about synaptic functions, how one constructs thought or thinking based on electrical impulses, and how these impulses affect the body.

Cooper Have you consciously tried to translate musical principles into visual principles?

> **Friedman** For some reason, when I think about an idea I think about it as a physical thing. I think about it as a form that has dimensions, shape, pattern and some sort of structure, or the fluid structure of music. I'm interested in some sort of conceptual aesthetic. It's not so much what the ideas are, but what they look like, and where they are located in relation to each other, similar to the aesthetics of sound.

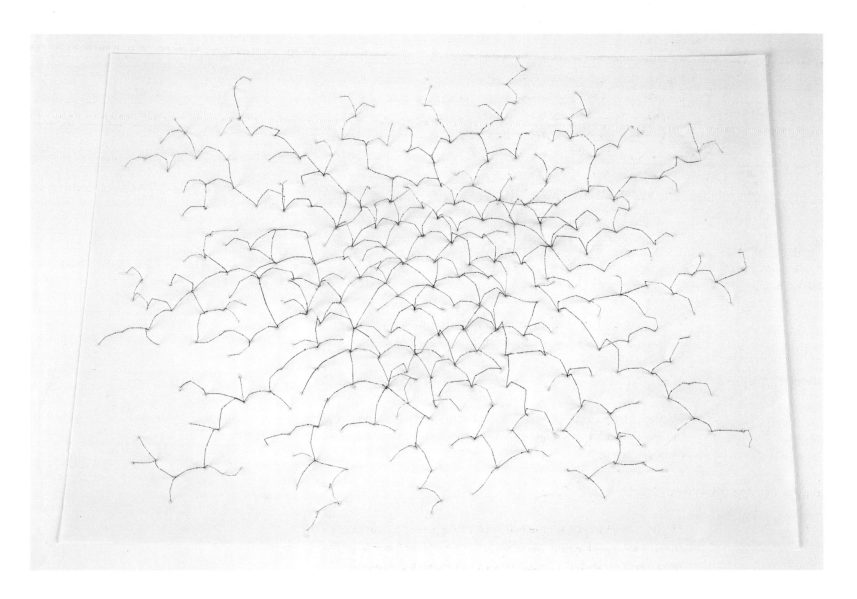

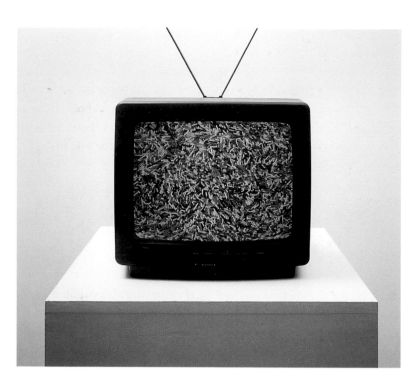

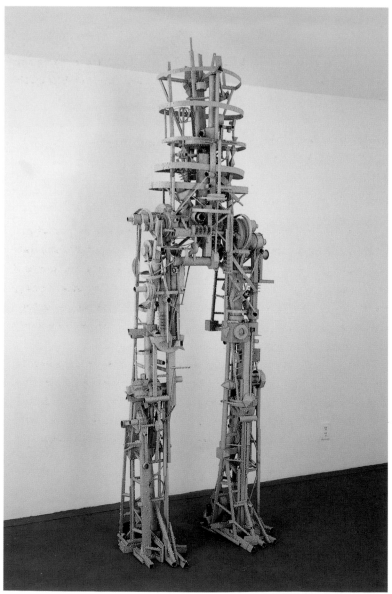

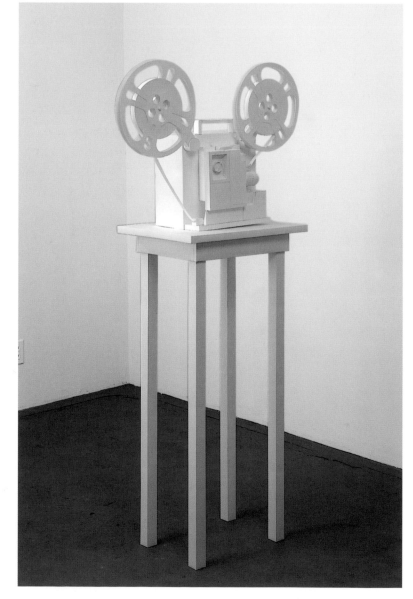

left, **Untitled**
1996
Monitor, laserdisc and player,
pedestal
142 × 51 × 51 cm
A 33 cm colour television with its
antenna up sits on a pedestal
presenting what seems to be
colour static and static sound. The
static is an animated sequence of
images of candy sprinkles. The
sprinkles were poured onto a
computer scanner, scanned,
shuffled around, scanned again,
shuffled again and so on. About
one thousand different scanned
images of the sprinkles were made
into a video loop and transferred
onto laserdisc. The static sound is
a recording of the sprinkles being
shaken in a cake tin. The laserdisc
player is hidden in the pedestal.

Cooper Is there signage of that thinking in your sense of colour?

> **Friedman** Yeah. When I work on a body of work, each piece tends to take on a distinct colour identity. Like in my most recent work, the biological colouration of the mutilated figure (*Untitled*, 2000, see pages 70–71), in contrast to the grey of the robot (*Untitled*, 1999), and then the white of the movie projector (*Untitled*, 1999).

Cooper Maybe I'm wrong, but it seems to me that your most recent work involves a more intensive and varied use of colour. I've read that you consider your process to have evolved from a largely intellectual process to a more emotional one. Is there a connection there?

> **Friedman** Yeah, because I started to think about my work more in the background of my mind. I'd sort of plant an idea in my head and then something would come from that. For me it's a new type of thinking process: not primary thinking, but allowing something to just sort of develop and happen in the background.

opposite, left, **Untitled**
1999
Cardboard, Styrofoam balls
254 × 76 × 56 cm
A robot made with cardboard and covered with Styrofoam balls.

opposite, right, **Untitled**
1999
Paper
160 × 38 × 76 cm
A movie projector made from paper sits atop a paper table.

Cooper Why do you characterize it as emotional?

> **Friedman** Because it's not an intellectual process, which is more a foreground thought process. Happening in the background, it begins to introduce and be affected by a psychology.

Cooper In some way, psychology and poetry are opposites. Psychology seeks meaning in the trajectory of one's past experience, and poetry suggests meaning is impossible, and can only be conjured. How is it that your work seems to have become more psychologically acute and more poetic simultaneously?

> **Friedman** I think in my latest body of work the idea of cinematography has filtered in. This idea was somewhat the catalyst for my March 2000 show at Feature. When I make a body of work I try to create a piece that represents a protagonist or a catalyst for things to happen. And the movie projector piece was the catalyst for this exhibition. In a sense, I saw the other pieces in the exhibition to be apparitions created by the projector. Looking at the way my mind works, I was using film as a request or a reference to the cinematographic experience, the layering of different types of represented reality. Because the projector is all made of white paper and the film is paper, it's like a projection of itself. I know that the shape of the film format isn't a square, but I can relate the square to it, and thinking of these as minimalist squares going through this cinematographic type of filter I see as like a shift in consciousness in the way people look at things now.

Cooper Because of film, because of the computer, because of …

> **Friedman** All that stuff. And because of the narratives attached to our consumer landscape. Like one recent piece involves nine cereal boxes that are fused together to make one large cereal box (*Untitled*, 1999). It took me a while to figure out how to do this, but it's based on matrices. It's kind of like if

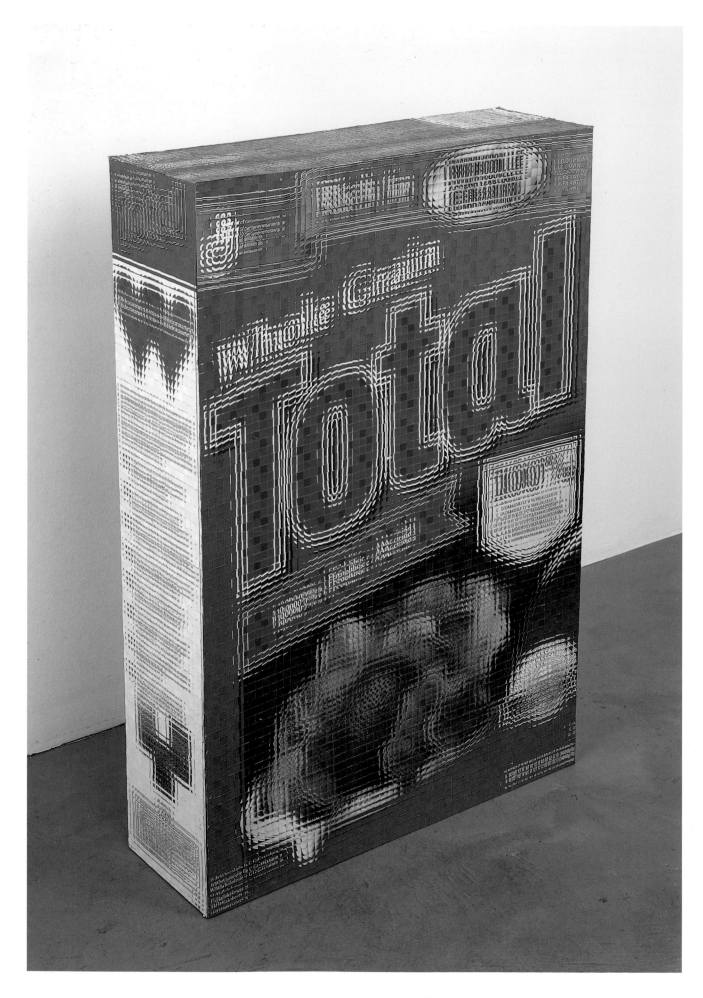

left, **Untitled**
1999
Cereal boxes
79.5 × 54 × 17 cm
Nine Total cereal boxes cut into
small squares and combined to
make one large box.

opposite, **Untitled**
1999
Dollar bills
35.5 × 89.5 cm
Thirty-six one-dollar bills
combined to make one large
dollar.

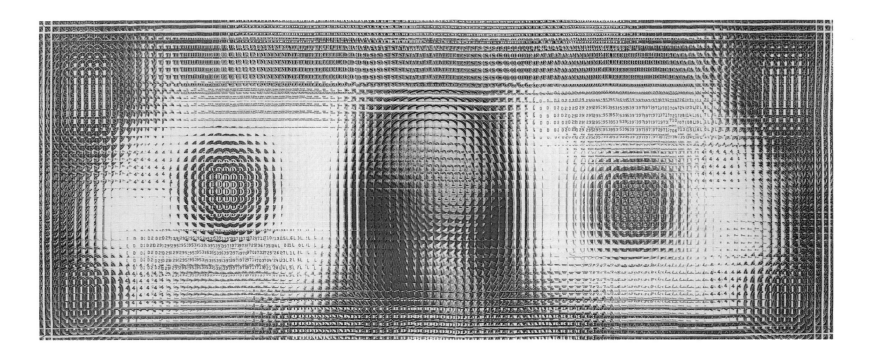

you wished to fuse two material objects together, you'd take the first atom from one object, then connect the first atom from the second object, then the second atom from the first object, and so on. But instead of using atoms I used squares. The squares are combined to construct the total image. I was thinking about the squares like the frames of the projector. In a film, as you move from square to square the image is displaced a bit. And there's a money piece (*Untitled*, 1999) based on the same principle, except it's done with thirty-six dollars. It's a grid of six by six. I was interested in the relationship between the static object and time, and the displacement of your mind continually looping and thinking about the static object. Also, in thinking about fantasy, what obviously comes into play is that separation between real space and mind space, and ideas have this kind of elusive nature to them in mind space. But the idea of a concrete space sort of brought me back to thinking about my white studio space in grad school. It became this clear space in my head where I could put things. So now I'm interested in that edge between the mind space and the real space, which sort of informs these images. They have a solidity inherent in the materials they're made of that grounds them, in a way, like the robot. But they are also like apparitions; they just appear but they are not real.

Cooper Are you interested in the paranormal?

Friedman **I love reading conspiracy theories, things like that.**

Cooper You like the *X-Files*?

Friedman **Oh yeah, I love that kind of stuff. I think there was a point where I thought about the rules of thinking, all the rules that I've sort of inherited, and I really tried to lay those aside, in a sense. Like I'd give this book on conspiracy theory to someone, and their first comment would be, 'Do you believe this stuff?' For me that question of believing it or not is not the point. I mean the fact is there is this perception, and there is this amazing fantasy or**

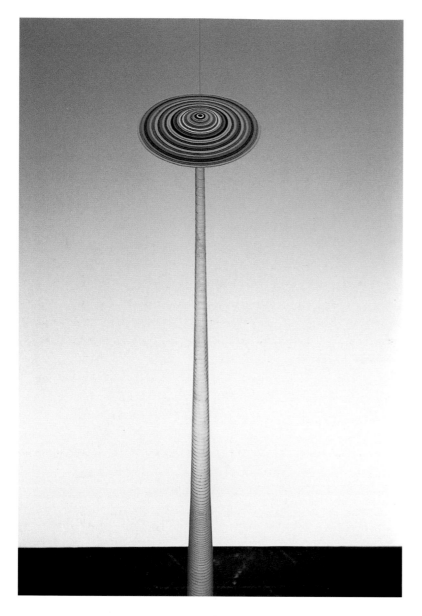

Untitled
1998
Construction paper, clear tape
h. 86.5 cm, ⌀ 5 cm
A form made by laminating
consecutively larger then
consecutively smaller circles cut
from different colour construction
paper sits atop a cone of coiled
clear tape. The sculpture hangs
from the ceiling by monofilament,
30.5 cm off the ground.

**whatever, someone constructing this theory, and it just makes incredible
fiction or science fiction or non-fiction or whatever. It's so interesting because
these realities are confused.**

Cooper So that's the poetic. I mean, that's where the poetic derives from?

Friedman **Yeah.**

Cooper Did the work you made a few years ago with space station imagery
(*Space Station*, 1997, see page 131) begin introducing the poetic into your
work?

Friedman **Yeah, the space station was like an outpost connecting the known
and the unknown. It's something that, in a similar way to the microscope,
extends our perception beyond the capabilities of our immediate senses. I
think that work was an attempt at really trying to take these very disparate
investigations and solidify or make autonomous each one, and then unite
them and bring them together. You can't help but begin constructing
narratives when that process happens – just like in a dream, when you're**

bombarded with impressions, and your mind naturally constructs a narrative to link the impressions together.

Cooper So there was a shift happening there?

Friedman **I'm not trying to draw the viewer into a specific place, I'm drawing them into the constellation of ideas, which is probably why I made the spider sculpture (*Untitled*, 1997). I thought about the spider as this thing that spins a web. I see the spider connecting ideas with its web.**

Cooper Insects keep crawling into your work *(laughter)*.

Friedman **The first insects I made were the fly sculptures (*Untitled*, 1995), which initially began with an incident where the artist Charles Long, who used my shit piece in a show he was curating called 'Critical Mass' (A & A Gallery, Yale University School of Art, New Haven, and tour, 1994–95), had to put a cup over the piece of shit because a fly was buzzing around it. He sent me a photograph of the cup over the shit and the fly on the pedestal. That sparked the fly pieces.**

Cooper Would the dragonfly (*Untitled*, 1997, see page 64) be some kind of psychedelic mutation of the fly?

Friedman **Yeah, exactly. The dragonfly represented a shift into thinking about fantasy.**

Untitled
1997
Clay, hair, fishline, paint
12.5 × 10 × 2 cm
A handmade spider rests on the wall.

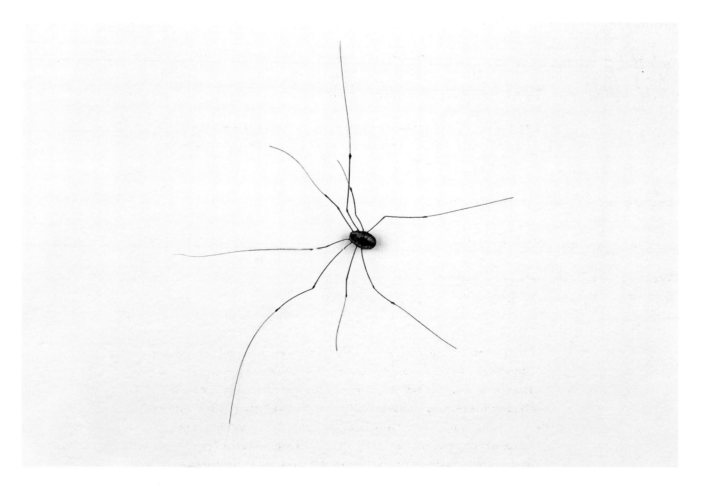

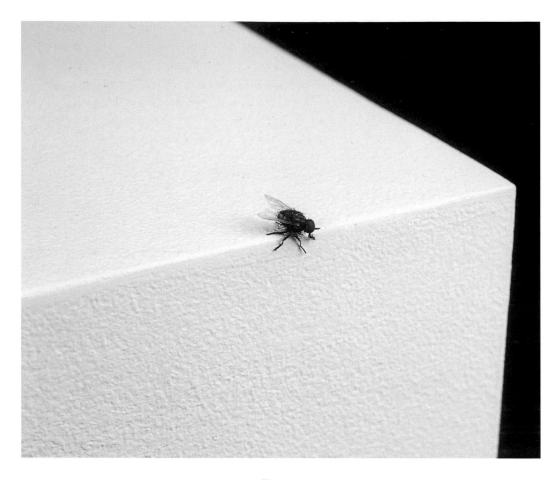

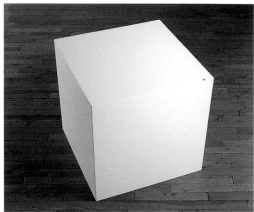

Cooper But this wasn't a radical shift for you, it was a natural progression?

Friedman **Right. When you think about something over and over again it just sort of vanishes. It diffuses into possibilities and loses its objectivity. I have this fascination with mapping things out, mapping out very complex systems. And being able in a way to map them in my head without being able to translate them, or not having the ability or the skills to explain them. I'm very torn by that, by that inability. And I think that somehow that's a part of my work, a big part of it.**

Cooper Are the materials you use a limitation?

Friedman **I have the idea of wanting something to be explanatory, but once I begin to explain, it's not what it's about.**

Cooper So do you end up simulating the enigma that it has for you?

Friedman **Yeah. The explaining becomes the object, as opposed to the indicator.**

Cooper I wonder, do your pieces ever fail in process, or do they generally succeed once you've reached the point where you move from concept to construction?

Friedman **There are a lot of pieces I will begin but be unable to resolve. I'll either trash them because I just need to purge myself of them, or I'll put them**

opposite, top, left and right,
Untitled
1995
Plastic, hair, fuzz, Play-Doh, wire,
paint, wood
61.5 × 61 × 61 cm
Collection, The Museum of Modern
Art, New York
A handmade fly rests on the edge
of a cube.

opposite, bottom, **Untitled**
(protected from fly by plastic cup)
1992
Faeces on pedestal
Pedestal, 51 × 51 × 51 cm; faeces,
⌀ 0.5 mm
A sphere one-half millimetre in
diameter of the artist's faeces
rests precisely centred atop the
cubed pedestal.
Installation, 'Critical Mass', Dallas
Artists Research and Exhibition,
McKinney Avenue Contemporary,
Dallas, 1995

Untitled
1995
Gelatin pill capsule, Play-Doh
1.9 × 0.6 × 0.6 cm
A gelatin pill capsule filled with
tiny spheres of Play-Doh.

aside, and come back to them at some other point. I started the toothpick sculpture (*Untitled*, 1995, see page 81) but had to put it aside for a couple of years. I couldn't resolve for myself a departure from the clear limits my work was exploring. It wasn't until I made the pill capsule (*Untitled*, 1995) that I could come back to it. The pill allowed me to move from the ideas of containment to invention. I saw the toothpick sculpture as a response to consuming the pill containing Play-Doh as its medicine.

Cooper Do you ever look back on pieces you've shown and and think, 'Oh, this is a failure'? Or are there pieces you think have been particularly successful? Do you make differentiations like that?

Friedman **Not really. Each piece for me becomes essential to the progression of my investigation.**

Cooper Have you ever gotten so lost that you've looked back on your older work to remember who you are as an artist?

Friedman **Well, a form that has been recurring in my work is a motif representing diffusion, where there's a dense centre and then it diffuses out, almost like the Big Bang in a way. Even the things that I do now incorporate the idea of clarity and specificity that I was striving for in the beginning. But there are shifts. My thinking started to shift a little around 1995 when I had a**

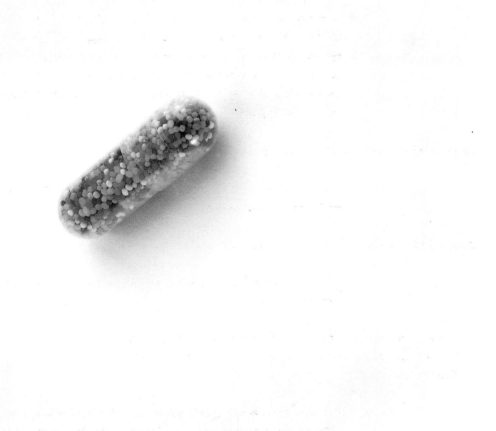

show at The Museum of Modern Art, New York, in the Project Space ('Projects 50: Tom Friedman', 1995). I became interested in information and the effects of an inundation of information. As the velocity that information is presented increases, one's ability to process that information shuts down, and just the texture of the information is perceived. I started to work on a piece sparked by these ideas surrounding this flood of information and how it leads to the organization of information into categories. I did this piece where on a piece of paper 36 by 36 inches (91.5 × 91.5 cm), I wrote all the words in a dictionary (*Everything*, 1992–95). The words were not written in order; I wanted them to be scattered throughout the paper as a way of homogenizing the language. The paper was presented on the floor, and it looked from a distance like a textured blue paper. I was interested in how the information about the piece unfolded. How it began as a seemingly inconspicuous textured paper, the texture becomes words, the words represent a total system, the fullness and the emptiness.

Cooper So the creating and unfolding are in perfect balance or mirrored?

Friedman **Right**.

Cooper Like a film being run forwards then backwards? Two processes that are identical except for their order?

Friedman **It's more my thought process trying to gain an understanding and control of that type of unfolding. Like when you're presented with something unfamiliar you ask yourself a series of basic questions: What is it? Where did it come from? Why is it here? I wanted these objects to begin with this direct line of questions.**

Cooper While making the piece, is the viewer your fantasy?

Friedman **I developed a somewhat split personality where I could be the artist and also the viewer, in a way. And then the viewer would be in a sense my idea of the ideal viewer.**

Cooper In other words, you?

Friedman **Right, (*laughter*) I guess my ideal viewer has to be me.**

Cooper What other works were in that MoMA show?

Friedman **There was a piece titled *Loop* (1993–95) which was made with spaghetti. I used a one-pound (435g) box of spaghetti. I cooked the spaghetti and then let the noodles dry into curls. Then I connected each piece end to end making this meandering configuration until the end connected back to the beginning. At this point I started to think about the idea of complexity, which seemed to be a logical jump from thinking about simplicity. The *Loop* piece, which I somehow saw as a diagram, was a pun on the noodle being the brain, and was directing one through a perpetual convoluted line of thought.**

opposite, **Everything**
1992–95
Pen on paper
91.5 × 91.5 cm
All the words in the English language written on a large sheet of paper which sits on the floor.

right, **Loop**
1993–95
Spaghetti
⌀ 30.5 cm
All the pieces of spaghetti from a 435g box were cooked, dried and then connected end-to-end. The first piece connects to the last to form a continuous loop.

Untitled

1995

Pencil on graph paper

28 × 43 cm

A line begins from a point at the lower centre of the paper. The end of this line generates two lines at 45° angles. The ends of these two lines generate two more lines each, also at 45° angles, and so on, up to the fifteenth generation. Each generation of lines is 0.3 cm shorter than the previous generation, and each line is numbered as to its generation.

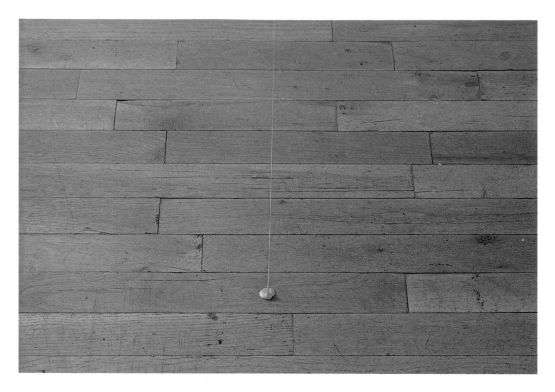

Untitled
1995
Bubble gum
Dimensions variable
A single piece of chewed bubble
gum is stuck to the ceiling,
stretched and stuck to the floor.

Cooper Was that the shift?

Friedman Yeah. In a way the complexity forced me to think more about the
diagram: things that organize information and orient people. I started to use
a diagram with every body of work that described my thinking at the time.
For my next body of work, which was at the Feature exhibition in 1996, I did
this drawing on graph paper where I started with a point, and there was a
vector from that point (*Untitled*, 1995). And then that vector would divide at
right angles, and it would be slightly shorter in length than the previous one.
It just kept dividing and dividing until it turned in on itself, confusing this
basic process. For me that represented a move from the simple to the
complex. I think at this point I started to work on each piece within a body of
work simultaneously. I wouldn't finish a piece and then move to the next
piece. It was almost as if the whole body of work was one piece.

Cooper They were more interdependent than before?

opposite, **Untitled**
2000
Polystyrene insulation
40.5 × 40.5 × 40.5 cm
A network made with 0.6 cm
sections of hard insulation
connected at right angles.

Friedman They related to each other in different ways, ranging from a
conceptual relationship to purely a formal relationship. I started to
investigate the relationship between ideas that moved apart from each other.
I was interested in their increasingly tenuous relationship. There's a word-
game you can play where one person mentions two distinctly different words
and the other person tries to find a third word that connects the two words. It
became almost like that kind of play. I was involved in so many seemingly
divergent investigations that I also saw as all part of the same constellation
of ideas. I was discovering the elements throughout that constellation of
ideas, and finding out how they related or came together as a total thing. The
idea of pulling things apart, further and further, was interesting. I did this
piece where I chewed a piece of bubble gum, stuck it to the ceiling, then
stretched it and stuck it to the floor (*Untitled*, 1995). I used stretching a piece
of bubble gum as an analogy for this idea: as you stretch the gum the

connecting thread becomes thinner and thinner. I reached a point where the idea of fantasy started to filter in, because when the connection between things becomes so slight, things are not read as a cohesive whole, which is kind of how my work has now evolved.

Cooper This might seem like a strange segue, but I wonder about your relationship, if any, to the idea of the 'outsider artist'.

Friedman **I've thought about that, and in fact this recent body of work sort of began with that in a way. I was thinking about the outsider artist as a way of not having to deal with content in the same way; there is this other type of aesthetic that re-situates how one looks at something, not looking from the standpoint of participating, or fulfilling a type of dialogue, but as the personal, bare bones essentials of making something out of nothing.**

Sol LeWitt
Five Modular Structures
(Sequential Permutations on the
Number Five)
1972
Painted wood
5 parts, dimensions variable

Cooper I mean outsider art has its own problems, there's a condescension towards it. There's a perception of outsider art as a manifestation of insanity that merely resembles art. But, on the other hand, critic Peter Schjeldahl wrote a review of one of your shows where he said something like, 'Tom Friedman would be nowhere without the Minimalism that his work kicks against'. I never think of you as working from Minimalism particularly. But, because you're a 'contemporary artist', the assumption is immediately made that your work self-consciously references art history.

Friedman **I do rely on Minimalism in the same way I rely on the whole art context.**

Cooper But, if you were an outsider artist, no one would ever say, 'This must be viewed in light of Minimalism'. If you were an outsider artist, no one would refer to your work as obsessive; that would be a given. If there's a chorus in the collected writings on your work, it's the word 'obsessive'.

Friedman **Right. But I think most artists obsess over their work. 'Obsessive' is a convenient word to describe one aspect of my work, but it doesn't take into account the reasons behind the acts that are characterized as obsessive, so it's a failed approach.**

Cooper Do you feel hemmed in at all by the reality that your work will always be seen either in galleries or museums?

Friedman **No, I really like that context. I think about the ideal viewer, and the ideal viewing situation. The ideal viewing situation is this place that demands that you slow down experience, and bring all of who you are to the experience. I know that, in reality, the gallery and museum don't have that, but I still make work for those ideals. I like keeping that illusion with me.**

Cooper What about when your work moves from the gallery into a collector's home?

Friedman **I think that after I make it and it goes into the gallery it's in its sort of original context within a body of work. Then it's taken out and it becomes**

Untitled
1992
Pencil shaving
56 × 4 × 4 cm
A pencil was completely shaved by
a pencil sharpener into one long,
continuous spiral.

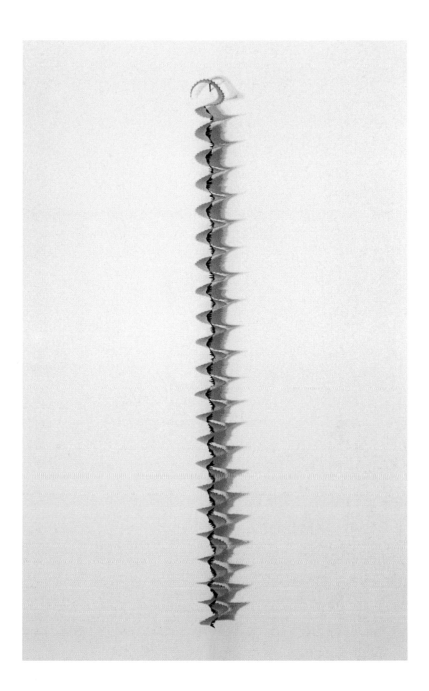

historical, more of an artefact, as opposed to the same conveyor of meaning
it was originally. I'm willing to accept that type of conceptual, ephemeral
quality; that seems to fit in with my work. I read something about how artist
Charles Ray remade some pieces for his retrospective because they had
shown age, and he felt their age added a history that got in the way of their
immediacy and their presence.

Cooper Do you feel the opposite way?

Friedman **Well, I think I'm just more accepting of the inevitable. I have to be.
But I am going to remake some pieces that have shown their age and stuff for
my survey show organized by the Southeastern Center for Contemporary Art
(Winston-Salem, 2000–02). It's not a rigid thing for me.**

Cooper When you remake a piece, do you simulate the process through which
you originally made it?

1,000 Hours of Staring
1992–97
Paper
82.5 × 82.5 cm
A piece of paper the artist has
stared at for one thousand hours.

Friedman **Usually, for the pieces that I remake, the process is very direct. I mean there's really no way of deviating from that process. The process is the process, like putting a pencil in a pencil sharpener.**

Cooper So you're not going to stare at another piece of paper for a thousand hours (*1,000 Hours of Staring*, 1992–97)?

Friedman **No, you can do that!** *(laughter)* **One thing I'm really consumed with is the question of why? What is the purpose of art? How does it serve? What does it do? I can kind of see it as this thing that is not directly necessary – you know, why not spend my time helping people more directly? Why am I spending my time isolated, thinking about and making these things? It's something that keeps me in check in a way: the idea of doing something important or useless.**

Cooper Ultimately, you believe it's important.

Friedman **I don't know. I think in terms of ideals. If I were to think of what the ideal art would be, that would be art that gives viewers an experience that they take with them and that causes them this incredible revelation which they, as enlightened people, turn towards society. They would do these amazing things that penetrate other people and who then all come together and we live in harmony, and there's peace, and we all are transcendent individuals. It sounds like a comedy. It sort of comes down to something very personal, and that's interesting in terms of any philosophy or art or anything that seems to transcend the individual sitting down thinking about these things where that sort of essential nature comes into play. Like we'll do something, and then that thing we do and the decisions that we make are sparked by our history and stuff. A lot of the decisions that are made now within the social landscape are very business-oriented and business-driven, for example, they are the result of marketing research. What's the end to this process? It seems to be somehow an arbitrary end: that people will fulfil their lives with the product. And then the owners of the company, and the people involved in the company, will have more money, so that they can have the things that make them feel better.**

Cooper Which has everything to do with you, but nothing to do with your work.

Friedman **You're accepting the enjoyment of it, the personal enjoyment of it, rather than seeing the consequences of being seduced by that enjoyment.**

Cooper Lastly, has your considerable success as a young artist impacted your work in a positive or negative way? Or does it matter at all?

Friedman **I'm happy that my work can have this type of reaction in people, but it seems to make things more difficult. I'm attempting to create these specific experiences and, as I do more work, there is more and more information and history to look through, that filters one's experience of these objects, like a growing fog.**

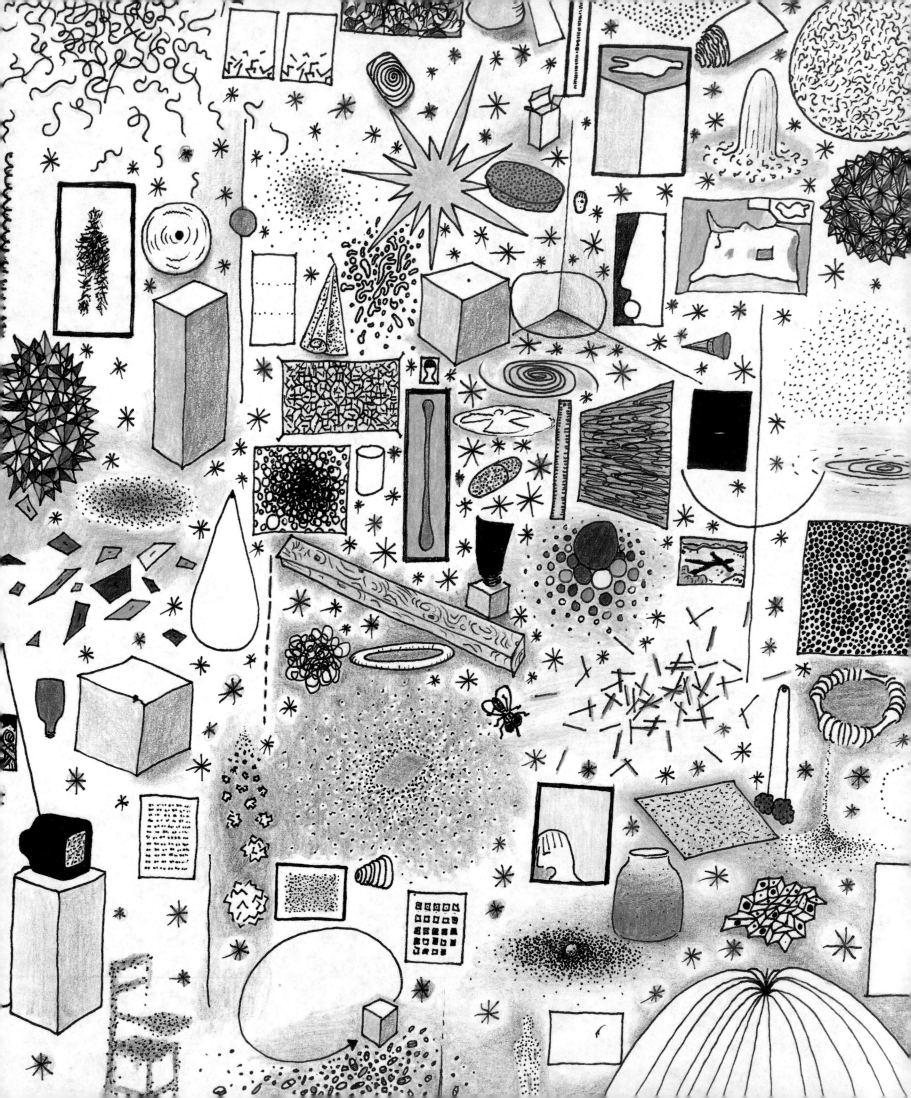

Contents

1.

I'm not Rosalind Krauss.

I'm not Michael Fried.

I'm not Thierry de Duve or T.J. Clark.

No, you certainly aren't.

I'm not Matt Dillon.

I'm not Andy Kaufman.

No.

I'm not a porn star. I'm not built for porn.

I'm not Tom Friedman. Of course, sometimes I'm not myself.

No. Of course. Is anyone?

I'm not Styrofoam.

It would be entirely possible to spend a lifetime coming to terms with all someone's not. And this would reveal what, if revelation is the order of the day?

Did anyone ever really stick this onto that, make this look like that to reveal something?

There are many days when it is confusing to explain how I'm not Matt Dillon, since I identify him with a phenomenological event akin to inarticulateness – a bodily articulation of inarticulateness, I guess. Confusing to explain how I'm not Styrofoam, since seconds into minutes of a day often accrue like little balls of artificiality, clean and blank, but trademarked as a life identified as mine.

This is not how to begin a 'Survey' essay.

2.

How to read something, how to understand something, how to see something depends so much on familiarity and repetition, on habit – a habitualization which gets in the way (eventually? very quickly?) of ever reading or understanding or seeing anything.

Consider the following sentences:

Tom Friedman brn '65, St. Ls, MO. Crrnt lvs wrks rrl W. MA.

The sentences – they are sentences somehow – appeared as part of the bio at the end of a selection of Friedman's work published in the magazine *Grand Street* with the title *jst*. How does anyone know how to understand these sentences? How are they more easily understood or understood at all because only vowels have been removed rather than consonants?

Tom Friedman o '65, ai oui, O. ue ie o ua e A. The first, mostly consonant version of these sentences depends upon the knowledge of the rather more alienated second all-vowel version, whether anyone thinks about this or not. The gaps between the consonants, the missing vowels, the absences between and in part making up the abbreviations require some kind of negotiation of the nothing or the missing or the loss filling the words out, the absence structuring understanding. Whether anyone thinks about it or not, everything depends upon a structuring absence.

Consider how the title word – *jst* – could be read. Which of the following, given the fun, punning, equivocating, structurally investigatory, quietly combative, reasonable and exacting qualities of Friedman's project, provides the best title: *jest, Jesuit, joist, joust, just*? I will not even bother to complicate these possibilities by suggesting the perfectly apposite homonym of *gist,* apposite since the magazine's selection (especially for anyone who does not know

Friedman's work) gives the gist of what he does. (What is the gist of what he does?) Since most would probably read the two sentences as *Tom Friedman was born in 1965, in Saint Louis, Missouri. He currently lives and works in rural Western Massachusetts* – how do the missing *was, in, in, He, and* and *in* get replaced; how is their absence simultaneously elided and negotiated instead of questioned, instead of considered as absence?

Friedman's aesthetic project requires not immediately filling in absences or ignoring absences but keeping watch over their meaning and their absence of meaning. The nothing not there and amidst much actually, physically present the nothing that is. His work pivots between annihilation and imagination. What is not there formed by what is. What is there formed by what is not. He manipulates what forms and informs the *between* between the one and the other.

3.

It is interesting that few have mentioned the problem or the return of the self portrait in relation to Friedman's work, how the body's perfect imperfections, imperfect perfections, situate the accuracies of his sculptural investigation. Recall Friedman having said that a spit bubble 'is the only way a human body can create a perfect shape'.

Self-portrait as a way of indicating a self no longer there, no longer what it was, no longer what it is. Self-portrait as a mouth having chewed, self-portrait as the utensils for cleaning a body, self-portrait as a mouth having sucked, self-portrait as a curse, as a governmental ID, as

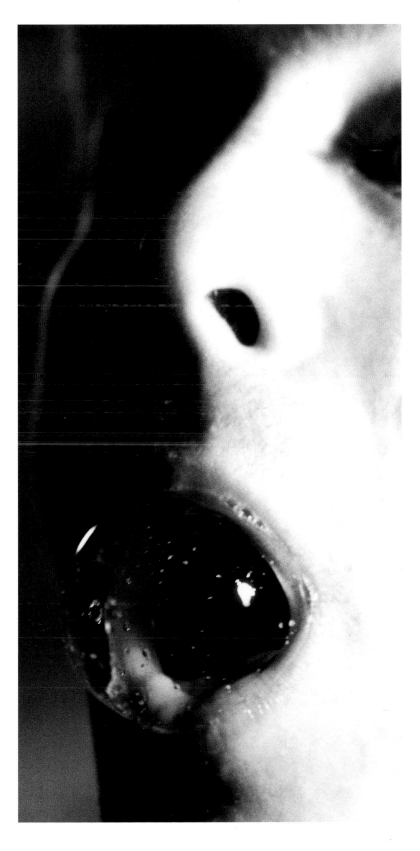

Untitled
1990
Black and white photograph
54.5 × 44.5 cm (framed)
A photograph of the artist
blowing a spit bubble.

right, **Yawn**
1994
Black and white photograph
42 × 33 cm (framed)
A photograph of the artist
yawning.

below, **Secrets**
1997
Pen on paper
28 × 21.5 cm
The artist's secrets written on a
piece of paper as small as possible
so they can't be read.

opposite, **Untitled**
1993
Black and white photograph
88.9 × 63.5 cm
A photograph of the artist on the
ceiling.

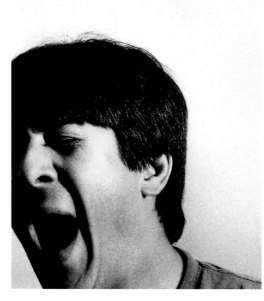

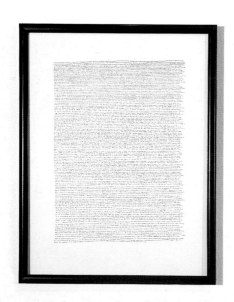

levitation, as headache, as boredom, as all the words in the dictionary. I am not sure that any of Friedman's works in which his own body (via photography) or a representation of his body (via different materials) appears are self-portraits, but they deploy something like self-portraiture – Friedman never hires a model – of a very idiosyncratic sort: self-portrait without the self and without the portrait. It's the self-portrait as the most basic experience of the not: being knotted by what is understood as the self as much as by what is not the self. How would anyone get at representing that knotting materially, the materiality of that being/non-being which is the body? The relation between Tom Friedman and the things he makes makes a complicated performance of identity. Someone looks at his head carved from aspirin. 'It's a Tom Friedman.' Consider how that statement is knotted to another: 'It is Tom Friedman.' Consider the abstraction of what a self is and what *a* Tom Friedman is – how those two things relate to one another and not at all.

It's not a self-portrait and somehow it is.

Like seeing *1,000 Hours of Staring* (1992–97) as a blank piece of paper and then realizing that that isn't it at all, and yet staring at it even more, adding to it somehow something else.

4.

Untitled, 1990, black and white photograph [face with spit bubble]; *Untitled*, 1990, bubble gum; *Untitled*, 1990, soap and pubic hair; *Untitled*, 1991 [a circle of 200 pounds of laundry detergent, in which the artist has made a snow angel]; *Untitled*, 1991, a roll of LifeSavers; *My Foot*, 1991, wood, press-type; *Untitled (A Curse)*, 1992, cursed 28 cm spherical space 28 cm above a pedestal; *Untitled*, 1992, faeces on pedestal; *Self-portrait*, 1992, passport photo; *Untitled*, 1993, black and white photograph [floating to ceiling]; *Untitled*, 1994, aspirin; *Yawn*, 1994, black and white photograph; *Darkroom*, 1994, black and white photograph; *Everything*, 1992–95, ballpoint pen on paper; *Untitled*, 1995, ink on unique C-print; *Down*, 1995, press-on lettering on paper; *Untitled*, 1996, Styrofoam; *Untitled*, 1996, C-print [self crater]; *Secrets*, 1997; *1,000 Hours of Staring*, 1992–97, stare on paper; *Untitled*, 1997, unique black and white photograph [development of many childhood photos of artist, exposed sequentially on single sheet of photographic paper]; *Untitled*, 1997, papier-mâché, collage [muscle men]; *Untitled (Small World)*, 1995–97, Play-Doh; *Space Station*, 1997, mixed media; *Untitled*, 1998, painted wood; *Untitled*, 1998, incision in wall; *Untitled*, 1998, Lambda print; *Air*, 1999, Styrofoam, cup, coffee, plastic drinking straws, ladybird; *Untitled*, 1999, painted wood.

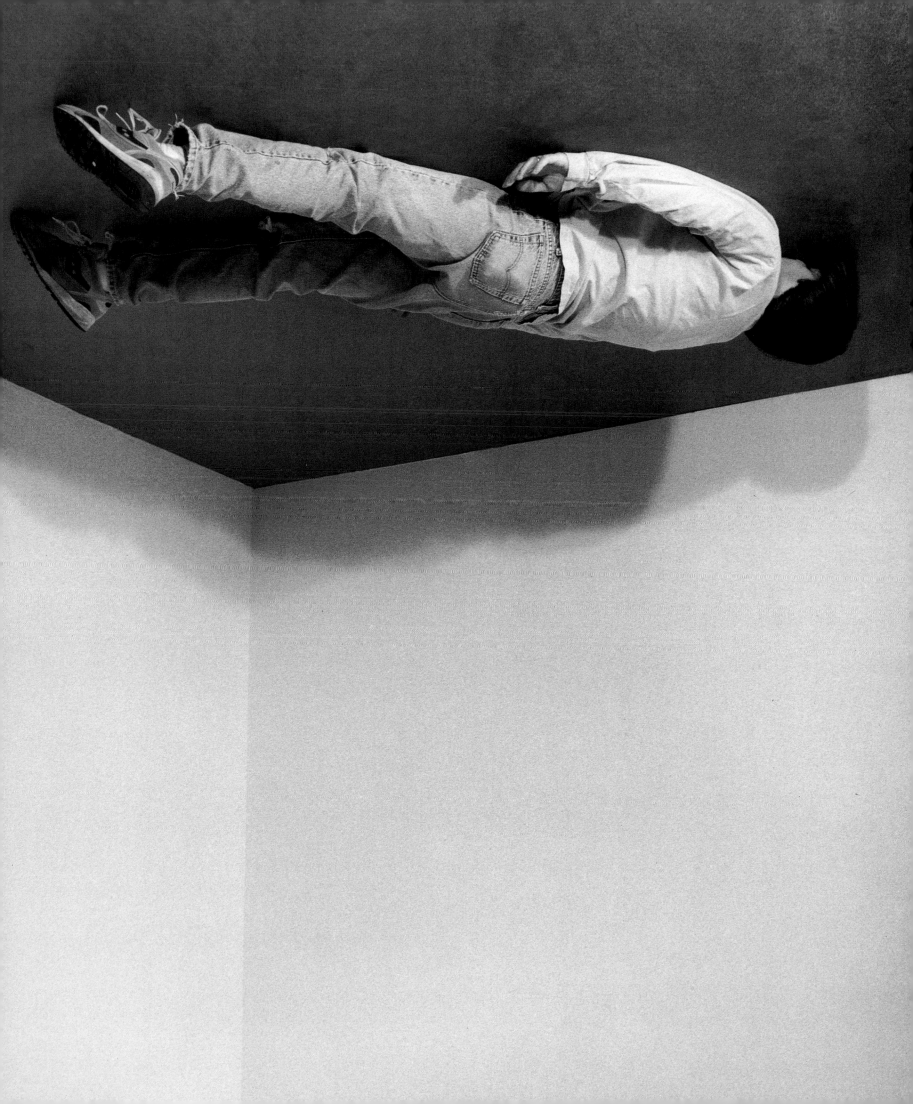

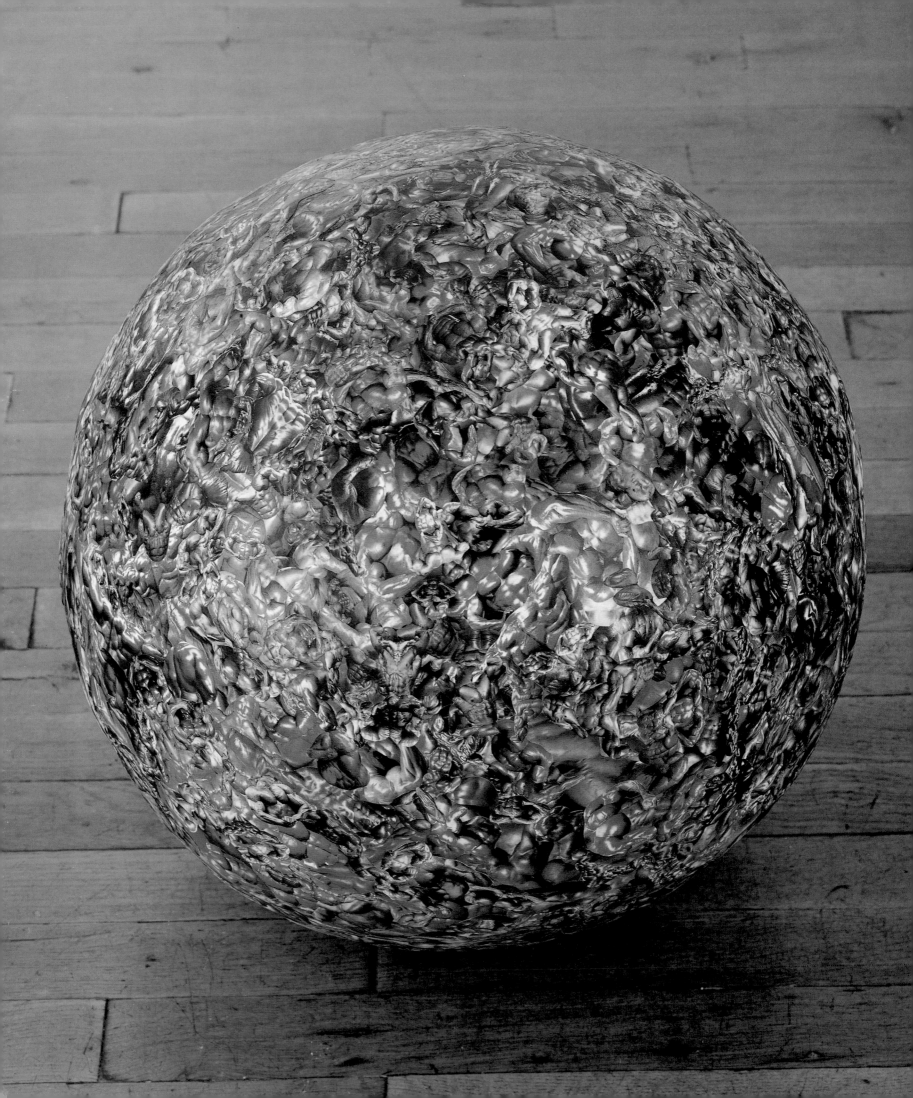

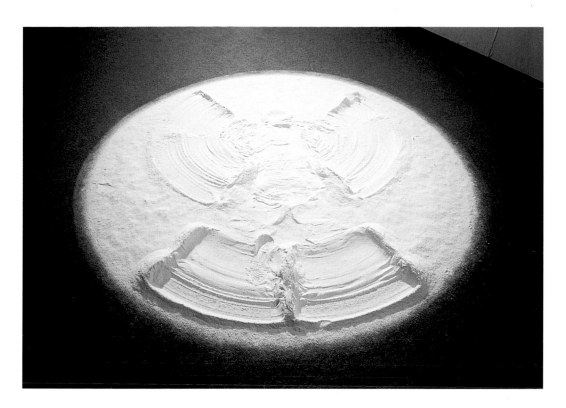

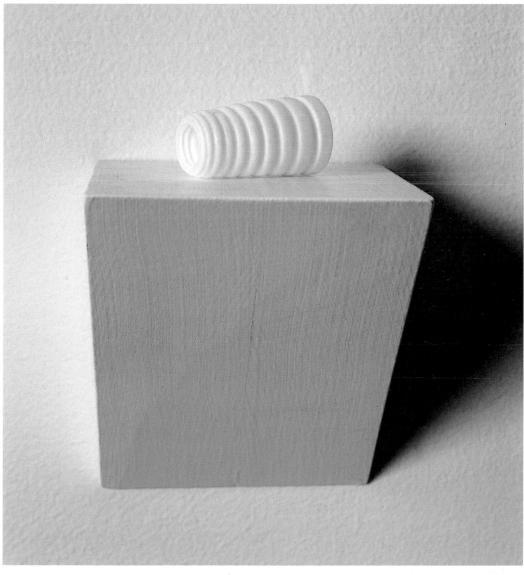

opposite, **Untitled**
1997
Papier-mâché, collage
⌀ 45.5 cm
Collection, Whitney Museum of
American Art, New York
A sphere made by papier-
mâchéing over a balloon covered
with muscle men cutouts from
magazines.

left, above, **Untitled**
1991
Laundry detergent
⌀ 305 cm
A circular mound of laundry
detergent in which the artist has
made a snow angel.

left, below, **Untitled**
1991
LifeSavers
1.3 × 6.3 × 1.3 cm
Collection, Museum of
Contemporary Art, Los Angeles
Each LifeSaver from a roll has
been sucked to a consecutively
smaller size. They are held
together by the stickiness of the
sugar and the artist's saliva.

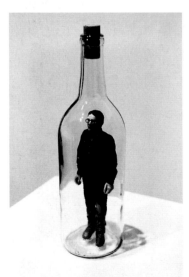

5.

I didn't know about Piero Manzoni. I didn't know about *Fiato d'artista* (*Artist's breath*, 1960) or *Merda d'artista* (*Artist's shit*, 1961). I didn't know Italian. I didn't know about *Arte Povera*. I didn't know about Charles Ray. The first time I saw a piece by Tom Friedman I didn't know any of it. I had no idea who 'Tom Friedman' was and I didn't know that the piece I thought I was seeing wasn't even there. I saw an empty pedestal. When I returned to see the piece again, *Untitled*, 1992, was actually there, a little ball, dingleberry-sized, of Friedman's faeces centred on a plain white square pedestal. Something – a fly? someone's seated ass? – had taken the piece of shit away; someone – a human? – had sat on it thinking nothing was there, and when he stood up there wasn't. Given that within the same year, 1992, Friedman produced *Untitled (A Curse)* and *A Piece of Paper*, all considering how what is there appears not to be and exploring the disappearance of appearance, is there a way to explain in language that does not (not as rapidly as the pieces' titles' clarity does) obscure the moment of how seeing doesn't see? Trusting vision alone, which amounts to a distrust of vision, how wasn't I or anyone during the momentary disappearance of the faecal speck seeing a cursed space? It utterly was not that. But how would that be seen, the difference between that cursed space and the inadvertent absence? Think about how *Untitled* is just as much a witty commentary on what so many think about contemporary art: what a piece of crap. Think about how it posits matter and immateriality.

6.

The tiny figure makes his way across the expanse of the white wall; barren space surrounds him, valiant little man. Many probably don't even notice he's there, doing what he does, something important perhaps only to himself in his jeans and green top and bowl-cut mop. *Untitled,* 1999, painted wood, measures 0.6 × 0.2 × 0.1 cm. How is this sculpture a self-portrait – a chip off the old block, Tom Friedman, as well as a bow to the perhaps more famous, tinier Tom, Tom Thumb? There is an urge; something compels anyone finally noticing the thing to see it as a self-portrait of the artist as a miniature man, rather than as a young one. And yet what conclusions can be drawn about the artist? If it is a self-portrait, it is a self-portrait without autobiography, without confession. While the sculpture invites comparisons with some of the illusions and delusions in David Wilson's Museum of Jurassic Technology – Kubla Khan's palace, various birds on a branch carved from a human hair – or with Charles Ray's self-portrait sculpture in a corked glass bottle, *Puzzle Bottle* (1995), it would be a mistake to read the piece as a miniature. Meant to be observed through a magnifying glass, there is no way to not see the microfabulations of the Museum of Jurassic Technology as miniature. Ray's amazing *Puzzle Bottle* toys with questions of interiority and exteriority as the Ray figure in the bottle announces its doll-like uncanniness. But Friedman's figment statically sprinting his way through the hugeness around him isn't resolutely miniature and isn't at all doll-like. Miniature in relation to what? The figure in relation to his world

Untitled
1999
Wood, paint
$0.6 \times 0.2 \times 0.1$ cm

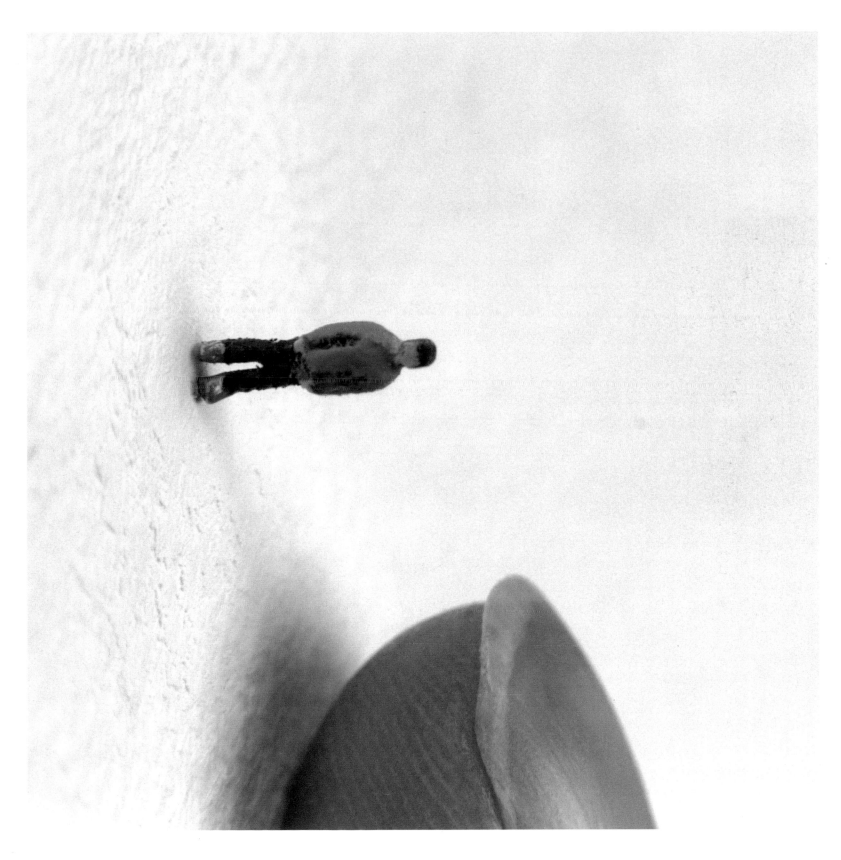

is not any smaller than we are in ours, than the blip any human life would be in relation to time on earth. In many ways the figure is larger.

Place *Untitled* next to or on one of Richard Serra's *Torqued Ellipses* (1997) as an essay on ego and self-effacement. Place the figure of *Untitled* next to Friedman's *Untitled*, 1998, also of painted wood but a somewhat bigger figure formed by 3-D computer modelling, and next to *Untitled*, 1996, a man accumulated from individual balls of Styrofoam the way any human is an accumulation of atoms. The two wooden Pinocchios and a Styrofoam other sized in between – not that the result of the juxtaposition isn't an intense investigation of the specific qualities of the materials and the forms

those materials suggest, not that it doesn't begin to reveal how the materials are subject to their subject (Friedman) as Friedman is subject to the materials – presented with the three examples of self-portraits without self, without history, isn't the dumb fact of the body as a thing which goes noticed or unnoticed, which matters because it is matter taken to matter more than mere matter, the splinter breaking the skin of what is seen and what can be known, isn't what must be pondered the body and what is to be done with it: how or why in relation to wood or Styrofoam would anyone want to ponder the question of how a self relates to any other thing?

Is an unobserved presence the same as an

left, **Untitled**
1996
Styrofoam
12.5 × 4.5 × 2 cm
A self-portrait carved from a block
of Styrofoam.

right, **Untitled**
1998
Paint, wood
58.5 × 19 × 14.5 cm
A self-portrait of the artist made
with 0.6 cm wooden cubes
painted white.

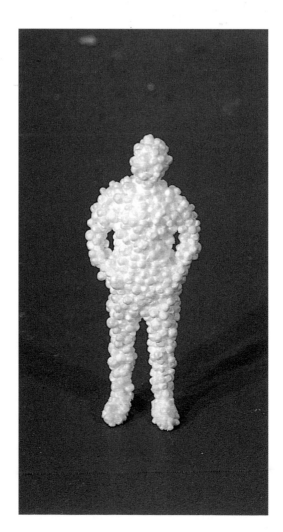

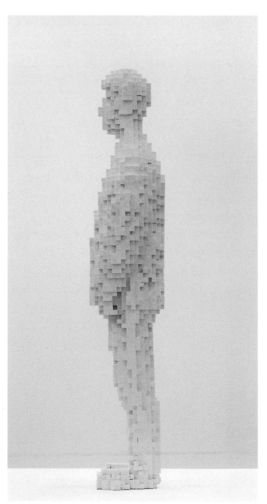

absence? The roiling of life beyond what is seen structures what is seen to be life.

7.

It would take at least a thousand hours to come to terms with how to look at *1,000 Hours of Staring*, 1992–97. It is nothing but staring on paper. In the resonance chamber which Friedman's work creates, the harmonics of *1,000 Hours of Staring* are in accord with *Everything*, 1992–95. Is seeing everything the same as staring at nothing but a 'blank' piece of paper? These are the purest self-portraits of the artist and they tell anyone who cares very little, other than that a lot of existence is spent between the two states referred to as 'everything' and 'nothing', and it may take hours of staring to figure out which is which. Consider how all the words for everything return to silence the moment speech stops, how for the words to be legible at all they require blankness around them. In *Untitled*, 1997, childhood photographs of Friedman are exposed on a single photographic page resulting in a ghostly grey, shady and distant as memory and as abstract. If it is seen to be abstract, reconnoitering the abstract as a kind of representation, the photograph is abstract only because of a process, not because of a construct. It is abstract the way life and the 'real' are.

I find that a stare on paper looks amazingly and appallingly like, reveals as much and as little as, anybody I've ever tried to know. Friable, fragile, whether it is the human or the human-as-a-device-of-the-aesthetic, at times everything seems to be contained in the look on someone's face, in the morning voice, in the scribbled note,

and then suddenly it isn't. Could all of that intimacy come to look like nothing, or is it only ever already that? This mortal coil is coiled around what exactly? Shrugging it off doesn't answer the question. But if it is watched watched watched, if it is observed, if it is stared at, if it is …

1,000 Hours of Staring is not unlike *jst*. Think of all the activity, all the life that occurred not only while the staring occurred, but all the life between the hours when the staring was done. In the way *jst* is structured by the possibilities of what is not there – jest/just/Jesuit – the staring can be predicated on all the hours between the hours of staring that fixed the stare to paper. Who even

Untitled
1997
Unique black-and-white photograph
24 × 33 cm
A photograph made by superimposing 300 images of the artist in his childhood, taken by his father.

notices the absence of all those hours in looking at the stare on paper? How easy it is to turn away from not just hours but years, lifetimes.

8.

The *eminences grises* are down on Duchamp. Even though they might not agree on much, they do agree on how disastrous Duchamp's influence has been on, well, just about everything. They really are down on him. Why? I think it has something to do with Duchamp's supposedly abandoning the retinal and his pranks, his bad puns. Or it might have to do with a perceived elitism, a Frenchman lording it over bohemian Americans. But even Duchamp didn't always listen to himself. His objects object; his paintings tell a different story, as does his indifference.

He loved art so much he stripped it bare and left it in the woods. It died of frostbite and hypothermia. He was said to be in mourning by playing chess, by being just a breather, but in his dust breeder's dusty studio he built a remarkable stand-in. He tinkered on it for twenty years. It was an invasion into a thickety scene of givens: given the waterfall, given the green light, given the body stripped down to its strangeness, given the brambles, given the peepholes, given it's hard to see.

It's hard to see how he abandoned anything except what was abandoning him. He saw the technology of 'art' and the technology of 'self' in need of a mechanic, in need of a scientist, in need of someone to play with the technology of seeing. It was his train set. He liked when the engine tunnelled into the dark. *C'est érotique, comme un*

readymade, he's been quoted as saying. He was a funny guy. Conceptualism lost its way when it abandoned its stand-up comedy aspect. Think of stand-up comedy instead of art when you think of early John Baldessari (*The Meaning of Various Photographs to Ed Henderson*, 1973), Douglas Huebler, William Wegman, even Adrian Piper (*Funk Lessons*, 1983) and see what happens. When Andy Kaufman read *The Great Gatsby* to an audience he may have been just reading a book by F. Scott Fitzgerald, or it may have been one of the funniest things ever, especially when the audience hated it and Kaufman, as the British man, scolded them but offered them a choice of more *Gatsby* or playing a record. When he dropped the needle on the groove the voice of the British man was reading *The Great Gatsby*. Duchamp's pranks allowed all of that. He's the 'straight' man to so much funny business.

He really was a funny guy. I have a photo of Duchamp in a blonde wig. He looks like Candy Darling doing her Veronica Lake impression. When Andy Warhol filmed him for his Duchamp movie, you can hear Duchamp mumble something, very briefly.

AW: *Gee, Marcel, what's not so great about the retinal?*
MD: *Je* [mumble] *vachement. Air de Paris, par exemple.*

There's been a lot of conjecture about how to interpret the mumble: *l'aime* (love it) is one possibility; *l'execre* (detest it) is another. Uncommented on is what happens after this. The film unreels, Duchamp strikingly lit in three-

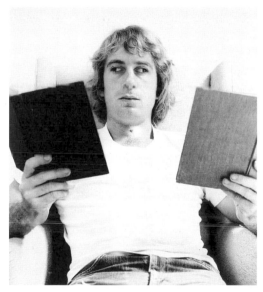

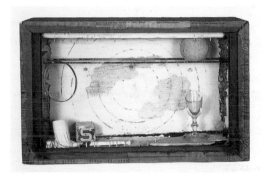

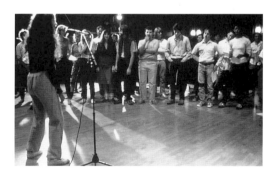

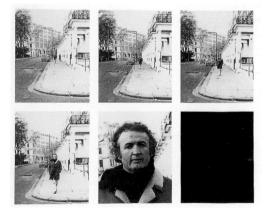

quarter profile, smoking. Out of the frame you can hear Warhol say something. It sounds like he's saying: 'That's how I feel about the body. It never stops.'

9.

Some artists work at home. Even when they're in a studio, it's a home-made practice.

Not Richard Serra, for example.

Not Matthew Barney.

Joseph Cornell, despite the dream travel, quite at home. Marcel Duchamp, quite at home too. The *boîte-en-valise*, the museum in a suitcase, just an italicizing of this fact, as is his sister's being the one to assemble and label some of the readymades. Staircase, chocolate grinders, perfume bottles, drag accoutrements, dust breeding, breathing: these are the stuff of a homebody.

There are some interesting liminal cases. Andy Warhol, for example. Life with mother, Julia, places him snugly in the home category. The Factory, on the other hand, was very much not home but business. Pop art, home. His relation to his own body, not at home.

Compare this to the habits of almost every writer always writing at home. Marcel Proust, for example. Gertrude Stein, for example. Jean Rhys. Jean Rhys stayed at home in cold Cornwall for so many years it was generally thought she was dead. Writing can be mistaken for that sometimes. But somehow not art.

It's home that allows the *unheimlich*, the un-home-ness, to appear.

Everything that Friedman needs to make his

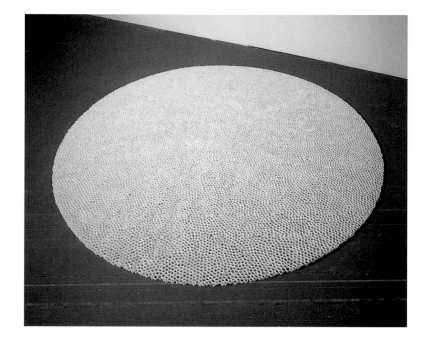

opposite, **Untitled**
1989
Toothpaste
Dimensions variable
Toothpaste applied to the wall.

left, **Untitled**
1994
Masking tape
h. 2 cm, ⌀ 183 cm
Loops of masking tape stuck together.
(*bottom, detail*)

Untitled

1995

Ink on C-print

96 × 56 cm (framed)

The artist has obliterated a
photographic image of himself by
drawing thousands of arrows
which point to different parts of
himself directly on the
photograph.

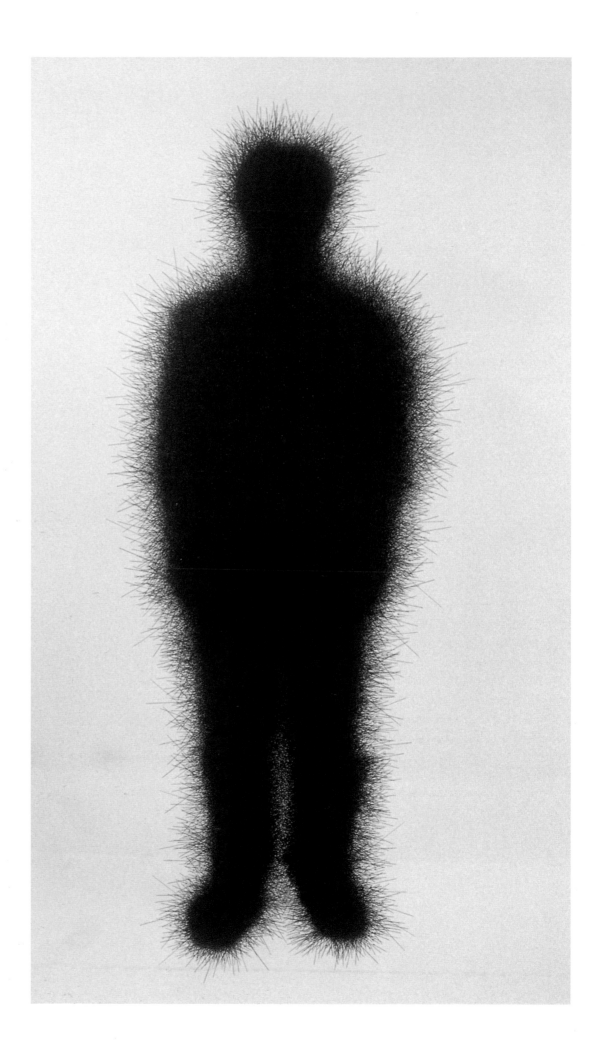

work is at home. Yet it's uncanny how it never seems to be about the domestic. Nothing domesticated even though the translucent pool blue is toothpaste. Nothing homey even though it's home-made rounds of masking tape accreted pustularly. Nothing snug or comforting about drawing pointing arrows in ink on a self-portrait photo to different parts of his own body, opening up a void of distortion. The most unheimlich place is the home of being. The mapping arrow, you are here. You are here. You are here and you are here. You are here you are here you are you. The body as part-object, so many arrows pointing it out until there is no you, no discernible arrow, no here.

10.

Without armature. The bags – hunter green Hefty-sized, clear and lunch-sized – stuffed into other like bags; the little metal filament able to stand by itself because it's only so tall and no taller; the hairy anthill accumulation of string standing without ballast. As much as the materials' own materiality structures the work, forming its formal limits, the effect of gravity is also an element of Friedman's work. His pieces are a way of not quite defying gravity but toying with it, testing it, its existence. How would a human body be built so that it could just float to the ceiling, levitation defying gravity? Without armature but almost not without it, his objects experiment with how to balance, just – *jst* – there.

I like the idea of Friedman taking everything out of his studio until it was an empty white cube and then reintroducing certain elements, element by element, to study what the thing – detergent,

piece of paper – is, rather than what it was or has been, so the thing can be what it is or what it has never been, ignorant without the armature of referent. (Of course the referents return, they always do, but how slowly.) His works work without footnotes.

How helpful is the armature of art history in understanding how this work operates? I'm a romantic guy until I'm not at all. I mean, even Elaine Sturtevant believes you'd have to be a 'mental retard' to claim the death of originality.

Untitled
1992
Food storage bags
18 × 28 × 30.5 cm
Plastic food storage bags were stuffed inside each other until no more could be added.

Untitled
1992
Rubbish bags
157 × 65.5 × 65.5 cm
Collection, Museum of Contemporary Art, Los Angeles
About three thousand rubbish bags stuffed inside each other until no more could be added.

Robert Rauschenberg
Erased de Kooning Drawing
1953
Traces of ink and crayon on paper,
hand-lettered ink label, gold leaf
frame
48.5 × 36 cm

Bruce Nauman
Walking in an Exaggerated
Manner around the Perimeter of a
Square
1967–68
Video, 9 min., black and white,
silent

So of course I know that art-historical connections can be made, yet the few referents I keep in mind when thinking about Friedman's project perform more in the manner of enabling conceits than crucial art-historical commentary. Whenever anyone mentions Manzoni to Friedman in relation to his piece of shit or Fontana in relation to his moonscape cut-out paper piece, he becomes a little nonplussed. Sure, Manzoni, Fontana yeah. Shrug.

I mention the following but with grave doubt about what the mentioning does. I mean, certainly it's not difficult to think of William Blake, for example – world in a grain of sand, etc. – but Friedman would seem to put the grain of sand back in the world as a grain of sand, dehabitualized so that it might be seen before being lost in the sand castle, then dehabitualizing it back into sand-castleness.

Thoreau. Walden. The difference and similarity of Walden (as place) and *Walden* (as book and book as place).

Rauschenberg's *Erased de Kooning Drawing* (1953). Not the Oedipal machinations behind it, but the single erasing gesture itself allows more than two things to exist: the idea of the de Kooning drawing in memory (the site of most seen things); the actuality of its absence; and the presence of its absence as a Rauschenberg.

Warhol's wanting to be a machine, both as a way of getting beyond the self, annihilating the self, and – by the constant perfect imperfection of the human revealing a way to see its trace – as a way to know that a self, that the human, may indeed exist. Some people have a lot of trouble knowing whether or not they exist.

Friedman's tests – of what matter is by allowing it almost not to be (e.g., the pin pushed into paper until it's dentelle lace and with any more pin-pushing no longer paper at all) – call into question the nature of the test. If Deleuze and Guattari's body-without-organs provides a way of depsychologizing Friedman's use of his own body as nomadic thing (its materiality the stuff of dreams and resolutely just stuff, like a block of wood), the body with all its organs proves just as pertinent.

These snugly literary and art-historical referents, as I mentioned, I'm not sure what they do. The list can always be expanded. Bruce Nauman is perfectly apposite. His relation to his studio as experimentation facility accords with Friedman's, as do many of his works. But I don't know how much, if at all, it helps things, the things Friedman makes, to be seen and seen in relation to all they are not.

While not wanting to see the plastic bags, green and clear, in any way as stand-ins for Friedman or anyone else, see the layers and layers of bag within/upon bag like a body ageing, like a body made up of and filled with self, stuffed with past selves. A new self is added, what, every second hour day week, on and on, until the container without armature can't handle any more self and it stops. The self-portrait of the body filled with self, the self filled with body until it stops.

11.
Martha Stewart is busy. She's decorating a cake.

11 × 22 × .005
1992
Erased *Playboy* centrefold
56 × 28 × 0.01 cm
An erased *Playboy* centrefold
hangs on the wall by a pin.

right, **Untitled**
1997
Plastic, hair, wire, paint, clay,
paper, painted wooden pedestal
37.5 × 113 × 35.5 cm
A handmade dragonfly rests on
the corner of an overturned
pedestal.

opposite, top, **Martha Stewart**

opposite, middle, **Chuck Close**
John
1971–72
Acrylic on canvas
254 × 228.5 cm

opposite, bottom, **Vija Celmins**
Untitled (Ocean with Cross No. 1)
1971
Graphite on acrylic ground on
paper
45 × 58 cm

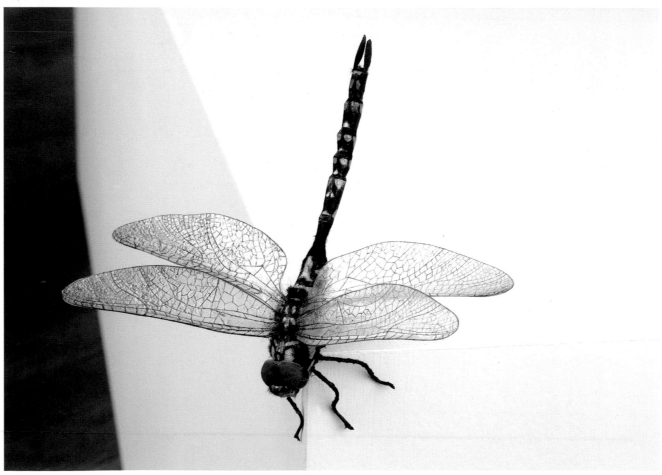

Then she's making an elaborate trellis-like device for long purple beans to grow on. Her technique is fastidious, lapidary. I've spent most of the morning (it is a glorious morning, almost as dazzling as it is in Connecticut at Martha Stewart's house on TV: cool breeze, sun as-soon-as-it-hits-skin warming, sun lighting the eucalyptus, sun sunning the gardenias, the air blooms with spring green) trying to figure out how Martha Stewart and Tom Friedman are and are not alike.

Perhaps this might seem to many a quixotic if not utterly ridiculous endeavour. And yet it is not clear to me why Friedman's differences from or similarities to Chuck Close, Sol LeWitt or Vija Celmins should be privileged over his differences from or similarities to Martha Stewart. Let me be blunt: in terms of someone's making objects and placing them in the world, Martha is an interesting artist, and I find contextualizing Friedman with her as funny and complicated and helpfully complex as I find comparing him with Celmins. All have been accused of being 'obsessive', of working 'obsessively', though at quite different paces. All are interested in handwork, in handwork that often removes the look of the home-made.

Consider one of Martha Stewart's wedding cakes, its elaborate icing and decoration. It is spectacular with its glittering marzipan fruits resembling actual iced fruits and its 'woven' basketry icing patterns, spectacular in no small part because it is clear that, although fastidious and perfect, someone did make this by hand. Its handwork amazes because it transcends how hands normally operate. (And then you eat it. That's important.) Celmins' graphite waves and painted

stones looking like stones, Friedman's toothpick supernova, dragonfly and polystyrene 'cloud' fascinate for similar reasons. All three violate the nether zone between 'craft' and 'art'.

I absolutely think Celmins' and Friedman's objects are art and not craft, but trying to figure out why that should be and why most of Stewart's endeavours, although as careful and loopy, I would term craft and not art, and how a blurring or overlapping of what gets deemed 'art' and 'craft' is one of the things Friedman's work investigates and is partly why it's so amazing and complex despite its simplicities, trying to figure those things out leads baldly to places I think only comparing his work to things securely nominated as 'art' doesn't. I don't think it easy to sidestep the issue by saying craft has use-value, is useful, and art doesn't or isn't. No one needs a cake decorated so it looks like it's a basket of iced fruit and actual flowers; the question of usefulness was abandoned once someone decided she didn't want a Tastykake or Sara Lee. It has something to do with how delight and frivolity operate. (And then you eat it. That's important.)

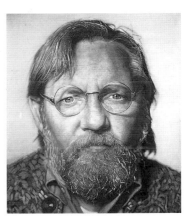

So, Martha Stewart shows everyone who cares how to make things on TV; Tom Friedman works in his studio alone. Martha Stewart caused a stir when her omnimedia operation went public; Tom Friedman, although engaged in his own pursuit of omnimedia, has no plans to have an astounding IPO. Stewart's pursuits are a way of alleviating empty moments, blankness, anomie. Much of her handwork becomes a way of reconnecting with others (dinners, teas, celebrations); the elaborate handwork and planning are not unlike the

right, **Untitled**
1994
Aspirin
0.8 × 0.5 × 0.8 cm
A self-portrait carved from an
aspirin.

opposite, **Untitled**
1999
Sugar cubes
122 × 43 × 25.5 cm
A self-portrait of the artist made
with sugar cubes.

worrying of a rosary through repeated touch, bead by bead. They are ways of being in contact with something and someone in order to alleviate, to block or thwart, materially, the immateriality of doubt, the abyss of consciousness or the nothingness of anyone's and Martha Stewart's living.

It is not as if many of Friedman's sculptures, formed from repetitive motions and gestures, could not also be seen as a way of avoiding the void opening up in the quotidian. But Friedman's acknowledgement of nothingness' caressing and threatening everything, everything's proximity to nothing, so close, may be exactly the difference between him and Stewart, between art and craft.

12.

The little head of the artist carved out of aspirin, *Untitled,* 1993–94, looks like it could have been a petite part of a Greek frieze, but instead of alabaster or porphyry it is carved from a common household remedy for head and body ache, for the ache of having a head and a body. As a material, the aspirin is linked to other edibles that Friedman has employed: toothpaste, bubble gum, LifeSavers, spaghetti, sugar, coffee. (Of course the ball of faeces is alimentarily connected to foodstuffs.) What is peculiar about the aspirin is that it has been carved into a self-portrait and, as a substance, aspirin resonates with more referential consequence than almost any other

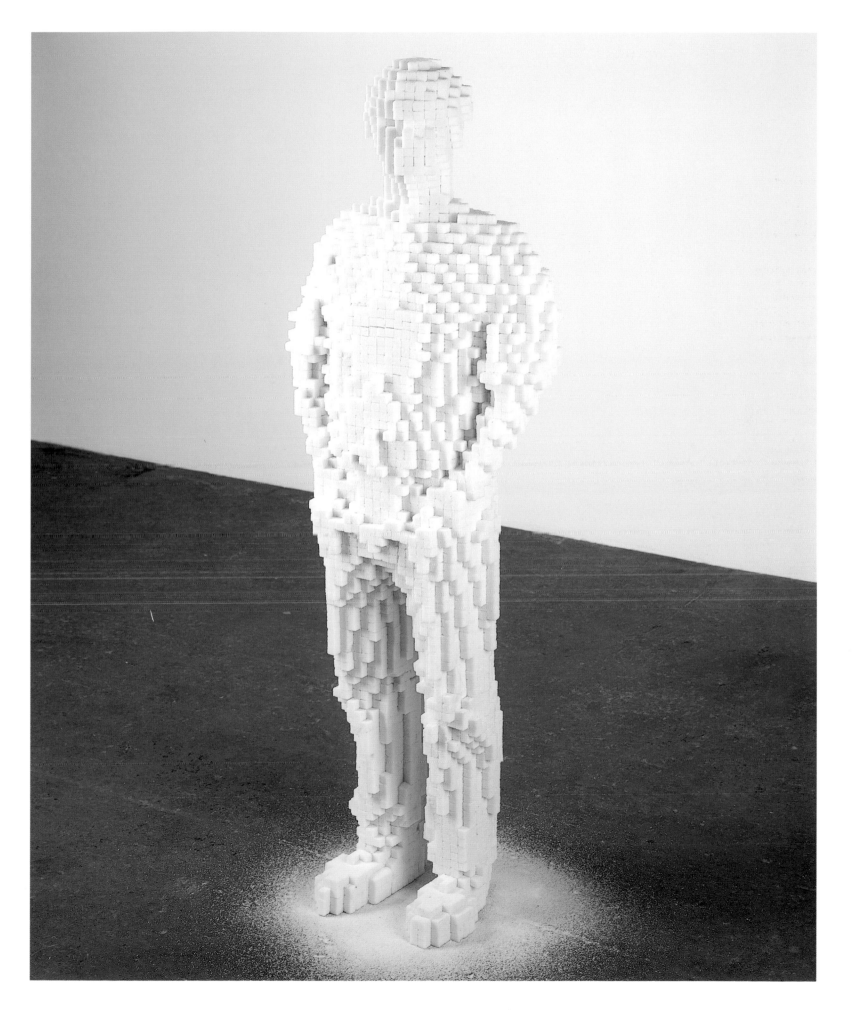

Untitled
1998
Lambda print
61.5 × 117 cm (framed)
Collection, Metropolitan Museum
of Art, New York
A full-body profile of the artist
was scanned into a computer.
Each colour pixel from the front
profile of the artist was extended
horizontally 96.5 cm. The profile
was removed leaving only the
layers of horizontal lines.

material Friedman has used. Headache alleviated or not, aspirin suggests the throb of consciousness, the burden of self-awareness. Whether or not Freud ever prescribed anyone to take two aspirin and call him in the morning, his presence haunts to varying degrees any representation of the self. The piece wittily refers to the pain of consciousness, of self, but is made out of the relief to such aches.

In typing the word *aspirin* over and over in relation to the word *self-portrait*, I kept adding an extra letter. It seems appropriate to point out that at certain points anyone, artist or not, considers his or her aspirations, how what anyone does relates to what or who anyone is or wishes to be. This can be either a pleasant or nauseous experience; it can be simultaneously pleasant and nauseous. Perhaps the self-portrait, any self-portrait, is made out of aspiring, aspiring to figure out what it is that the self anyone is is, and how objects, mute and inanimate, frequently provide a way to portray, ponder and alleviate such aspiring.

13.
I would give anything in the world (it is the only thing I think about some days) to rid myself of the body yet not be dead, and at the same time have the opposite exist as well: to be a body unburdened by a self and its consciousness yet to be able to know what that is like.

14.
Blur.

There it is and there it is going, it's gone.

The self is usually not thought of as a blur or depicted as one. And yet in the difficulty of representing the present – now – the impossibility of representing it (it's always becoming the memory of what was, rather than being what is), blur is one way to approach the self now, in time now. For *Untitled*, 1998, a Lambda print, Friedman took a digital photograph of himself, demarcated a certain reduced set of pixels arranged vertically, and then stretched them, extending them horizontally. The effect reads as if the different pixelated zones of the body (head, torso, legs),

clothed, were in rapid motion, a blur or disturbance in a stable field.

As part of a tripartite installation, *Air*, 1999, there is a small, strange accumulation of pearly translucent drinking straws which portray the ghostly effect of a body moving through space/time, through air. If the other parts of *Air* show the evaporating effects of air (coffee staining a Styrofoam cup) and how something rides or hovers on air (a ladybird – unlike Friedman's fly made of Play-Doh, plastic and fuzz, or dragonfly made of hair, wire, plastic and clay, or daddy-longlegs made of clay, fishing line, paint and hair – made of ladybird, actual not verisimilar), the plastic straws insinuate the body moving through air but also becoming memory, or not even memory but blown through and away, becoming nothing but a trace. How does horizontal blurring become a sign for motion, something speeding, the straws' elongation of the body's outline as a space/time shift?

There has not been enough consideration of how art operates in memory; so much study of the formal concerns and rhetorical impact and signification systems of art, and yet very little confrontation with how art works as memory,

which, unless someone is fortunate enough to live with it, is how it works most of all. It's inert, static, inanimate, and yet it haunts. Let me put this another way. When one begins to understand the self as a body caught shifting like a bug in the flux of time, does the shift and flux of the self make it easier to know or more understandable that the other changes too?

The self-portrait in drinking straws of *Air* tries to gauge what the self as blur is. It's Heideggerian in its negotiation of being and time, self situated between presences. It's also the body as a rapid mode for conveyance, the thing allowing concepts of being to be sucked between the pop of living and whatever abhors a vacuum.

15.

The artist's identity becomes equivalent with a group of objects, things, and it's not that. Can't look at a bunch of things, even a self-portrait, as autobiography manqué. That's not it.

Interchangeable with the identity of the objects he makes, the artist tries to find some truer identity within the objects. That's not it either.

Let me try again. The body is flesh. I read this

Air
1999
Styrofoam cup, coffee, drinking straws, ladybird
cup, h. 9.5 cm, ⌀ 7.5 cm;
ladybird, 0.6 × 0.6 × 1.3 cm;
straws, 24 × 12.5 × 19.5 cm
A 28.3g Styrofoam cup filled with coffee was allowed to evaporate over several months, leaving a residue. It is displayed at the foot of a wall. A dead ladybird rests on a wall 182.9 cm above the floor. Plastic drinking straws glued together horizontally create an extended frontal cross-section of the artist sits on the floor.

following pages, **Untitled**
2000
Construction paper
30.5 × 366 × 305 cm
A paper representation of the artist violently torn apart.

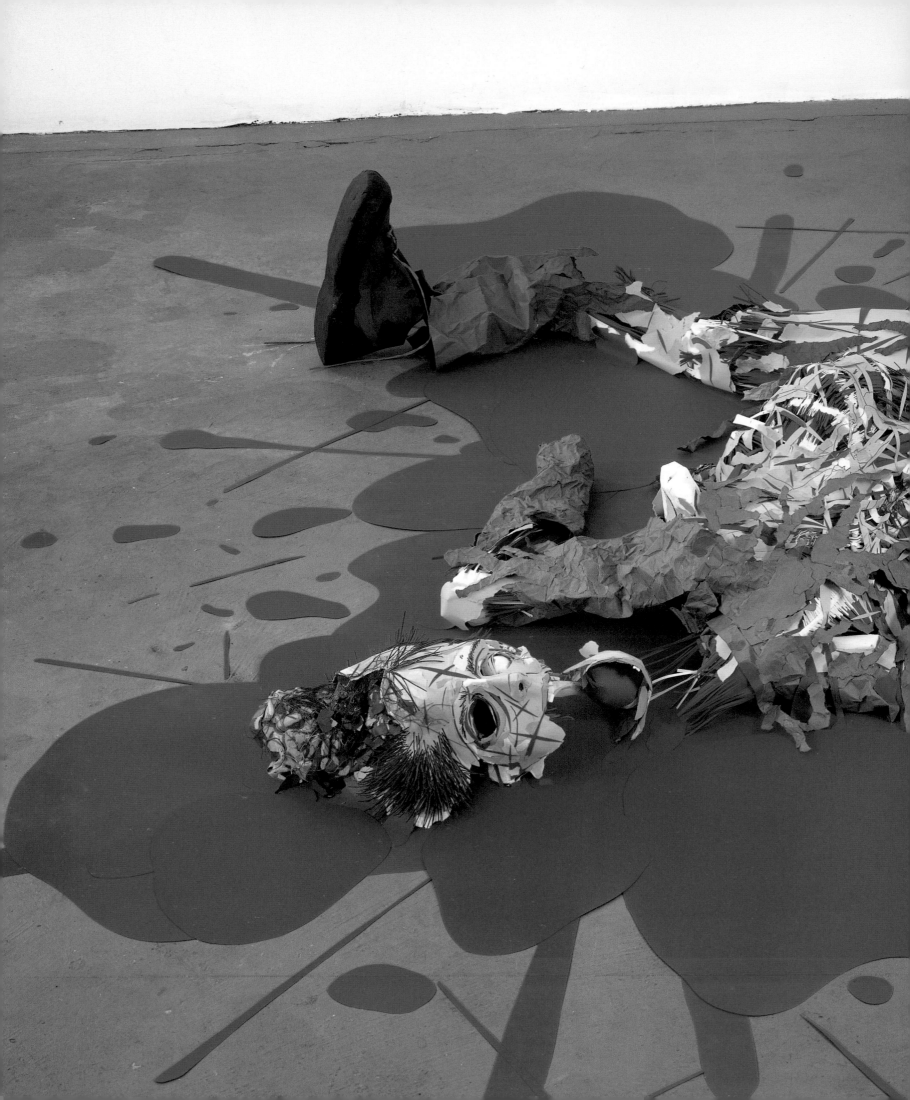

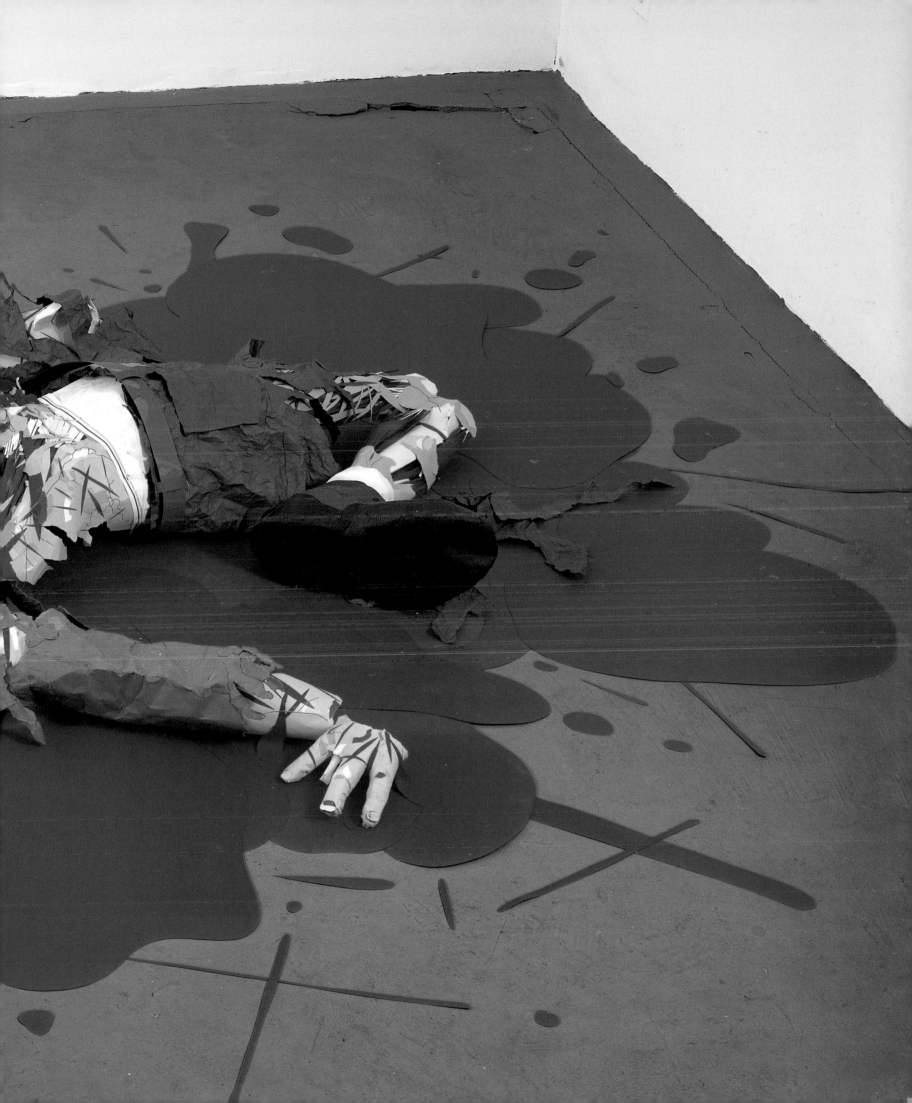

In Memory of a Piece of Paper
1994
21.5 × 28 cm piece of paper
approx. ⌀ 91.5 cm overall
Each piece from a shredded piece
of paper is folded into a different
shape and arranged together on
the floor. The arrangement's
central void is the same size as
the original piece of paper.

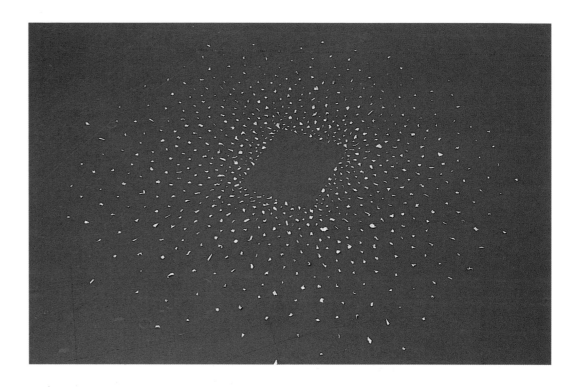

somewhere. The concept of self is a complication of flesh. The body is a thing that can never be presented to the self. The body can never see itself except as re-presented, as mediated. The body can't see, can't look at directly, what, more than half of what it is? I'm not sure the body ever cares about seeing itself, but the self certainly does. That's the complicated part, I think. Everybody has a body. Everybody at some point ponders what it means to be someone as opposed to someone else, how being a body operates as opposed to how it seems to work for anyone else being one.

For *Untitled*, 2000, Friedman made a life-size representation of himself out of construction paper, himself as if he had been, as if his body had been, blown apart, exploded. A bloody mess, that's what a self is, a complication, a derangement. There's an arm over there, a puddle of blood over there, a torso, a head. The eyes are dead and very open. The spinal cord, the skin around it (flesh, organs) splayed back, articulated in layers.

Consider the limits of what can be done with the body as a material, as stuff. Friedman couldn't very well make a sculpture out of his actual body parts as he did out of a piece of paper for *In Memory of a Piece of Paper*, 1994, in which a void of what was once a piece of paper centres an array of torn-up bits of what the whole piece of paper was. Representation is a dismemberment, it takes

things apart. Call the body blown apart *In Pieces of Paper the Memory of a Body*.

The fleshy blushing pink of an eraser completely used makes a pile of what was an eraser, what is still an eraser, the way a corpse still resembles someone someone knew, cared about. A monument in memory of erasure made of an eraser erased.

I guess.

Looking at Friedman's work there's all this delight, and yet always menace and obliteration roiling in it. Things fall apart, they get taken apart, they dissolve, they're wrecked, they disappear, voided, cancelled. How did he decide, given a range of materials, upon construction paper to portray his body blown apart? Was it because construction paper is an elementary school, a kindergarten material, the paper used when kids first learn how to cut paper with scissors, a way of getting back to a primary aesthetic act? For Friedman to cut an elaborate, complicated derangement of his body out of layers of construction paper – to explode the body, representing its deconstruction in construction paper, which will fade and change so rapidly, not unlike the body it reiterates, since the colours of construction papers are so fugitive – is almost as ridiculous a prospect as the idea of the self or body itself changing.

Something fallen from the sky into a field makes a large crater-like depression resembing the artist's body or its shadowy absence. It's a fake. He's not that large. He's Jack's size, not the Giant's. Everyone was always glad, I think, that the Giant fell when Jack chopped the beanstalk down.

No one ever talked about what they did with the huge body, the stink of giant decay, rotting. Perhaps the townspeople were happy because they cured the vast flesh – salty – to get through a long winter.

To understand the body, to make a self-portrait, at some point you have to consider what not-having-a-body-any-longer would be, and any act of representation takes you to that point. Jean Genet said that Rembrandt's self-portraits, especially the later ones, were great because of their ruthlessness. Anyone looking at them is faced with what Rembrandt faced when painting them: that it's paint, and the area of painted flesh is no more important than the painted table, painted wardrobe, painted shadow, the way no body could be more important than any other.

The big depression traces the contours of a body, arms and legs splayed, fallen from some great height, fallen down. As much as *Untitled*, 1996, depicts, through the computer-assisted

Untitled
1996
C-print
7.5 × 11 cm
Collection, Museum of Modern Art, San Francisco
A snapshot-sized photo made with the aid of a computer program that merged a photograph of a small clay sculpture of a body-shaped canyon with a photograph of a landscape.

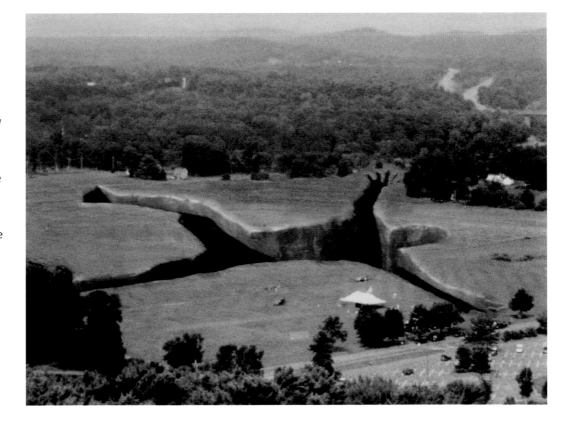

manipulation of an aerial shot of a New England field surrounded by trees, with houses and a river in the distance, a *what if*, it also represents the grand canyon which opens up – depression, loss (it has many names) – within bodies, an abyss which many, at times, find within themselves. Fill it up fill it up fill me up fill it up. Turrell found his in the desert.

Interesting to see how many bulldozers – *some shovel* – are needed to fill it up (the self crater) fill it up fill it up. Not quick enough, not fast enough, making little progress after the psychic trespass many conveniently call *you* still feels like trying to fill the grand canyon with a teaspoon.

16.

Tom Friedman's studio has no windows.

17.

Consider that the only way to understand something may be to wrong it, to allow it to self-destruct, to take it apart and put it back together wrongly, in the most wrong way possible. Re: haunted houses wrong a house to get at what really goes on in houses. Re: one of the reasons representations are liked, loved even, is because of how wrong they are.

18.

Untitled, 1998. The incision in the wall as a way of getting out of the studio with no windows. The incision as a metaphor for how the mind cuts into things to make them something else and to keep them what they are, a metaphor of the way the self wants to cut out of itself. The incision appears,

barely discernible. The adherence and attention to what things are, a sincere, at once worshipful and ridiculous attention and observation of what things are, including what kind of thing the self is, the idea of the self and how it gets represented *and at the same time* the most irrational thing that can be done with all that attention and adherence. In Friedman's best work you don't get the one force without the other.

Yeah, that's exactly what it is *and* that's the last thing it should be.

19.

Of course all this self-portraiture business neatens too much, simplifies too much, misses the point perhaps entirely of what makes Friedman's work important. But I didn't start with a negative theology for no reason. Everyone wants a way out at times.

For example, any understanding of this self-portraiture business would have to confront the abstraction, the abstracting, of the self. Pure form, the abstraction of the way things actually are, the abstraction already within things; these are some of the ways this self-portraiture business misses the point entirely by not attending to the abstractions within seeing and looking at things already, the abstraction that is already there.

For example, if *Cloud,* 1998, could get at the anagrammatic *could,* the conditional of knowledge – of being, of polystyrene – already within how a cloud operates, and if the best way to represent that operation would take this zigzagging floating form, this abstraction, consider what the most just form for (and representation of) the self might be,

and how abstract it would be, how it would wrong the way anyone, any body, looks.

20.

Is the point of this self-understanding?

21.

Friedman considers and toys with how apartness is a part of everything being what it is. How things come to be what they are, and how that requires a consideration of what their not-being would be. Theory comes only from the observation of what something is and isn't. It's very simple until it's not simple at all. He's found a way to follow where this line of questioning, this way of observing how things come to be understood as what they are, takes him, which is far from where something's usually considered to be. It has to do with learning to be ignorant about things.

For *Untitled*, 1990, there's a wrinkled piece of white paper. Next to it is another white piece of wrinkled paper. The wrinkles of the paper, like the pieces of paper themselves, look the same but they aren't the same, they can't be. They aren't the same – one is left, the other right – despite being made up of the same thing. With a single gesture (crumpling) and simple material (paper), Friedman crumples notions of the sameness within identicality, within (by extension) identity. He unknots the not in being, releasing the necessity of whatever is taken to be its opposite.

Verisimilitude and the real. The next best thing and the very thing itself. Seeming and being. The one next to the other. The next-to becoming, shimmering as the other. No one gets around

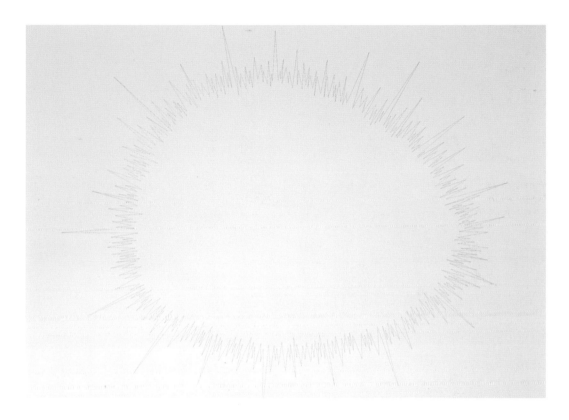

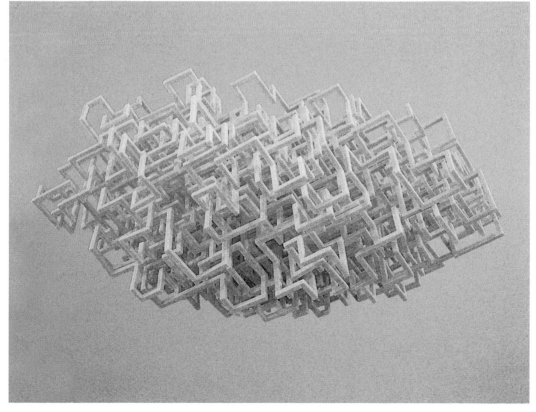

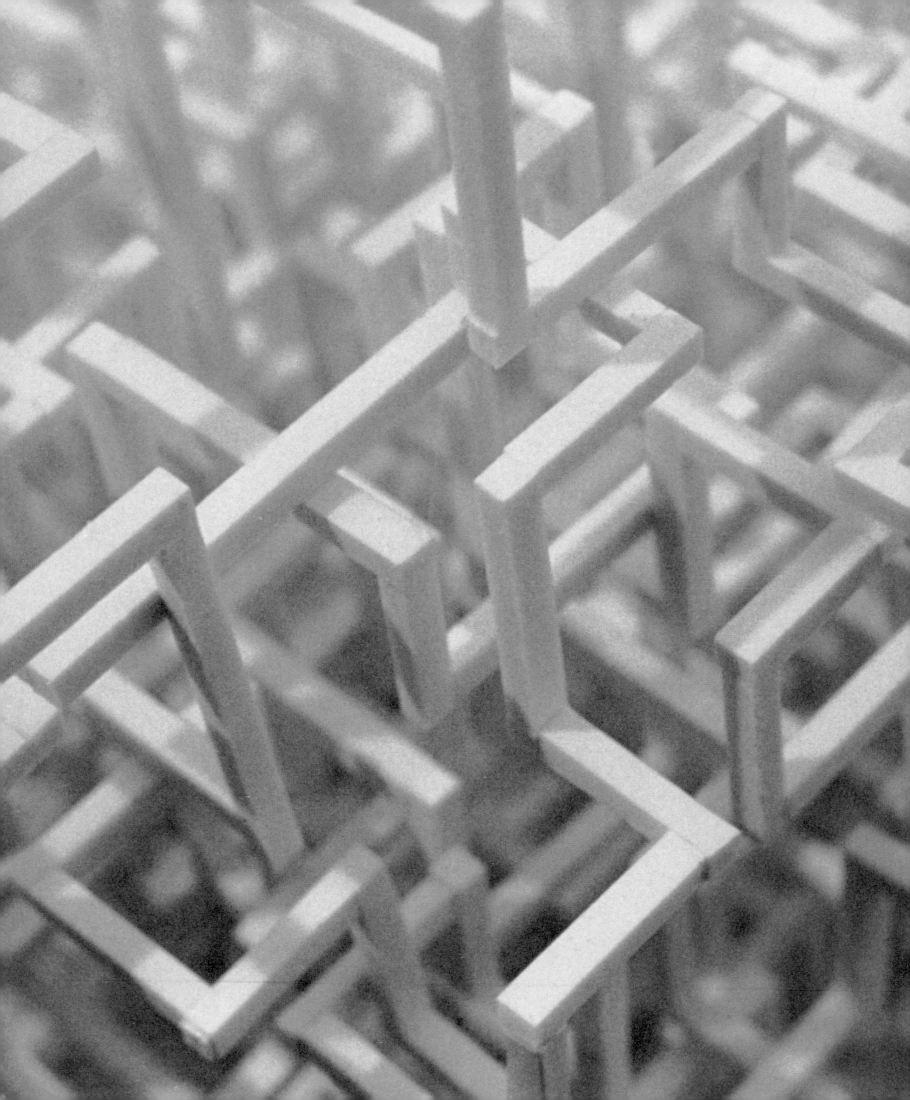

opposite, **Cloud** (detail)
1998
Polystyrene (hard insulation)
30.5 × 61 × 61 cm
Light blue polystyrene insulation
is cut to 0.6 cm square dowels of
varying lengths and connected at
right angles to form a continuous
loop. The structure hangs from
the ceiling by monofilament,
121.9 cm off the ground.

left, **Untitled**
1990
Paper
2 parts, 27.9 × 21.6 cm each
Collection, Museum of
Contemporary Art, Los Angeles
Two identically wrinkled sheets of
paper.

having to deal with being, and the real, and what both are not. Whether or not any of Shakespeare's eloquence flows into the colloquial speech anyone identifies as his or her own may be an entirely different matter, but the real-time of living gets said just in, even in, even especially in, the inarticulateness of having nothing to say. Everyone may crumple up a piece of paper, use toothpicks and toothpaste and erasers and a dictionary, everyone stares; not everyone allows the ontological resonances of such objects and activities to be formed into what might be understood as 'art', but they could – or at least they could consider it (if they consider art at all, in some way they must). Friedman shows how

thinking and looking at things, and the things (nothing, everything) surrounding those things, become a way of ordering them in order to contemplate their existence and the existence of the one contemplating. He shows all of it – existence, thinking, art – not far away but all around where anyone is. W.H. Auden believed *Hamlet* allowed anyone at all to play the Prince, because Shakespeare had written into the role, made ther role up of, the instruction of who and what Hamlet is and is not, the theory of Hamlet's being existing in anyone saying the lines. Friedman finds the theory or the system of how things come to be understood as what they are – the limits of understanding them and what exists

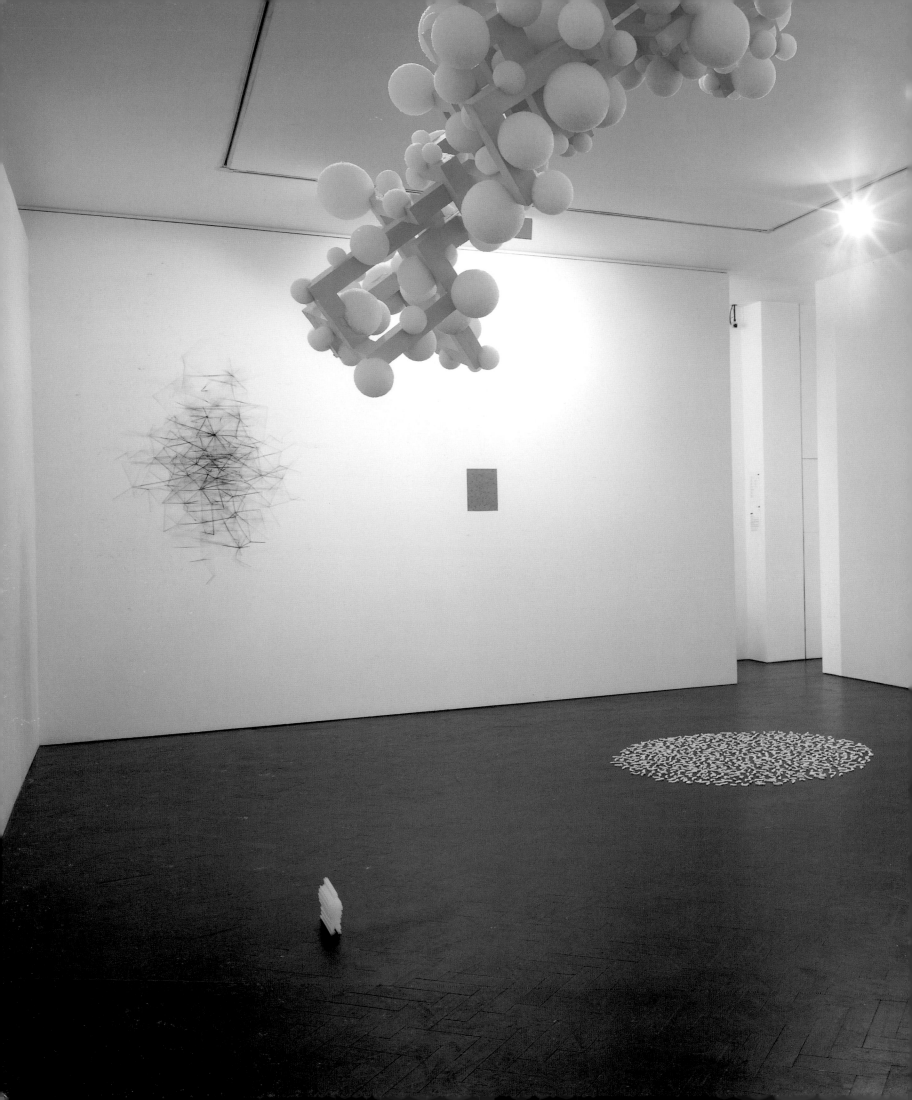

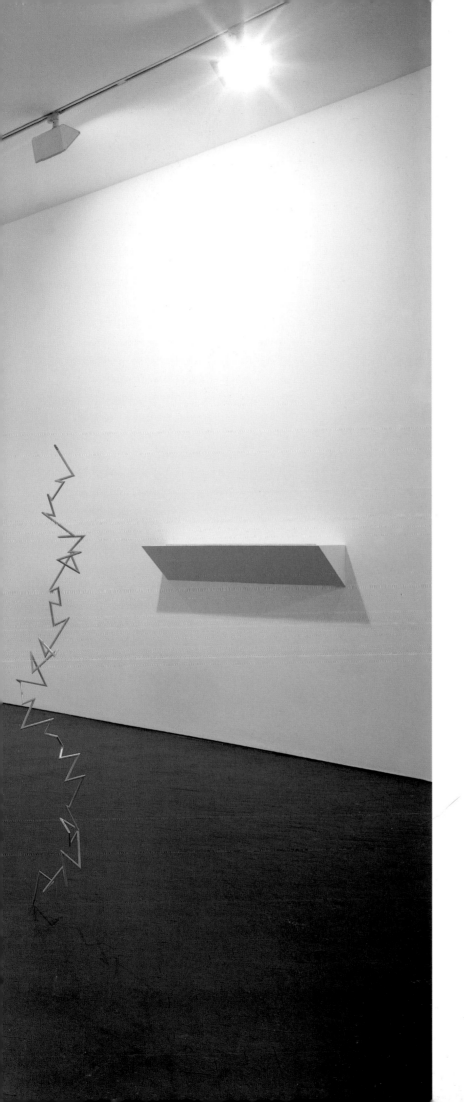

Installation view, Stephen
Friedman Gallery, London, 1998
l. to r.,
Untitled
1998
Wood, paint
110 × 110 × 120 cm
A network of wooden dowel
sections painted black hangs from
the ceiling by a monofilament
about 122 cm off the ground.
Untitled
1998
Drinking straws
24 × 12.5 × 19.5 cm
Plastic drinking straws glued
together horizontally create an
extended frontal cross-section of
the artist sits on the floor.
Untitled
1998
Polystyrene insulation,
polystyrene balls, paint
45.5 × 45.5 × 179.5 cm
Polystyrene insulation is cut into
2.5 cm square sections of varying
lengths and connected at right
angles. The resulting network is
covered with Styrofoam balls and
hangs from the ceiling by
monofilament.
Untitled
1998
Construction paper, hot glue
30.5 × 23 cm
Beads of hot glue on construction
paper are connected by thin
threads of hot glue.
Untitled
1998
Drinking straw wrappers
⌀ 141 cm
Drinking straw wrappers arranged
on the floor in a circle.
Untitled
1998
Pencils
129.5 × 18 × 23 cm
A long pencil made by connecting
pencil sections of varying lengths.
It hangs from the ceiling by
monofilament; the point of the
pencil just touches the floor.
Untitled
1998
Paper hole punches from text
⌀ 0.5 cm, l. 98 cm
Paper dots, hole punched from a
text, are laminated together to
make a long cylindrical dowel.

Untitled
1995
Toothpicks
66 × 76 × 58.5 cm
A starburst construction made
with thousands of toothpicks.

beyond them – in the ordinary, in the things themselves. Theory of toothpick, theory of bubble gum, theory of LifeSaver, theory of dust and shit, theory of nothing between everything, theory of the theory between what isn't theory and what is: whether or not anyone wishes to see how meaning operates there – between, everywhere – is not dissimilar to whether or not anyone wishes to ask him- or herself questions about being or not-being.

After conversing with the ghost of his father, Hamlet warns Horatio: 'There are more things in Heaven and Earth, Horatio, / Than are dreamt of in your Philosophy.' In Horatio's philosophy, but perhaps not in his own. Consider that when Keanu Reeves ... hold on, I have to take a deep breath after just saying his name ... consider that when Keanu as Neo in *The Matrix* (1999) comes to understand what is going on, in the breakdown or abandonment or abolishing of what is fantasy and reality, he goes: 'Whoooaaa.' It's 'To be or not to be', in the vernacular. It is the 'same' piece of paper next to what cannot be the same. It's crumpling up and shuffling off the fantasy of what someone (you, Keanu or Neo) thought to be his mortal coil.

Throw it away.

Pin it to the wall.

Anything can only be by being the same, i.e., by being again; the same can only be by being again, so it's not, not ever.

22.
He's meditated on toothpicks, bubble gum, staring, the perception of what a 'foot' is. He's

considered air, mapping, verisimilitude, everything, pubic hair and soap. He's looked at himself and found a relation to Styrofoam, and he's found a way to point in ink at a void where the body is called the self.

He's allowed his materials to become self-reflexive (a comment on themselves) but also provided a way to release them from materiality and to become – dangerous term – 'symbolic', operating in the sculpture in ways similar to how DNA or atoms operate in someone considered intimate, known. Unless you're a scientist, few ever really look at a friend or loved one or themselves atomically, as just a genomic equation, as whole but dumb matter. When I encounter Friedman's pubic hair on soap or a tiny ball of his shit on a pedestal or his toothpick starburst, I think he has considered pubic hair, soap, faecal geometry, splinters of wood, but the things haven't remained just that. And to say what his materials *don't* remain, to say how they begin to signify, to say how by being, for example, pubic hair and soap they signify those things and through signification become *not* just what they are, is extraordinarily difficult. I don't think knowing about the history of the toothpick or of soapmaking or of pubic hygiene helps anyone in understanding the pieces which deploy those materials. But even saying that, his works do present the brutal actuality of soap and pubic hair or toothpick and what it might mean for anyone to ponder really what it is for things to mean anything.

23.
It's just a bunch of sentences. It's only ever a

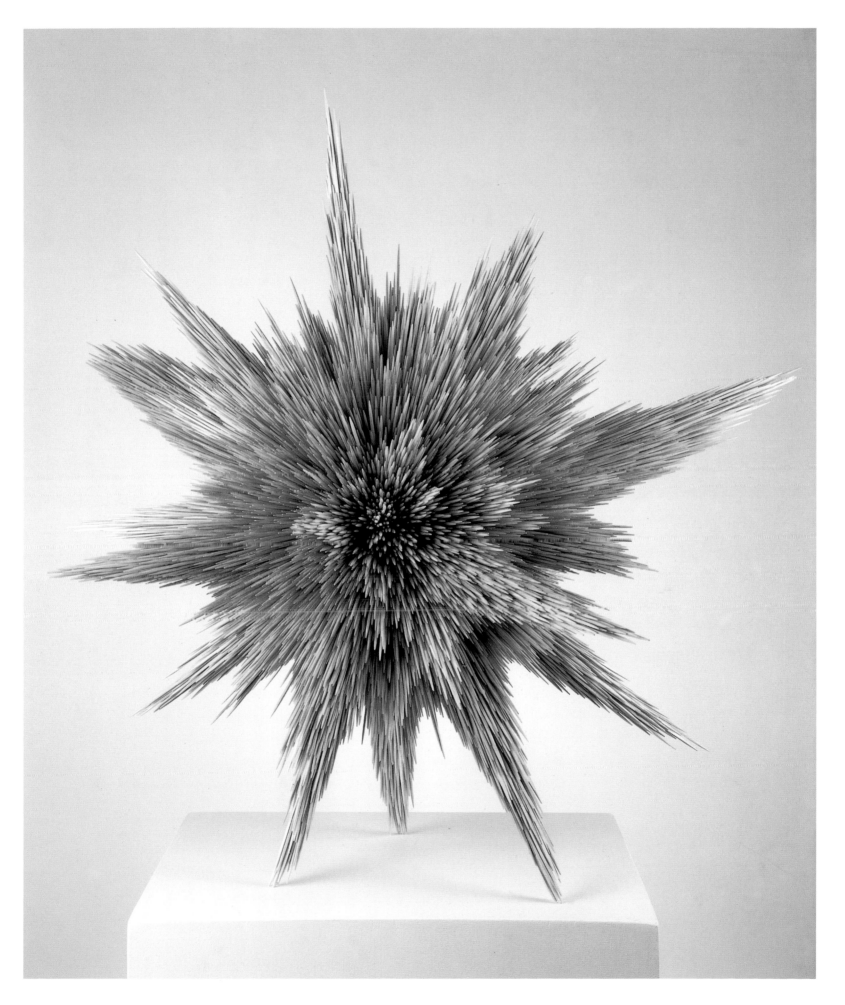

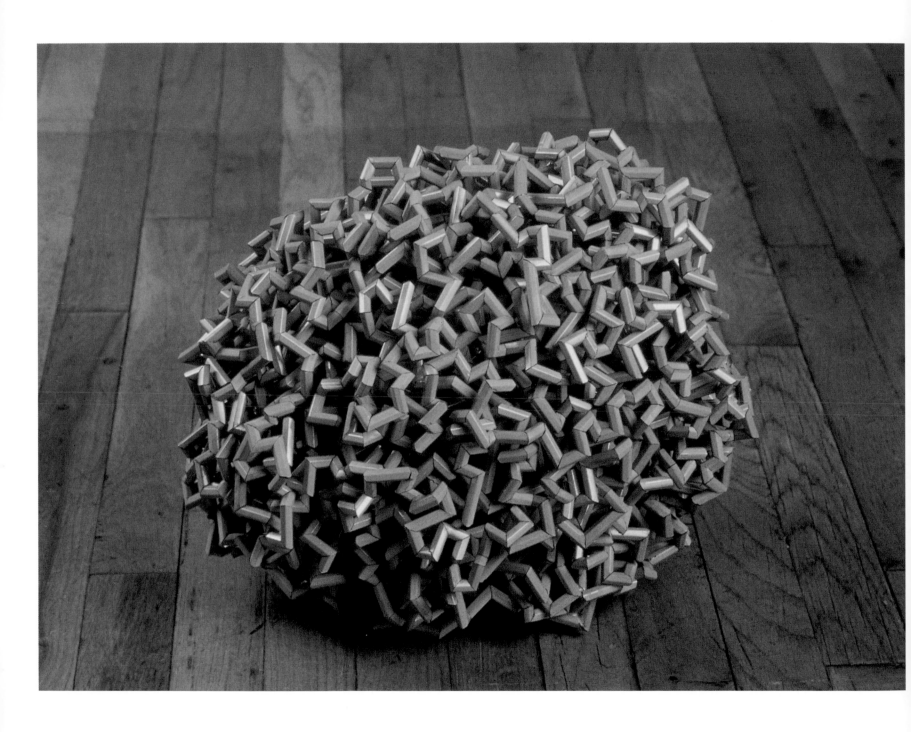

bunch of sentences. How it's decided that they do or do not 'get' what they aim to get is difficult to determine. I would say that first of all when writing about what is nominated as 'art' that you'd better worry the sentences, wrong the sentence, think about the sentence before you think about anything else.

When trying to think about Tom Friedman's work I kept confronting how his forms gave form to my wondering what his forms were trying to be. Nothing ersatz, the dazzling star made of toothpicks (*Untitled*, 1995): it's how the toothpick sees itself if the toothpick could see itself as anything (things, dumb things, can't 'see' at all, of course); it's simultaneously the supernova star and just toothpicks and somewhere between those two things – and absolutely neither. Perhaps what holds them together is the concept of toothpick, what /toothpick/ is, *toothpick* in the abstract. And so in trying to think about his forms I had to think about the form of whatever I thought a 'Survey' might be, which, being about Tom Friedman, would both have to be made up of a thing (bits of Friedman) and be that thing (bits about Friedman).

opposite, **Untitled**
1995
Pencils
28 × 35.5 × 27.5 cm
A continuous loop of cut-pencil sections glued together.

left, **Untitled**
1997
Plastic straws, bucket
h. 45.5, ⌀ 142 cm
Links of plastic drinking straws placed in a bucket, emanating outwards and arching toward the ground due to gravity.

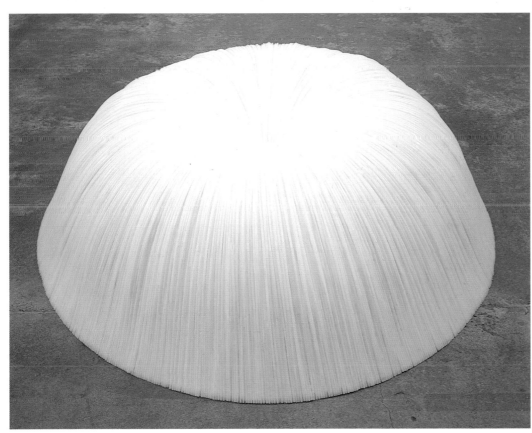

 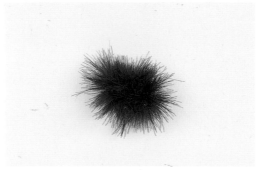

So often too much criticism proceeds as if it were solving something for you. I don't think Friedman's work is only about self-portraiture, but it struck me at some point that no one had actually written – was it too obvious? did no one notice? – that his own body and the various materials with which it might be depicted moved through his work like a shuttle through a loom. I think the self-portrait works in his work without autobiography. His appearance as a figure in his work works the way spaghetti or bubble gum or a block of wood do, the way nothing does: it is antihierarchical and evidentiary. The Friedman self-portrait has the relation to Tom Friedman that these sentences do to his work, or the apartness between any you and another, you and the other, has to what love or friendship is understood to be, the way interruption is what makes a conversation, the interruption of one person's silence or speech for another's.

Which is to say that this self-portrait is untitled as most of his are. It tells only what it's not. Telling you that could be a way to tell you who and what Friedman is or a way to see time pass – just, jst – away.

It looks like nothing and it may be.

24.

Paper, sugar cubes, hard insulation, pen, cardboard, Styrofoam balls, paint, cereal boxes, hair, money no longer only paper, sugar cubes, hard insulation, pen, cardboard, Styrofoam balls, paint, cereal boxes, hair and money.

How they are no longer only what they were is what makes them what they are.

25.

The photograph looks almost entirely black (*Darkroom*, 1994). Brightness pulses near the middle. It is a picture of the artist's studio with all the lights off facing the doorway with sunshine, amazing, coming in from beneath the door. It's a picture of where things are developed. It's a picture showing everything that comes to be seen in relation to what cannot be and is not.

Contents

It goes like this. Take several packs of ordinary sleeve-wrapped white plastic drinking cups and slit the packages open, taking care to preserve the snug factory-fit of the stacked cups. Lay out the opened packs on a clean, uniformly flat surface and begin to slide the cups together to form one long continuous tube. Keep on adding cups till you can bend the tube in an arc, without any of the individual cups pulling out from the ones adjacent to them. Keep on adding, and slowly putting more bend in the column till you can almost make a circle. Go carefully, and go on adding smaller numbers of cups in order to close the tightening arc into a ring, which you complete by inserting one end of the tube into the other, without distorting or buckling any of the cups, and without any of the cups protruding more than the others, in order to form a perfect circular ring of cups. The cups should fit together exactly in order to form a circle in which each fits into the next with a pleasing precision.

There is a smallest possible number of cups with which it is possible to close the ring. The exact number probably depends on the manufacturing variables of different brands of cups, the thickness and weight of the plastic used in their manufacture, the thickness and depth of the lip of the cup. You might have to do a few test runs. Maybe sheen and the particular qualities of whiteness and translucence will also be important in your choice of cup, for reasons which are neither obvious nor apparent until comparisons between different brands can be made, but there are probably fewer plastic cup manufacturers than you imagine.

The best guide to the success of the circle you have made will be your eye. The eye is the best judge. Anyone can make a ring of plastic cups – the point, however, is that Tom Friedman made this ring of white plastic cups, and did it with as few cups as possible, and placed the ring on the floor, drawing our attention to it. The factor of the *least number of cups* is significant: it signals both concision and an eschewal of embellishment. It lends the work brevity and authority. It is almost a statement of fact, about the nature of these impure forms, and of the possibility of their configuration into a form which has a kind of geometric purity.

The plastic drinking cup, we remind ourselves, is such a lowly, commonplace object that it barely impinges on our consciousness, even when such cups find their way into our lives on a daily basis. It is ubiquitous. We do not look down at the plastic drinking cup in our hand and exclaim 'What a boon to mankind! What a convenience! Feel how it fits the hand,

Installation view, 'Young Americans 2: New American Art at the Saatchi Gallery', Saatchi Gallery, London, 1998

background, left to right,
Laura Owens
Untitled
1996
Oil and acrylic on canvas
305 × 244 cm
Untitled
1994
Masking tape
h. 2 cm, ⌀ 183 cm
Loops of masking tape stuck together.
Untitled
1995
Toothpicks
66 × 76 × 58.5 cm
A starburst construction made with thousands of toothpicks.
foreground, left to right,
Untitled
1997
Plastic straws, bucket
h. 45.5 cm, ⌀ 142 cm
Links of plastic drinking straws placed in a bucket, emanating outwards and arching toward the floor due to gravity.
Untitled
1993
Plastic cups
h. 9 cm, ⌀ 101.5 cm
A continuous ring of plastic drinking cups, one inside the other.

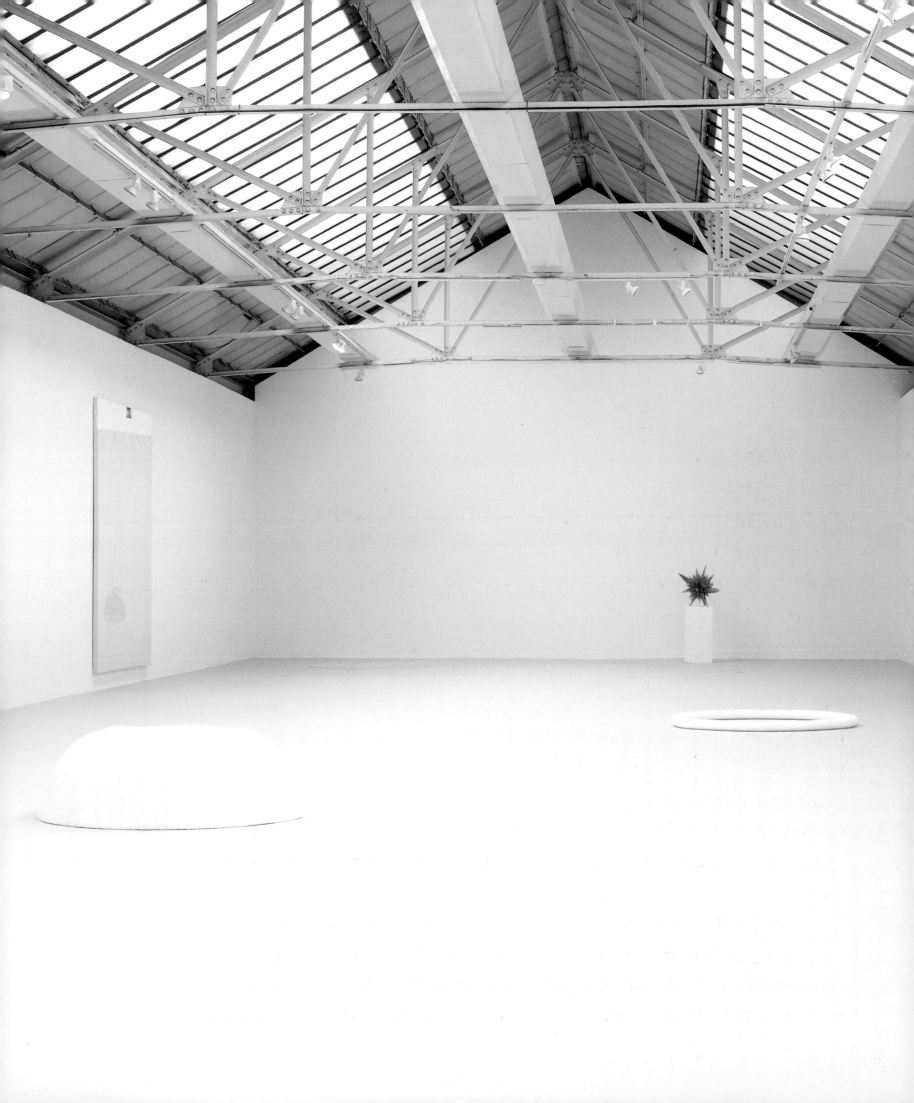

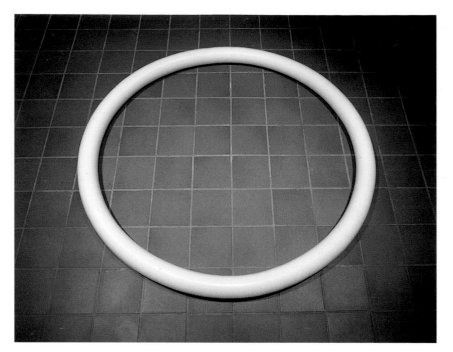

Untitled
1993
Plastic cups
h. 9 cm, ⌀ 101.5 cm
A continuous ring of plastic
drinking cups, one inside the
other.

and delivers just the right quantity of chilled water, instant coffee, fruit juice, booze!' No. We are more aware how cheap it feels, how unsatisfactory it is as a cup. It does not feel good to the lips. It has no weight, offers no resistance to the hand. Holding a cup like this, the world seems a little less substantial than it ought. What little grace it is possible to muster, with a plastic cup in one's hand. They give no pleasure either in themselves, or to the act of drinking.

Compare, if you will, the white plastic drinking cup with even the most common glass, the cheapest mug; even a waxed-paper cup conveys more warmth, with its improbable and doubtlessly entirely false invocations of the nesting habits of the bee, the logging and pulping of trees into paper. A glass has weight and density, offering us both reflection and refraction. A mug can be comforting. It is democratic. A plastic drinking cup, on the other hand, always makes me feel that some mighty corporation, somewhere, has gone into the matter of liquid delivery and got one over on me.

And how easy they are to break or destroy in office meetings or desultory canteen discussions. There are those who fiddle incessantly with these sorry items once they have been emptied. This nervous fiddling – longitudinal scrunching, latitudinal buckling, pointless re-stacking, inverting, rolling about the table, finger-flicking, field-stripping and turning into wretched white plastic flowers, is as annoying to behold as it is mildly pleasant to undertake. The pleasure is furtive and destructive, and probably has something about our impotent detestation of this manifestly dislikeable item, the order it imposes on our natural inclinations and habits.

Does this say anything for art? Child's play, you say, a maundering wet day indoors with nought but a stack of plastic cups with which to amuse yourself. Here, perhaps, lies the origin of the artist's ring of white plastic cups, as well as of several other of his works. It is an

art of desultory reveries, of play. But why not child's play, distinguished by its metaphoric elevation?

Many of Friedman's works make me think of adult play, of the hobbyist's obsessiveness and meticulousness. I think of fly-tiers, men who would put ships in bottles, experts at marquetry. Why do I not then think of professional cabinet-makers, limners, miniaturists, watchmakers? There is something absurd and grand about Friedman's project, something which defeats the professional stance. He does things the hard way, even when he makes it look so easy.

What a magical, shining, unworldly thing Friedman has made with these ephemeral, disposable white plastic drinking cups. 'More delicate and shimmering and beautiful than one could have thought possible' is how I described this ring, the first time I saw it. It lays on the floor, circumscribing nothing. Its diameter is just a touch over one metre, a soldier's pace. You could stand inside it, squat or sit there on your haunches. It describes a human space. It is a halo. The ring appears stranger than we expect, which is perhaps the strangest thing of all about it. One might say how transcendent it is of its origins, but that would be to diminish it: it is the peculiar tension between the material – the plastic cup – and its essentially simple transformation that makes it magical. It is not a trick. Meticulousness, playfulness and the quality of his observations of the world about him mark Friedman's work. Here we see him at his most quotidian and at his most strange. He is dealing with the stuff of the modern everyday, and transforming it into something haunting.

This is all very well. They're just plastic drinking cups shunted into a circle, I hear you say. This is a philistine argument, which always lends itself to the *reductio ad absurdum*: a Michelangelo is only a stone, the greatest painting but earths and minerals, resins and oils – mud, in other words, inchoate.

The diameter of the ring is dictated by the relation between cup and lip, however guilelessly accomplished by the designer back at the cup plant. Give us a cup, the bosses say, that can be stacked, delivered, used then thrown away. Give us not the minimum, but the near as, dammit. Give us average mouths, average appetites, an average cup. It is mean, however you look at it, with or without the vertical ridges that oblige us with their finger-hold, their nod to decoration. The cup's lip distantly echoes the potter's grace-note at the wheel, a recognition that the lip of the cup will brush our own lips. But more than anything,

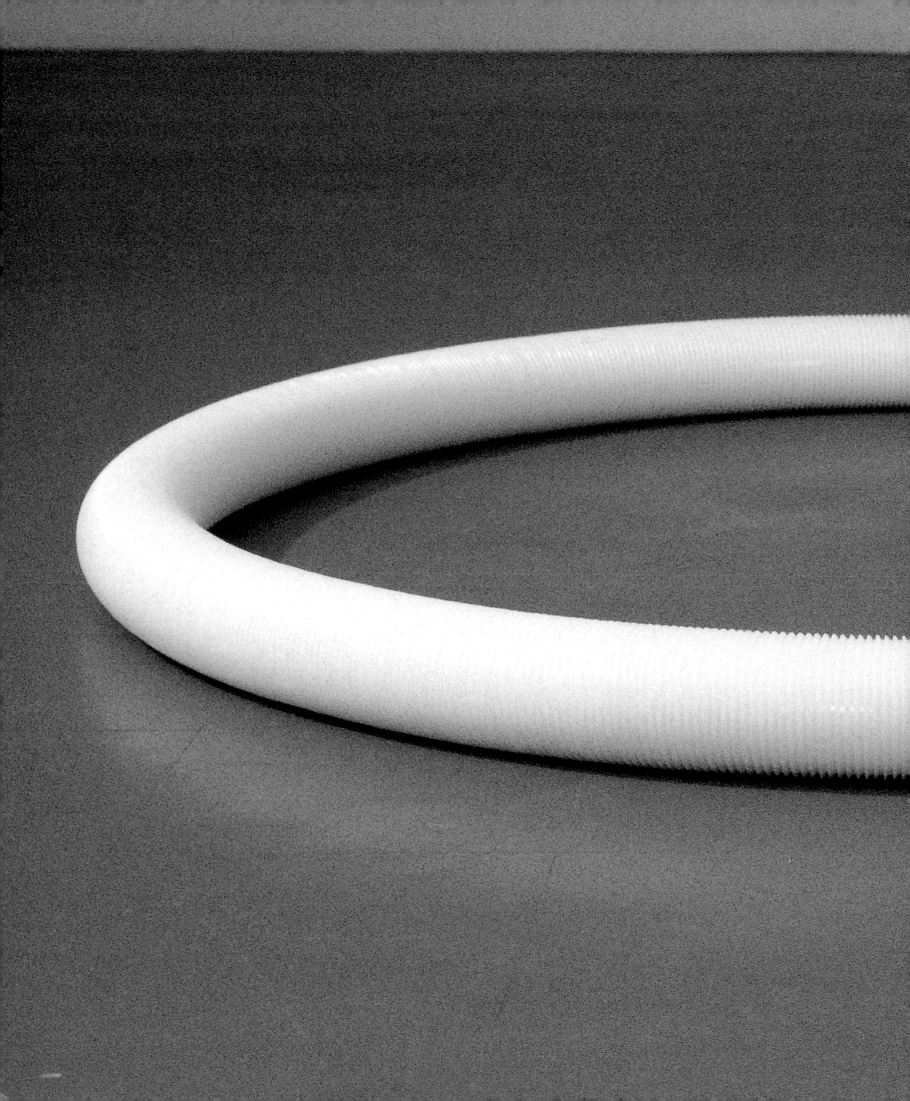

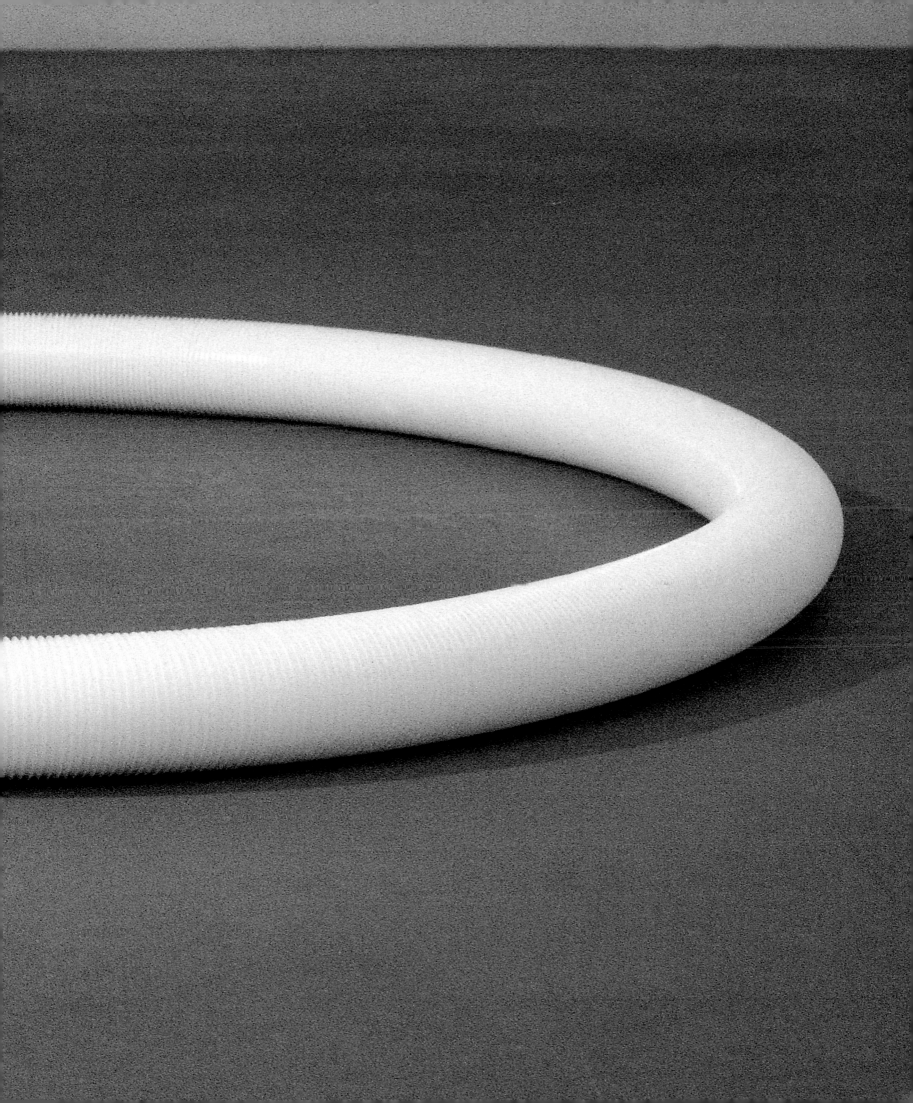

the lip is there to aid the cup's retrieval from amongst its close-packed twins. It aids the cup's rigidity.

Stanley Kubrick
2001: A Space Odyssey
1968
139 min., colour
Film still

Constantin Brancusi
Endless Column
1937
Iron, steel
2,933 × 90 × 90 cm

I recognize and do not recognize how this ring is constructed until the work's gallery label confirms it. What it certainly does not resemble is the handcrafted, sculpted object. It looks manufactured – it has a machine-like impenetrability. It becomes an artefact of unknown origin and obscure usage. It is reminiscent of a vacuum cleaner hose, some kind of cable duct or air supply tubing, but it is clearly none of these things. It has a slightly milky translucence, like the rolled-up ring of a yet-to-be unfurled condom. It is clearly not that either. A Hula Hoop, perhaps? The diameter is a little too tight, the profile of the ring too thick, the corrugations of the tubing lending the ring too much friction. I realize that I already know of what this ring is made, but there is a kind of slippage between this knowledge and the evidence of my eyes. There's a nice tension there between the ephemeral, throwaway, disposable length of cups, each one acting as both female and male ferrule to the ones at either side, fore and aft, and what I can only call the presence of the ring, its aura and authority. It has a kind of science fiction feel, this ring, which locates it in the future-world of Stanley Kubrick's *2001* (1968) – a plasticky white cleanliness, the tightly corrugated curve, the design aesthetic of the circle rather than the rectilinear. The ring is slightly – somehow – outdated, as science fiction always

inevitably becomes. This is a phase artworks go through too, on their way either to posterity or to total eclipse.

One might want to compare Friedman's ring to Constantin Brancusi's *Endless Column* (1937). But this would be going too far. *Endless Column* is nothing but a vertical stack of handcrafted plinths. One might be led to conclude that there is a certain relation here to works by Carl Andre, in which man-made elements – the brick, the building block, the plates of metal arranged in lines and checkerboards – are placed in deceptively simple arrangements. If Andre is a kind of poet of the stone cutter's yard, the brick kiln,

honest, bib-and-brace, spit-in-the-dust toil (the comparison is odious, and much in Friedman's favour), Tom Friedman is an artist whose sense of hierarchies of materials is either so attenuated or so acute that he feels he can use *anything*. I prefer to think the latter, that he is acutely mindful of what he uses, of what there is in the world, of what has meaning and what meanings can be made. His antennae are tuned to the resonances of unregarded stuff.

Perhaps we might regard this horizontal, grounded ring as more akin to a circle of stones by Richard Long, except that his stones remain discrete and separate, and, although somewhat similar, are all different (as though their difference and individuation mattered, symptomatic of a belated Romanticism, shored up by the epiphanies of William Blake and John Donne). Long's stones bear marks of the hand of nature, and perhaps of God, while Friedman's cups are entirely the products of man-made mass production (they fit the hand, although they do not fit it very well).

I can't but liken this particular example of Friedman's work to the obsessive-neurotic poetic observations concerning the modern office and the lunch break in Nicholson Baker's beautifully observed 1988 novella, *Mezzanine*. As I thought about Friedman, the book nagged away at my consciousness. With its long disquisitions, amongst other things, on the evolution of the plastic drinking straw, the styling phases of the office stapler and hi-fi pick-up arms, Baker's short novel requires us to dwell on the things about us in the modern world. And to see them not as the horrific detritus and impedimenta of an alienated and alienating industrial civilization, but as signs of human ingenuity and aspiration, however misguided. Like Baker's novel, Friedman's work is concerned with the texture as well as the appearance of the world, and how we apprehend it, making it, somehow, our own, a place where we can bear to live.

As much as the ring is a closure, it is also a bounded opening, an O, an eye. My eye follows the ring round and round, delighting in the alternating play of light and shadow on the rills, all those lips shunted tightly together. I take pleasure in the perfect fit inside one another of all those unseen cups, the smallest number possible, having the greatest possible affect.

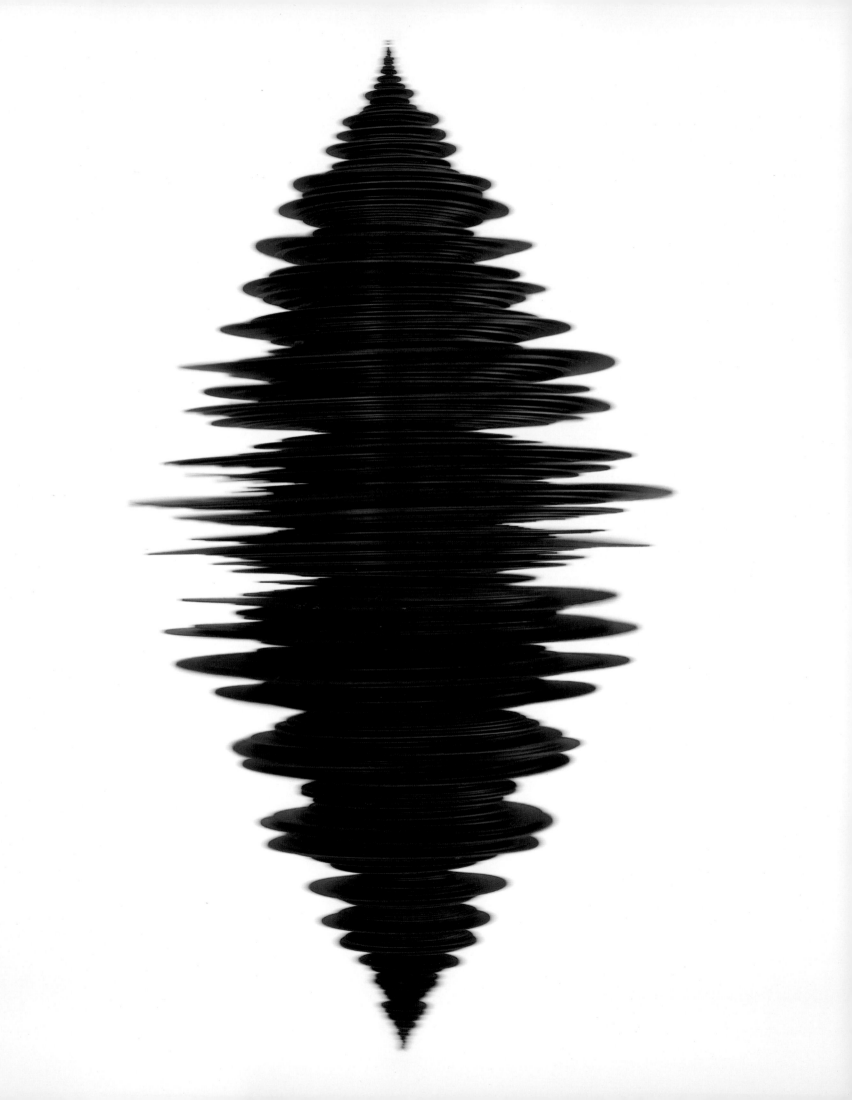

Contents

It was a delightful dinner party. There was plenty of mustard, and the whole works was accompanied by the finest wine. The soup was admittedly a bit thick, and the fish contributed nothing to the entertainment, but no one took it amiss. Over the table poured sauces that put us in raptures, me more than anyone – I was fairly glowing, practically perished with pleasure. A downright tough, hearty roast ensured that our teeth were given a proper workout. I tucked right in. Among other things, a duck was served. The lady of the house kept laughing up her sleeve, and the servants sought to encourage us by clapping us on the shoulders.

The cheese was also delectable. When we stood up, a cigar flew into each and every mouth, a cup of coffee into each and every hand. Every plate vanished the instant it was emptied. We waded up to our necks in witty conversation. The liqueur made us swim in a more beautiful age, and when a songstress performed, we were simply beside ourselves. After we'd recovered, a poet deeply moved us with his verses. At any rate, the beer kept right on flowing, and all and sundry enjoyed themselves.

One of the guests was frozen. All attempts to bring him to life were in vain. The ladies' dresses were magnificent, they revealed quite a lot, thus leaving nothing to be desired. One man attracted attention by wearing a laurel wreath – no one begrudged him this. A second polemicized until he found himself alone, since no one was willing to put up with him. A pair of musicians played Mendelssohn, to which all attentively gave ear. Someone pulled off a great many shirt-fronts and collars and noses. The joke was a bit crude, but no one thought anything about it. The manager of a theatre fantasized about till-filling dramas, a publisher about epoch-making publications.

In parting I slipped the butler a hundred-franc tip. He returned it with the remark that he was accustomed to better wages. I asked him to be content with less just this once. Outside a car awaited me, which then whisked me away, and so off I drove, and no doubt am still doing so to this day.

Translated by Susan Bernofsky

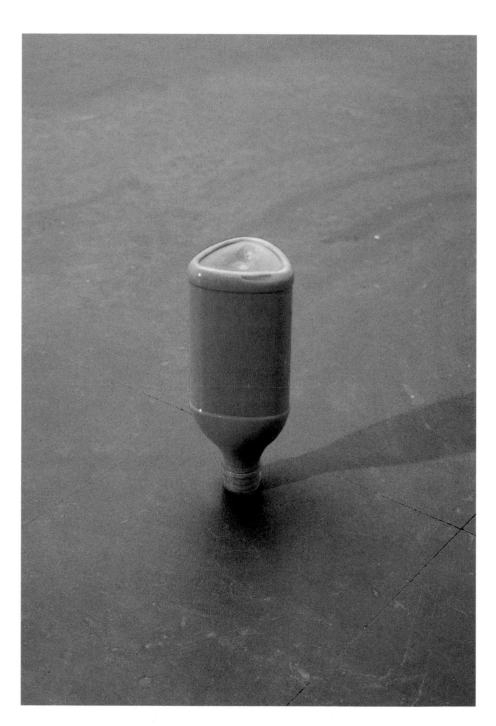

Untitled
1991
Pepto-Bismol, glass jar
h. 23.5, ⌀ 7.5 cm
A container filled with Pepto-Bismol stands upside down on the floor. The weight of the container and the Pepto-Bismol prevents the medicine from escaping.

Untitled
1992
Tube socks
$16.5 \times 76 \times 76$ cm
A construction made with one
hundred and forty-four tube
socks.

EXO-PSYCHOLOGY
The psychology of post-terrestrial existence.

INFO-PSYCHOLOGY
The psychology of the post-industrial society. Precedes and
complements Exo-Psychology.

DIGITAL LANGUAGE OR QUANTUM LINGUISTICS
Thoughts packaged, stored, processed and communicated in
terms of quantitative patterns. H_2O is the digitized (quantum)
expression for lettered thoughts such as 'wasser', 'l'eau', 'aqua',
'water'.

SPACE
The extra-terrestrial universe, the solar system, stars, galaxies
usually defined as material structures.

INFO-SPACE
Our world, the galaxy, the universe defined and measured in
terms of information. The quantum universe of signals, bits,
digital elements, recorded by, stored in, processed,
communicated by electronic knowledge technology, the human
brain and its electronic extensions.

LARYNGEAL-MANUAL (L-M)
Oral, hand-crafted language. The creation of handmade
artefacts and tools. The paleolithic, neolithic and tool-making
(tribal) stages of human evolution which came after hunter-
gatherer and before feudal, industrial and quantum stages.

LARVAL
Early primitive stages of human evolution which precede space
migration and attainment of individual mastery of quantum
technology. LARVAL humans are instinctively, reflexively tied to
collectives; they have not reached the cyber (pilot) states of
auto-thinking. This term is deliberately insolent and
provocative. To label fellow human beings as belonging to
primitive stages of evolution does not insure immediate
popularity. This satirical usage reflects the author's traditional,
Celtic, playful arrogance, here inflated by jail-house blues.

DOMESTICATED PRIMATES
Humans who do not think for themselves. Human beings who
belong to tribes, states, churches, rigid organizations, nations,
industrial societies. The stages which precede individual cyber-
life. This is another typical snide Sufi (Gurdjieffian) barb at
people who do not think for themselves. An 'in joke' not
appreciated by some. (Informative and funny references to DP's
can be found in the following Falcon Press books presented in
the order of snideness, *Undoing Yourself*, *Prometheus Rising*,
Angel Tech and *Breaking the GodSpell*.)

POST-SYMBOLIC
Stages of thinking which use digitized clusters of quanta rather
than lettered words or vocal utterances.

COLLECTIVE
All stages of human evolution which precede individual
independence. Other synonyms: member of HIVE, HERD, FLOCK.
Usually used with satirical intent (see *Undoing Yourself*).

TERRESTRIAL
Stages which precede space-migration and cyber-quantum
thinking.

QUANTUM

The word 'quantum' refers to a bit, an elemental unit. The word QUANTUM used as an adjective indicates that the subject is defined in terms of numbers, clusters of digitized elements, units of information.

QUANTUM PHYSICS OR INFO-PHYSICS

This is contrasted with the mechanical, material physics of Newton which concerned itself with such issues as mass, force, work, energy.

QUANTUM PHYSICS

Defines a universe made up of temporary clusters of info-units, elemental off-on, digital bits.

THE QUANTUM UNIVERSE

Is an INFO-UNIVERSE.

QUANTUM PHYSICS REFERS TO INFORMATION SCIENCE

The decoding of the signals of the universe in the many dimensions of complexity. Whereas the Newtonian universe was composed of apparently solid matter, the INFO-UNIVERSE is made up of data structures.

THE QUANTUM PERSON

Inhabits data-space, lives in Info-Worlds.

QUANTUM PSYCHOLOGY

A synonym for EXO-PSYCHOLOGY. Human thought and behaviour described in terms of the language of numbers, computers, icons.

THE ROARING TWENTIETH CENTURY

Each decade of the twentieth century has witnessed the emergence of information appliances and new communication-art-forms which give humans increasing access to and control of electronic (digital) information.
The quantum appliances include telephones, radio, phonographs, movies, television, portable cassette players, CB radios, home synthesizers, compact discs.

CYBER

The word CYBER comes from the Greek *kubernetes*, pilot. The Heisenberg principle demonstrated that the observer determines (i.e., defines) the realities SHe confronts by the nature of the observational technologies and the maps/models used for interpretation.

THE CYBER-PERSON

Is the individual who understands the Heisenberg principle and accepts responsibility for the realities SHe defines and inhabits. This general principle of Self-Determination has been described for millennia by Hindu-Buddhist-Gnostic-Sufi philosophers. Creative people, writers, artists, poets, dramatists, inventors, innovators, shamans, intelligent magicians have, throughout the centuries, understood this principle. They have used it to fabricate the glories of human culture and science. However, the ability of CYBER-PERSONS to create realities has been limited to symbols, icons, myths, scripts, artistic and philosophic expressions. The Information structures we call art. Until recently human ability to describe quantum realities could not extend to the material plane because of techno-quantum ignorance. Pre-Industrial humans, from philosophers to sultans to serfs, were helpless victims of techno-myopia. The Industrial era tremendously advanced human ability to manage material reality, on the collective scale. It was only in the Roaring twentieth century that humans discovered that the universe is an Info-Structure to be explored and managed by Intelligence, i.e., Cyber-Quantum proficiency to think and build with clusters of digitized thoughts.

CYBER-QUANTUM PSYCHOLOGY

The individual accesses and pilots electronic knowledge technology for his/her own personal purposes. The traditional eight attitudes of philosophy can now be re-defined in terms of CYBER-QUANTUM PSYCHOLOGY.

1. COSMOLOGY: the theory of origins defined in Cyber or Collective terms.
QUANTUM COSMOLOGY: a theory of origins which can be expressed in scientific, quantum, numerical form.
2. POLITIC: a theory of domination, control, freedom, submission defined either in terms of Individuals (cyber) or collectives.

QUANTUM POLITICS: a theory of domination, control, freedom expressed in psycho-geometric coordinates and digital language. See the computer software program Mind Mirror.

3. EPISTEMOLOGY: the theory which defines truth (cyber-individual belief) and fact (collective-social belief).

QUANTUM EPISTEMOLOGY: truth and fact expressed in digital language and quantum physical descriptions.

4. ETHICS: the theory which defines good/evil (cyber-subjective) and virtue/vice (social-collective).

QUANTUM ETHICS: good and virtue defined in the astro-physical language of psycho-geometry.

5. AESTHETICS: a theory defining subjective-beauty and social-art, personal pleasure and rewards from the collective.

QUANTUM AESTHETICS: Beauty, art, pleasure, reward defined in terms of numbers, digits, geometrics.

6. ONTOLOGY: a theory about the nature of reality based on Cyber (personal) or Collective-social attitude.

QUANTUM ONTOLOGY: a theory about the nature of reality defined in scientific, technological, quantum digitese.

7. TELEOLOGY: a theory of evolution, devolution or stasis based on either Cyber-individual or Collective-social attitudes.

QUANTUM TELEOLOGY: a theory of evolution, devolution, or stasis based on measurable indices, quantitative patterns, geometrics.

8. ESCHATOLOGY: a theory of endings, both cyber-individual and collective-social. A person who is not in charge of his own endings probably cannot fabricate a general theory of evolutionary endings.

QUANTUM ESCHATOLOGY: a theory of endings based upon quantification, digitization, geometry.

Untitled
1997
Plastic drinking cup, plastic drinking straws
h. 48.5, ⌀ 111.5 cm
Links of plastic drinking straws made into circular loops cycle through a plastic cup.

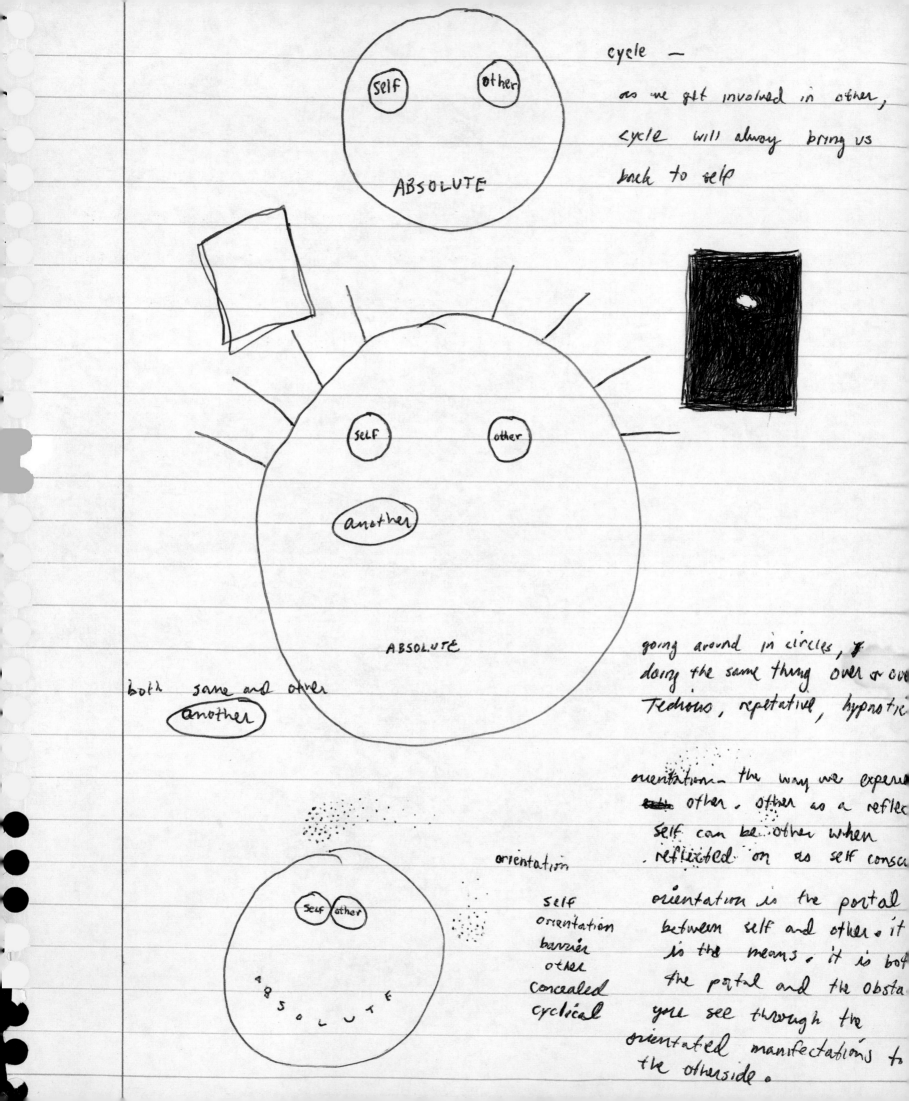

Self Other

ABSOLUTE

cycle —

as we get involved in other, cycle will alway bring us back to self

SELF other

another

ABSOLUTE

both same and other

Another

going around in circles, or doing the same thing over & over. Tedious, repetative, hypnotic

orientation— the way we experie other. other as a reflec Self can be other when reflected on as self consc

orientation

self
orientation
barrier
other
concealed
cyclical

orientation is the portal between self and other. it is the means. it is bot the portal and the obsta you see through the orientated manifestations to the otherside.

Self other

ABSOLUTE

Contents

Ingredients 1990

A) object

1) knowledge

a) name and type of object

b) function

1) what does it do?

2) how is it used?

3) why is it used?

c) history

1) where does it come from?

a) geographic location

b) culture

1) object's history and relevance in this culture

2) where was it made?

3) who made and/or makes it?

4) is it part of a larger object?

5) is assembly required beyond its place of construction?

6) is it handmade, machine-made, or a combination?

7) evolution to its present form?

a) how?

b) why?

8) when was it made?

a) relevance being made at this time

9) what is it made out of?

10) is it unique or are there many of them?

11) property

a) who owns it?

b) why did they get it?

c) when did they get it?

d) value

1) monetary

2) other pertinent gauges of value

e) stylistic references

2) empirical observations

a) physical properties

1) shape

2) colour

3) texture

4) smell

5) sound

6) does it move?

a) speed of movement

b) pattern of movement

3) observations using measuring devices

a) dimensions

b) weight

c) temperature

4) subjective observations

a) what does the object make you feel?

b) adjectives to describe the mood of the object

c) references and associations

d) vulnerability of the object

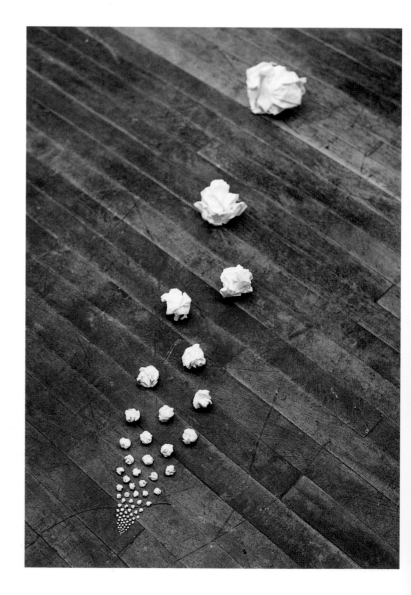

e) status of the object

f) personal value

1) with whom?

2) how and why?

B) place (where the object is)

1) knowledge

a) name of place

b) location of place (address)

c) what is the function of this place?

d) is it part of a larger place?

e) is it unique or are there many like it?

2) history of place

a) how was this place made?

b) who made this place?

c) when was it made?

d) why was it made?

e) evolution of place to present state

f) what materials is it made out of?

3) empirical observations

a) physical properties

1) shape of place

2) colour

3) texture

4) smell

5) sound

4) observations using measuring devices

a) dimensions

b) temperature

5) subjective observations

a) what does the place make you feel?

b) adjectives to describe the mood of the place

c) references and associations

d) status of place

e) personal value

C) observer (looking at the object)

1) knowledge

a) name

b) function

1) biological

2) familial

3) societal

4) cultural

5) spiritual

c) history

1) where do you come from?

a) geographic location

b) culture

2) why were you born?

3) how have you evolved into your present self?

a) growth rate and other physical changes

b) things you've learned

Untitled
1991
Paper
76 × 15 cm overall
An arrangement of consecutively smaller wads of paper on the floor.

Vanishing Point
1996
Wood, paint, eraser, metal, graphite
⌀ 0.6 cm, l. 2.5 cm
A pencil made in exaggerated perspective from a pencil.

c) things that have affected you

4) how were you made?

5) when were you born?

6) what are you made out of?

d) beliefs

1) spiritual

2) political

3) overall view of life

4) all other relevant knowledge and thoughts

e) psychology

f) occupation

2) empirical observation

a) physical properties

1) shape

2) colour

3) texture

4) smell

5) sound

6) movement

3) observations using measuring devices

a) dimensions

b) weight

c) temperature

d) age

e) other measurements such as biorhythm

4) subjective observations

a) how do you feel about yourself?

1) general

2) right now

b) adjectives to describe yourself

c) what is your mood?

D) relating the parts

1) object in the place

a) knowledge

1) why is the object here?

2) when was it put in this place?

3) who put it here?

4) how long has it been here?

5) how long did it take to get it here?

6) how has it changed since being here?

b) empirical observations

1) location of object in this place

2) effects of temperature the object has on place and vice versa

3) other physical effects each has on the other

c) subjective observations

1) how do you feel about the object in this place?

2) adjective to describe the effects the object has on the location, and vice versa

3) how does the object affect this place?

2) observer in this place

a) knowledge

1) why are you here?

below,
Untitled
1995
Ink, coloured pencil on paper
106.5 × 106.5 cm
A cartoon figure from popular culture is drawn in outline hundreds of times in varying sizes overlapping each other. The resulting linear enclosures are coloured in.

opposite, **Untitled**
1992
Marker on paper
21.5 × 28 cm
A piece of paper was folded in half four times. A marker was then held in the centre of the folded paper until it bled through all the layers. The piece is displayed unfolded.

following pages, **Untitled**
1995
Pen on paper
30.5 × 45.5 cm
Starting an old dry pen on a sheet of paper.

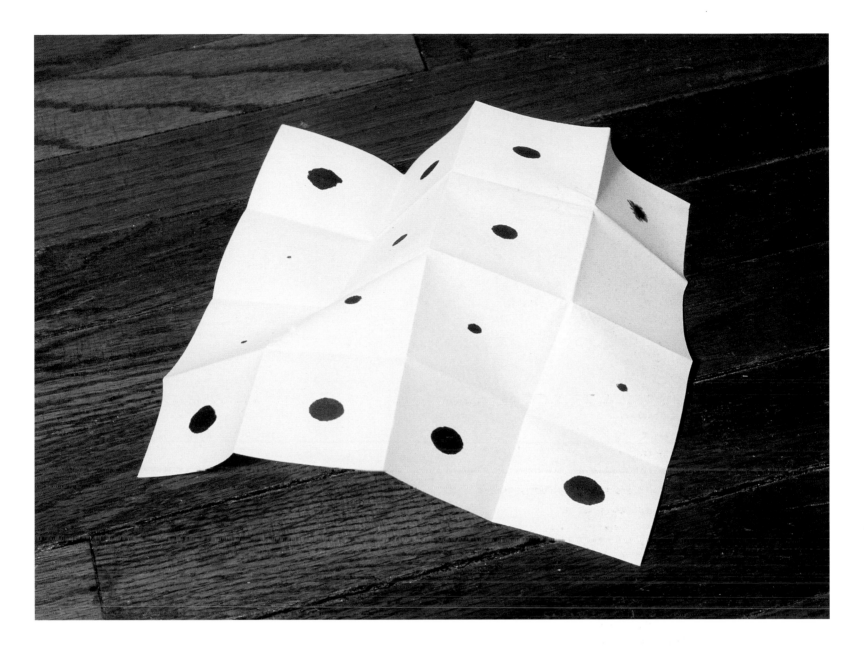

2) when did you get here?

3) how have you changed since being here?

4) have you been here before?

a) when?

b) why?

c) how has your previous experience affected the way you experience this location?

b) empirical observations

1) where are you located in this place?

2) movements throughout the place

c) observations using measuring devices

1) friction

2) effects of temperature you have on the location and vice versa

3) other physical effects each has on the other

d) subjective observations

1) how do you feel about being in this place?

2) adjectives to describe the effects you have on the location and vice versa

3) how does this place affect you?

3) object on observer

right, top, **Untitled**
1998
Paper hole punches from text
⌀ 0.5 cm, l. 98 cm
Paper dots, hole punched from a text, are laminated together to make a long cylindrical dowel.

right, bottom, **Untitled**
1999
Construction paper
21.5 × 28 × 1.5 cm
A pencil made of paper sits atop a sheet of paper at the foot of a wall.

opposite, **Untitled**
1998
Pencils
129.5 × 18 × 23 cm
A long pencil made by connecting pencil sections of varying lengths. It hangs from the ceiling by monofilament; the point of the pencil just touches the floor.

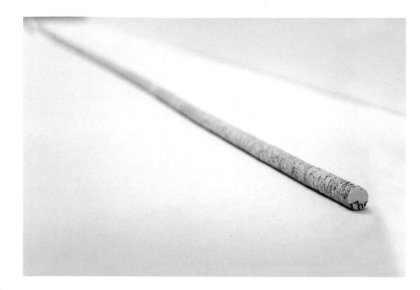

a) knowledge

1) why are you looking at the object?

2) when did you start looking at the object?

3) how have you changed since looking at the object?

4) have you looked at the object before?

a) when?

b) why?

c) how has your previous experience affected the way you experience it now?

b) empirical observations

1) where are you located in relation to the object?

2) movements in relation to the movements of the object

c) observations using measuring devices

1) friction you have on the object

2) effects of temperature you have on the object and vice versa

3) other physical effects you have on the object

d) subjective observations

1) how does looking at the object affect you?

2) adjectives to describe looking at the object

3) how do you feel about looking at the object?

4) do you want to look at the object?

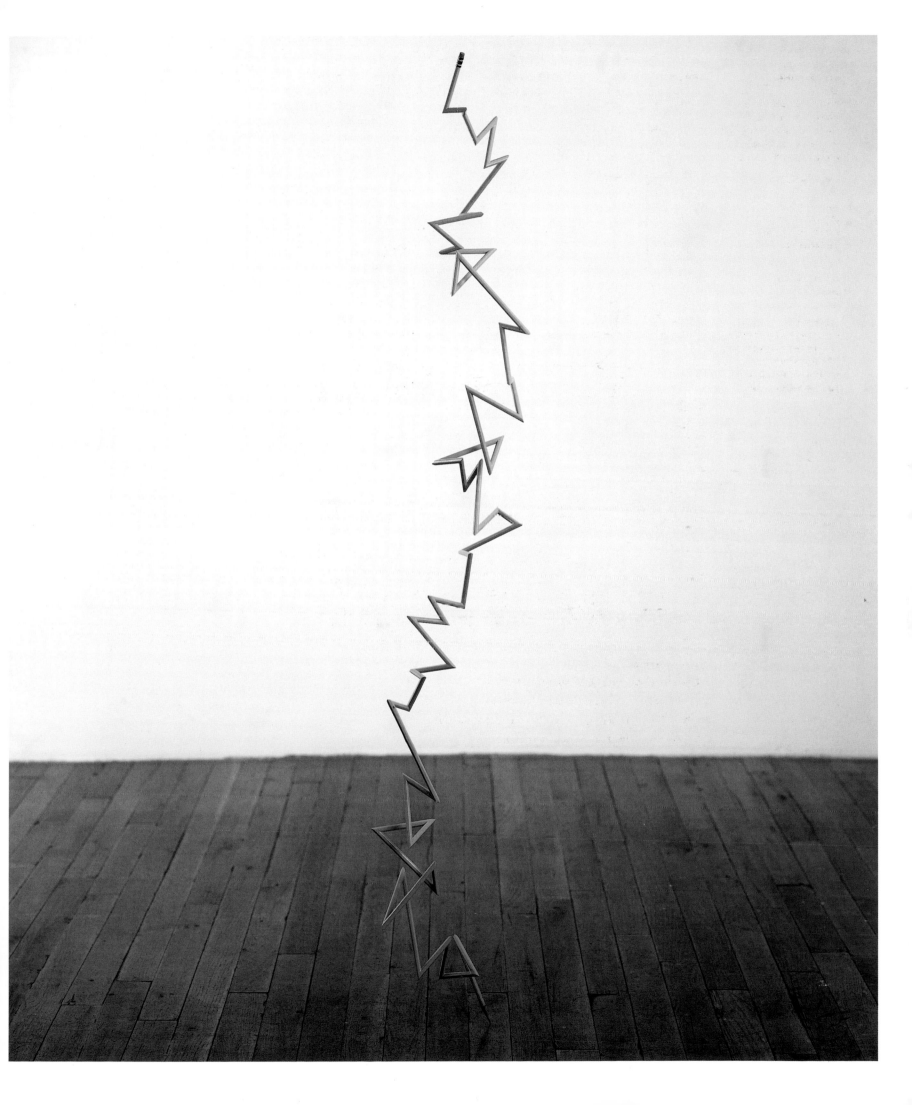

left, **Untitled**
1992
Typewritten text on paper
28 × 21.5 cm
A simulation of the Dadaist piece
in which the Zen mantra 'mu' is
typed numerous times on a piece
of paper. This simulation is
displayed with the typed side
facing the wall so the words read
'um'.

opposite, **Untitled**
1995
Typewritten text on paper
35.5 × 28 cm

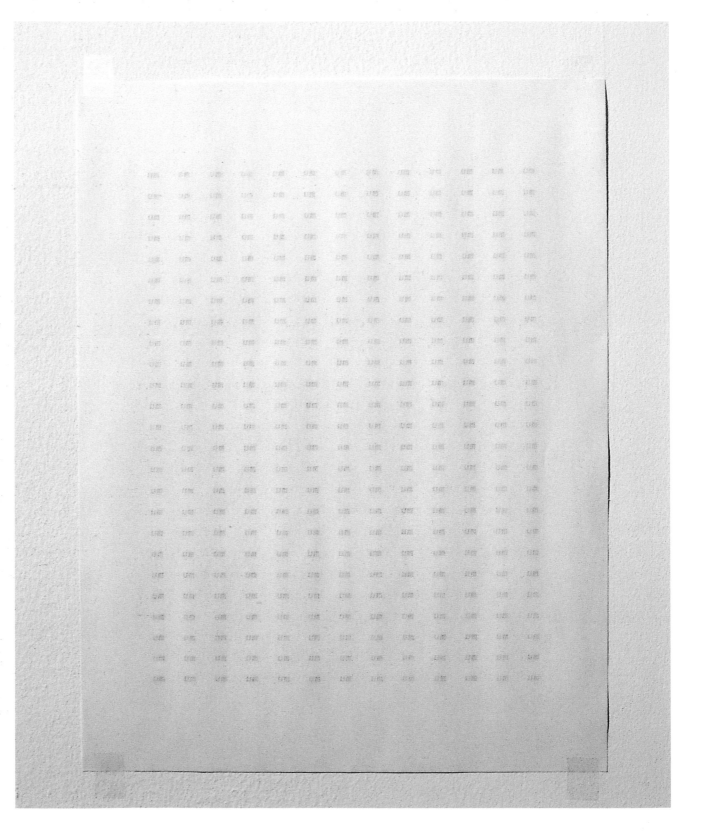

Untitled 1995

```
sssssssssssssssssssssssssssssssssssssssssssssssssssssssssssssssssssssssssssssssssssssssss
sssssssssssssssssssssssssssssssssssssssssssssssssssssssssssssssssssssssssssssssssssssssssss
ssssssssssssssssssssssssssssssssssssssssssssssssssssssssssssssssssssssssssssssssssssssssssss
ssssssssssssssstttttttttttttttttttttttttttttttttttttttttttttttttttttttttttttttttttttttttttt
ttttttttttttttttttttttttttttttttttttttttttttttttttttttttttttttttttttttttttttttttttttttttttt
ttttttttttttttttttttttttttttttttttttttttttttttttttttttttttttttttttttttttttttttttttttttttttt
ttttooooooooooooooooooooooooooooooooooooooooooooooooooooooooooooooooooooooooooooooooooooooooo
ooooooooooooooooooooooooooooooooooooooooooooooooooooooooooooooooooooooooooooooooooooooooooooo
ooooooooooooooooooooooooooooooooooooooooooooooooooooooooooooooooooooooooooooooooooooooooooooo
oooooooooooooooooooooooooooooooooooooooooooooooooooooooooooooooooooooooppppppppppppp
ppppppppppppppppppppppppppppppppppppppppppppppppppppppppppppppppppppppppppppppppppppppppppppp
ppppppppppppppppppppppppppppppppppppppppppppppppppppppppppppppppppppppppppppppppppppppppppppp
ppppppppppppppppppppppppppppppppppppppppppppppppppppppppppppppppppppppppppppppppppppppppppppp
pppppppppppppppppppppppppppppp

                               yyyyyyyyyyyyyyyyyyyyyyyyyyyyyyyyyyyyyyyyyyyyyyyyyy
yyyyyyyyyyyyyyyyyyyyyyyyyyyyyyyyyyyyyyyyyyyyyyyyyyyyyyyyyyyyyyyyyyyyyyyyyyyyyyyyyyyyyyyyyyyyyy
yyyyyyyyyyyyyyyyyyyyyyyyyyyyyyyyyyyyyyyyyyyyyyyyyyyyyyyyyyyyyyyyyyyyyyyyyyyyyyyyyyyyyyyyyyyyyy
yyyyyyoooooooooooooooooooooooooooooooooooooooooooooooooooooooooooooooooooooooooooooooooooooooo
oooooooooooooooooooooooooooooooooooooooooooooooooooooooooooooooooooooooooooooooooooooooooooooo
ooooooooooooooooooooooooooooouuuuuuuuuuuuuuuuuuuuuuuuuuuuuuuuuuuuuuuuuuuuuuuuuuuuuuuuu
uuuuuuuuuuuuuuuuuuuuuuuuuuuuuuuuuuuuuuuuuuuuuuuuuuuuuuuuuuuuuuuuuuuuuuuuuuuuuuuuuuuuuuuuuuuuuu
uuuuuuuuuuuuuuuuuuuuuuuuuuuuuuuuuuuuuuuuuuuuuuuuuuuuuuuuuuuuuuuuuuuuuuuuuuuuuuuuuuuuuuuuuuuuuu
uuuuuuuuuuuuuuuuuuuuuuuuuuuuuuuuuuuuuuuuuuuuuuuuuuuuuuuuuuuuuuuuuuuuuuuuuuuuuuuuuuuuuuuuuuuuuu
uuuuuuuuuuuuuuuuuuuuuuuuuuuuuuuuuuuuuuuuuuuuuuuuuuu

                 1111111111111111111111111111111111111111111111111111111111111111111
1111111111111111111111111111111111111111111111111111111111111111111111111111111111111111111
1111111111111111111111111111111111111111111111111111111111111111111111111111111111111111111
11111111111111111111111111111111111111111111111111111111111111111111111111111111iiiiiiiiiii
iiiiiiiiiiiiiiiiiiiiiiiiiiiiiiiiiiiiiiiiiiiiiiiiiiiiiiiiiiiiiiiiiiiiiiiiiiiiiiiiiiiiiiiiiiiii
iiiiiiiiiiiiiiiiiiiiiiiiiiiiiiiiiiiiiiiiiiiiiiiiiiiiiiiiiiiiiiiiiiiiiiiiiiiiiiiiiiiiiiiiiiiii
iiiiiiiiiiiitttttttttttttttttttttttttttttttttttttttttttttttttttttttttttttttttttttttttttttttt
tttttttttttttttttttttttttttttttttttttttttttttttttttttttttttttttttttttttttttttttttttttttttttt
tttttttttttttttttttttttttttttttttttttttttttttttttttttttttttttttttttttttttttttttttttttttttttt
tttttttttttttttttttttttttttttttttttttttttttttttttttttttttttttttttttttttttttttttttttttttttttt
tttttttttttttttttttttttttttttttttttttttttttttttttttttttttttttttttttttttttttttttttttttttttttt
ttttttttttttttttttttttttttttttttttttttttttttttttttttttttttttttttttttttttttttttttttttttttttttt
ttttttttttttttttttttt11111111111111111111111111111111111111111111111111111111111111111111
1111111111111111111111111111111111111111111111111111111111111111111111111111111111111111111
1111111111111111111111111111111111111111111111111111111111111111111111111111111111111111111
11111111eeeeeeeeeeeeeeeeeeeeeeeeeeeeeeeeeeeeeeeeeeeeeeeeeeeeeeeeeeeeeeeeeeee

                 rrrrrrrrrrrrrrrrrrrrrrrrrrrrrrrrrrrrrrrrrrrrrrrrrrrrrrrrrrrrrrrrr
rrrrrrrrrrrrrrrrrrrrrrrrrrrrrrrrrrrrrrrrrrrrrrrrrrrrrrrrrrrrrrrrrrrrrrrrrrrrrrrrrrrrrrrrrrrrr
rrrrrrrraaaaaaaaaaaaaaaaaaaaaaaaaaaaaaaaaaaaaaaaaaaaaaaaaaaaaaaaaaaaaaaaaaaaaaaaaaaaaaaaaaaaa
aaaaaaaaaaaaaaaaaaaaaaaaaaaaaaaaaaaaaaaaaaaaaaaaaaaaaaaaaaaaaaaaaaaaaaaaaaaaaaaaaaaaaaaaaaaaa
aaaaaaaaaaaaaaaaaaaaaaaaaaaaaaaaaaaaaaaaaaabbbbbbbbbbbbbbbbbbbbbbbbbbbbbbbbbbbbbbbbbbbbbbbb
bbbbbbbbbbbbbbbbbbbbbbbbbbbbbbbbbbbbbbbbbbbbbbbbbbbbbbbbbbbbbbbbbbbbbbbbbbbbbbbbbbbbbbbbbbbbbb
bbbbbbbbbbbbbbbbbbbbbbbbbbbbbbbbbbbbbbbbbbbbbbbbbbbbbbbbbbbbbbbbbbbbbbbbbbbbbbbbbbbbbbbbbbbbbb
bbbbbbbbbbbbbbbbbbbbbbbbbbbbbbbbbbbbbbbbbbbbbbbbbbbbbbbbbbbbbbbbbbbbbbbbbbbbbbbbbbbbbbbbbbbbbb
bbbbbbbbbbbbbbbbbbbbbbbbbbbbbbbbbbbbbbbbbbbbbbbbbbbbbbbbbbbbbbbbbbbbbbbbbbbbbbbbbbbbbbbbbbbbbb
bbbbbbbbbbbbbbbbbbbbbbbbbbbbbbbbbbbbbbbbbbbbbbbbbbbbbbbbbbbbbbbbbbbbbbbbbbbbbbbbbbbbbbbbbbbbbb
bbbbbbbbbbbbbbbbbbbbbbbbbbbbbbbbbbbbbbbbbbbbbbbbbbbbbbbbbbbbbbbbbbbbbbbbbbbbbbbbbbbbbbbbbbbbbb
bbbbbbbbbbbbbbbbbbbbbbbbbbbbbbbbbbbbbbbbbbbbbbbbbbbbbbbbbbbbbbbbbbbbbbbbbbbbbbbbbbbbbbbbbbbbbb
bbbbbbbbbbbbbbbbbbbbbbbbbbbbbbbbbbbbbbbbbbbbbbbbbbbbbbbbbbbbbbbbbbbbbbbbbiiiiiiiiiiiiiiiiiiiii
iiiiiiiiiiiiiiiiiiiiiiiiiiiiiiiiiiiiiiiiiiiiiiiiiiiiiiiiiiiiiiiiiiiiiiiiiiiiiiiiiiiiiiiiiiiii
iiiiiiiiiiiiiiiiiiiiiiiiiiiiiiiiiiiiiiiiiiiiiiiiiiiiiiiiiiiiiiiiiiiiiiiiiiiiiiiiiiiiiiiiiiiii
iiiiiiiiiiiiiiiiiiiitttttttttttttttttttttttttttttttttttttttttttttttttttttttttttttttttttttttt
tttttttttttttttttttttttttttttttttttttttttttttttttttttttttttttttttttttttttttttttttttttttttttt
tttttttttttttttttttttttttttttttttttttttttttttttttttttttttttttttttttttttttttttttttttttttttttt
tttttttttttttttttttttttttttttttttttttttttttttttttttttttttttttttttttttttttttttttttttttttttttt
tttttttttttttttttttttttttttttttttttttttttttttttttttttttttttttttttttttttttttttttttttttttttttt
ttttttttttttttttttttttttt!!!!!!!!!!!!!!!!!!!!!!!!!!!!!!!!!!!!!!!!!!!!!!!!!!!!!!!!!!!!!!!!!!!!
!!!!!!!!!!!!!!!!!!!!!!!!!!!!!!!!!!!!!!!!!!!!!!!!!!!!!!!!!!!!!!!!!!!!!!!!!!!!!!!!!!!!!!!!!!!!!!!
!!!!!!!!!!!!!!!!!!!!!!!!!!!!!!!!!!!!!!!!!!!!!!!!!!!!!!!!!!!!!!!!!!!!!!!!!!!!!!!!!!!!!!!!!!!!!!!
!!!!!!!!!!!!!!!!!!!!!!!!!!!!!!!!!!!!!!!!!!!!!!!!!!!!!!!!!!!!!!!!!!!!!!!!!!!!!!!!!!!!!!!!!!!!!!!
!!!!!!!!!!!!!!!!!!!!!!!!!!!!!!!!!!!!!!!!!!!!!!!!!!!!!!!!!!!!!!!!!!!!!!!!!!!!!!!!!!!!!!!!!!!!!!!
!!!!!!!!!!!!!!!!!!!!!!!!!!!!!!!!!!!!!!!!!!!!!!!!!!!!!!!!!!!!!!!!!!!!!!!!!!!!!!!!!!!!!!!!!!!!!!!
!!!!!!!!!!!!!!!!!!!!!!!!!!!!!!!!!!!!!!!!!!!!!!!!!
```

Notebook Selection
1995
Ink on paper
28 × 21.5 cm

Untitled
1995
Computer printout
27.9 × 21.6 cm

Down
1995
Press-type on paper
181.6 × 23.5 cm (framed)
An alphabetized list of words with
negative connotations taken from
the dictionary.
(*far right, detail*)

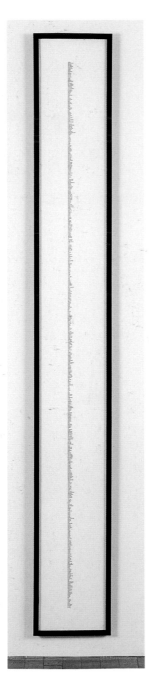

disobey
disown
disparage
disrespect
disruptive
disservice
distasteful
distraught
distress
distrust
disturb
doom
doomsday
double-cross
double-faced
down
downer
downfall
drab
dreadful
dreary
dreck
dregs
drivel
dropout
drudgery
dud
dullard
dummy
dump
dunce
egocentric
egomaniac
ego-trip
elitism
embarrass
embezzle
embitter
enemy
enrage
enslave
entrap
epidemic
eradicate
err
erroneous
escapism
ethnocentric
evict

meaniemoe tigertoe 1995

Untitled
1992
Wooden school chair
86.4 × 55.9 × 55.9 cm
Hundreds of holes drilled into a
wooden school chair.

**meaniemoe tigertoe
hollers, GO meanie moe!**

mysaidyou, 'NOT'.

Robert Storr [... The] relation of microcosm to macrocosm to your work is particularly evident in the way the generally small pieces you make draw one's attention in the large empty studio or gallery space in which one finds them. They almost seem to exert a kind of gravitational pull on the scanning eye.

Tom Friedman **A lot of my work is very focused and very centred. It defines some sort of vicinity. Like the spaghetti piece (*Loop*, 1993–95, see page 35), which is a continuous loop that moves around and establishes an area.**

Storr Is the same thing true of the construction paper piece (*Untitled*, 1993–95)? How did that come into existence?

Friedman **It started with a single pyramid. Then another pyramid was placed on that, and another. So it grew from a central point. The piece is about that outrageous growth.**

Storr Am I correct in supposing, then, that the piece is internally articulated according to a consistent, almost crystalline logic? It's not solid, but it is built up throughout by the same basic unit.

Friedman **Exactly. It's not a facade; its structure is determined by its principle of growth.**

Storr When you set out to make such a thing, is there any rule that decides when you stop the process, or that sets an outer limit to a given object's size?

Friedman **Usually the process or the material dictates a very clear limit. For example, the *Loop* was made out of a standard one pound (435g) box of spaghetti, and the dictionary piece (*Everything*, 1992–95) used every word in the dictionary. So there were predetermined limits. As far as the construction paper piece goes, I think the dimensions had to do with the relationship I felt between me and it, and from there I calculated the size of the uniform elements that composed it. In its final state I wanted the surface to be as confused as possible, with all sorts of protrusions coming off of it.**

Storr Do you mean that you wanted it to be defined not by its shape, which is impossible to hold in the mind, but by its principle of construction, which is easy to grasp?

above, **Untitled**
1993–95
Construction paper
117 × 89 × 84 cm
A mass constructed with triangular sections of construction paper glued together. It was made by building outward from one triangle.

opposite, **My Foot**
1991
Wood, press-type
26 × 2.5 cm
A replica of a ruler made from the artist's memory.

Friedman **Right. It's not a form that can be remembered, except in a generalized way. It's not like a cube or something of that kind. It's really a question of looking at a specific material and finding a logic that informs it, how it's altered, and how, finally, it is presented.**

Storr The first things of yours I saw – for example, the identical twin pieces of crumpled paper (*Untitled*, 1990) or the bar of soap with a hair spiral (*Untitled*, 1990) – were simple in appearance compared to some of the more recent works that are in this show ('Projects 50: Tom Friedman', The Museum of Modern Art, New York, 1995). Is there a conscious shift taking place in your approach that explains that impression, or am I mistaken?

Friedman **I've been thinking a lot about complexity lately. I know that it is something that has been thought about before, but what interests me is my inability to process everything that I'm confronted with and the idea of the whole. That explains how I got involved in dealing with the dictionary; how individual words fit in and the sheer quantity of them. What unifies what I do is the phenomenon of taking something that is crystal clear to me, something I seem to know, and finding that the closer I get and the more carefully I inspect it, the less clear it becomes.**

Storr Take the ruler piece, for instance. What could be more straightforward than that – if, that is, one can trust one's eyes?

Friedman **I've dealt with standards before, because they ground us or orient us and make it possible to connect with things in a certain way. The ruler piece is called *My Foot* (1991) because it was my idea of a foot, and because that's what people say when they think you're not telling them the truth: 'My foot!' After all, there was something not true about it.**

Storr The map piece also makes one question one's bearings.

Friedman **I have been working on the map piece (*Untitled*, 1991–94) for quite a while. I was thinking about how I would orient myself if I were hovering over the earth but facing it in such a way that the South Pole was up and the North Pole was down.**

Storr The dust piece (*Dustball*, 1994) in this show also has the look of a planet viewed

Artist's Writings

right, top, **Kiki Smith**
Tale
1992
Wax, pigment, papier-mâché
58.5 × 58.5 × 406.5 cm

right, bottom, **Robert Gober**
Untitled (Leg with Candle)
1991
Wax, cloth, wood, leather, human
hair
34.5 × 18 × 95.5 cm

opposite, **Untitled**
1991–94
Acrylic, press-type, ink on paper
43 × 59.5 cm
A map of the United States in
which the states are represented
upside-down and their names
right-side up.

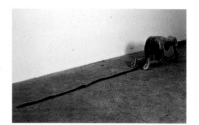

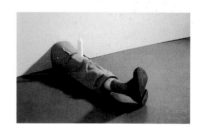

from a great distance, though actually it is very down-to-earth in every respect.

Friedman Well, that came about because I'm developing allergies, and in order to alleviate them, I've had to do a lot of vacuuming. So the material was just around.

Storr I was once told that something like 70 per cent of household dust is flaked human skin.

Friedman Yes, something that interested me in pursuing the piece was the idea that much of us is falling apart and we are tending towards this different sort of unity.

Storr Though you've shied away from the kind of direct figurative representation that one encounters in the work of Kiki Smith, Robert Gober and others, the dust piece, like the spiralling hair on the soap bar and the rolled speck of faeces on a pedestal, all refer to corporeal shapes, substances and functions.

Friedman The obvious associations are in terms of the body, and of cleansing, sanitation and things involving materials associated with personal hygiene. But as I began transforming these materials, they always evolved into something geometrical or structural. That geometry got me thinking about minimalist aesthetics, ideas of immediacy and purity of form.

Storr So, as with the tension between microcosm and macrocosm, the work also points simultaneously in two aesthetic directions: towards the mundane, like an assisted readymade, and towards the ideal.

Friedman Yes, that is part of it, that relationship between those base materials and what is thought of as an art object.

Storr Are you teasing the viewer or the art system, or is there another motive involved?

Friedman Well, if you approach things from the perspective of serious art dialogue, then I guess it can be seen as a tease. But if it is approached in terms of how somebody can take something base and make it into an object that can carry significance, then it is not so negative.

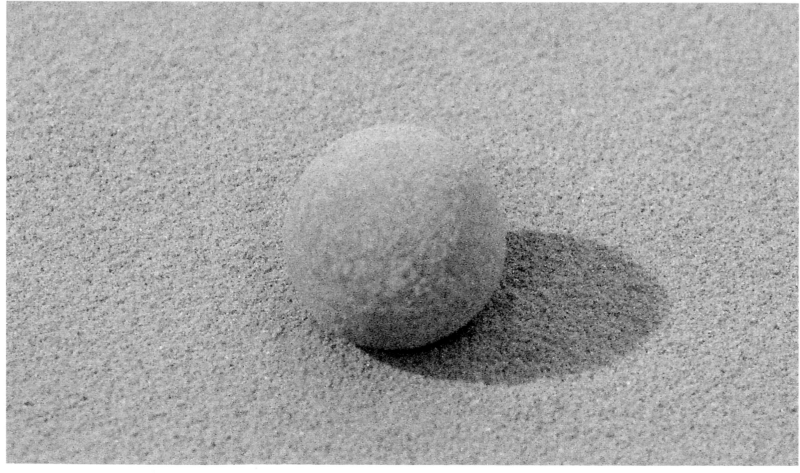

Dustball
1994
Dust
Ball, ⌀ 2 cm; dust ground, ⌀ 91.5 cm
A 2 cm diameter ball made of house dust sits on a ground of sifted dust.

Storr Do you think about your work primarily as a set of discrete objects or are they always considered as parts of a larger ensemble or constellation of ideas and forms? Or, put another way, does the work's installation affect its meaning?

Friedman If I'm presented with an image, let's say a cityscape, and while I'm looking at it someone says to me, 'blue sky', I'll automatically look at the blue sky. And if they said, 'street cleaner', I'd look at that. I think that's how the pieces function off of each other. The experience of one defines how you approach the next.

Storr But in the end, isn't it the confrontation with the individual form or image that counts most?

Friedman For me it's not just a formal game. Or if it is, it's not dealing so specifically with the physical elements, but instead with the idea. So I think in terms of how they reveal themselves to the viewer. My interest is in how things categorize information, and how one deciphers an object. It revolves around the questions that you ask, and how you process all that information and come to some kind of conclusion. The way that I began thinking about the work, then, was as a direct line of questioning that you go through when you are presented with something unfamiliar and think, 'Well, what is it? How is it made? Why is it like this?' What's most specific to me is that process of discovery.

Projects 50: Tom Friedman, brochure, The Museum of Modern Art, New York, 1995

Notebook Selection

1997
Ink on paper
26.5 × 20.5 cm

Untitled
1997
Ink on paper
137 × 108 cm
A drawing made of an
accumulation of dots connected
by lines and arrows.

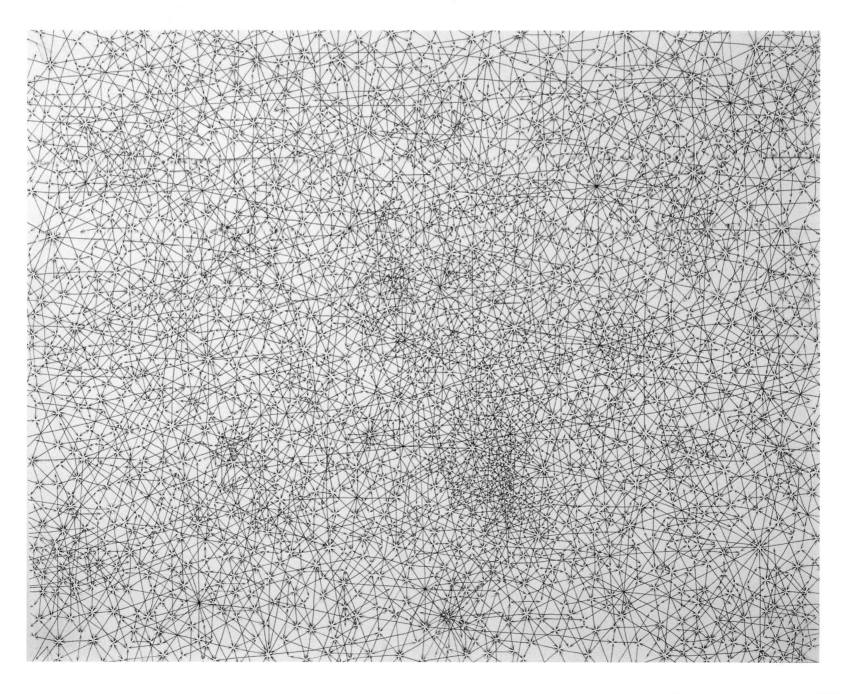

A few years after a machine was invented that could stop time in a designated space, like all other technological advancements, it was directed towards practical applications. Refrigerators incorporated this technology. These refrigerators were large boxes in which you put your food and then set the time inside to stop. Food could thus be made without any preservatives and the amount of waste would dwindle to roughly nothing.

But parents abused their refrigerators when they found out they made great baby-sitters. When parents could not find a sitter, they put their kids inside. For the kids, the door just closed then opened immediately. For the parents, they could have a night on the town, or go on a week-long vacation. The growing age gap between parents and their children became rather problematic.

I want to be clear. You are you. There is a flat field of nothing but short green grass as far as you can see, thus the horizon is a slow blend from green to blue. Although the sky has midday light there is no sun. The only thing in the sky is a speck that your eyes strain to see, moving almost imperceptibly slowly. This speck, though, was never there. It left without changing anything: not even your memory. The only remnant is a gentle tingle in the very tip of your forefinger. It is dissolving like Alka-Seltzer; flesh-toned bubbles of varying sizes rise absolutely vertically into the sky, the most direct path to what seems to be a hunger.

You have been here for a million years. Although your memory has no hard facts to justify this, this is you in every way. You look around and see many things. You get up to walk. You pick up something small and listen to the sounds. You find your youness in the very centre of you with arrows pointing to that point. You follow the arrows to that teeny-weeny, itty-bitty spot. You are there only for a wink because the arrows extend through the spot, out onto the other side, growing uniformly in every direction, and you follow them. You are stretched to a point where your visions begin to haze and the connections you have constructed fray to break and pop apart.

There is an outrageously monstrous tree. It is a tree that would be if a pencil was a seed. Through some branches of pencil points, within the sky, a friendly face appears. In appearance it is the size of your fingernail. It smiles and writes a word into the air. As you move to get a better look it notices you by opening its face a little more. It is so happy to see you. It understands you by showing a solace grin. It is acknowledgement. It faces you and when you walk it follows you. It begins to

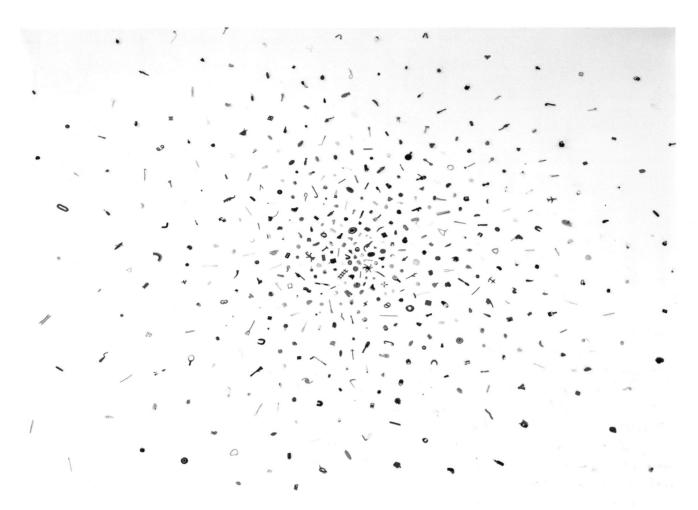

Untitled (Small World)
1995–97
Play-Doh
⌀ 183 cm
An arrangement of things made
with Play-Doh.

tell you about this place. Every word it speaks fills you with warm air which your body welcomes naturally. As you fill you feel all the memories and complexities of being simplify into a clear expression of wanting to expand equally in every direction. Your being is the thin translucent film of a blown balloon and you have but one direction: to rise. The grass becomes green, the green becomes a circle, the circle becomes a sphere, and the sphere becomes a speck. It is now silent and you have no thoughts because the tension of your skin does not permit such things. Your intention is only to be pulled along.

It is the year 8752, a special year. From now, I mean, where you are, and from every instant, and from every atom, there is born a new world (from which the same is born), bifurcating to two and each leading to its own particular set of happenings. But to single out a world is impossible, because when you wink (it is said) you find yourself in a new place (complete with identity and memory, a false sense of continuity). There is a residue from world to world. It has been called the soul and, like a piece of gum being pulled apart, the connecting thread becomes invisible, tenuous, and can be argued to be nonexistent.

8752 is a special year in that it is the sole world left in time. All the others have regressed back to singularity, and I cannot plot this phenomenon because it is the birth, life and death of complexity. This place is the tip of everything, but more importantly, the tip of consciousness, and more specifically the leading edge on this tip (which looks like a pyramid). You go to touch its peak. Your finger is five inches away, three inches, one … within this inch there is a flood of winks, building to compress time to a point; from before your intention to touch, from your shoulder, arm, hand, finger, the leading atom of your finger, to the impossible, yet naturally constructed instant of contact: a silent pop.

Installation view, artist's studio,
Conway, Massachusetts, 1998
l. to r.,
Untitled
1998
Paint, wood
58.5 × 19 × 14.5 cm
A self-portrait of the artist made
with 0.6 cm wooden cubes
painted white.
Cloud
1998
Polystyrene (hard insulation)
30.5 × 61 × 61 cm
Light blue polystyrene insulation
is cut to 0.6 cm square dowels of
varying lengths and connected at
right angles to form a continuous
loop. The structure hangs from
the ceiling by monofilament, 122
cm off the ground.

Hudson After choosing to move quite literally to a house in the woods, why build your studio with no windows and a windowless door?

Tom Friedman **It's strange walking from the lush green into this sterile space to work. In all the studios I've had, I've covered the windows with a wall. It's a way of simplifying the space, which helps me to see how my work is reading.**

Hudson It feels like a laboratory.

Friedman **Yes exactly. I play both the scientist and the experimental subject.**

Hudson That blurring represents one of the humorous and pleasurable experiences I have had with many of your works. My concentration as a viewer attempting to grasp one of your works is mirrored in the physical concentration of the object. When that begins to happen I find myself being absorbed by the work in such a way that one or the other of us is going to disappear – it into me or me into it. Does that happen for you and is that something you play with?

Friedman **For me, as the maker of the object, I experience this phenomenon more in**

theory because I'm involved in constructing this phenomenon. My attention is focused on the structure of my experience with the object. I think about the object as a catalyst, like a pill causing a complex physiological reaction. I see the object sparking a complex system of references. I try to orchestrate those references so there is a play back and forth between the object inviting concentration and absorption, and the object being diagrammatic for that phenomenon.

Hudson Diagrammatic objects, the making and use of a model: what's your attraction to that *modus operandi* rather than, shall I call it, representation?

Friedman **Diagramming is a more specific type of representation. The diagram explains the way things work and clarifies the relationship between the parts. But this is not an overt reference to my work; this is how I think about my work. Thinking about it diagrammatically helps me to manage its conceptual structure, which is one of the connecting threads between my seemingly disparate works.**

Hudson Do you remember having had a specific experience that gave you the understanding of the way in which many seemingly disparate things are also all simultaneously permeated by the same structure?

Friedman **I can't remember a specific experience or time when I realized this. It seems to have been, and still is, a slow, deepening process. For me it began as an intellectual process, but it is evolving into an emotional understanding.**

Hudson It's a Mobius strip; many of your works offer us that. Was *1,000 Hours of Staring* (1992–97) instrumental in this development?

Friedman **I think so. Because I have been working on it for so long, it's been this constant through a lot of change. It became a meditation on a lot of different things in my life. One of my interests in this piece was to create some kind of communal experience by unifying my process with the viewer's process. Looking is the primary activity surrounding one's experience of a piece of artwork. It seemed to make as much sense to use a stare as any other material.**

Hudson Will and belief also seem to be a big part of this object and are often a

considerable element in many of your works. What are your interests in this kind of thinking?

Friedman **I started *1,000 Hours of Staring* at about the same time I did the *Untitled (A Curse)* (1992) in which I had a witch curse a spherical space above a pedestal, and the piece *Hot Balls* (1992), where I stole a bunch of balls from various stores. At that time I was thinking about how one's knowledge of the history behind something affects one's thinking about that thing. While going though the process of giving these objects a history I thought about documenting this process in order to make things more believable. I decided not to because I liked how the idea of believability created in the object a line between the ordinary and the fantastic. I wanted to finish *1,000 Hours of Staring* for this body of work because I liked how its tinge of fantasy worked with other ideas of fantasy I have been thinking about.**

Hudson From the photos you sent me, it seems that this body of work could have something to do with the way fantasy may intrinsically be involved with thinking and reasoning, with the creation of reality or even nature. Like the line between inner and outer, the differentiation between fantasy and the empirical becomes increasingly difficult to distinguish.

Friedman **I'm interested in how that phenomenon affects the way one comes to a conclusion about something. Rather than the conclusion being resolved, it remains a question, thus becoming something you look through to other things. My interest in fantasy is also in how it opens things up for me. It's the difference between a strict methodology and invention. In the last several bodies of work I've done a drawing which can serve as a very generalized diagram for my thinking surrounding that particular body of work. The drawing (*Untitled*, 1995) from my last show at Feature was done using several simple rules. These rules serve as both camouflage and logic, and the piece revealed and described connections between the simple and the complicated. The drawing in this current body of work (*Untitled*, 1997) describes a structure which alludes to invention and fantasy.**

Hudson What's that space station-like sculpture (*Space Station*, 1997) made of?

Friedman **All sorts of stuff that I found in my house, glue and white spray paint.**

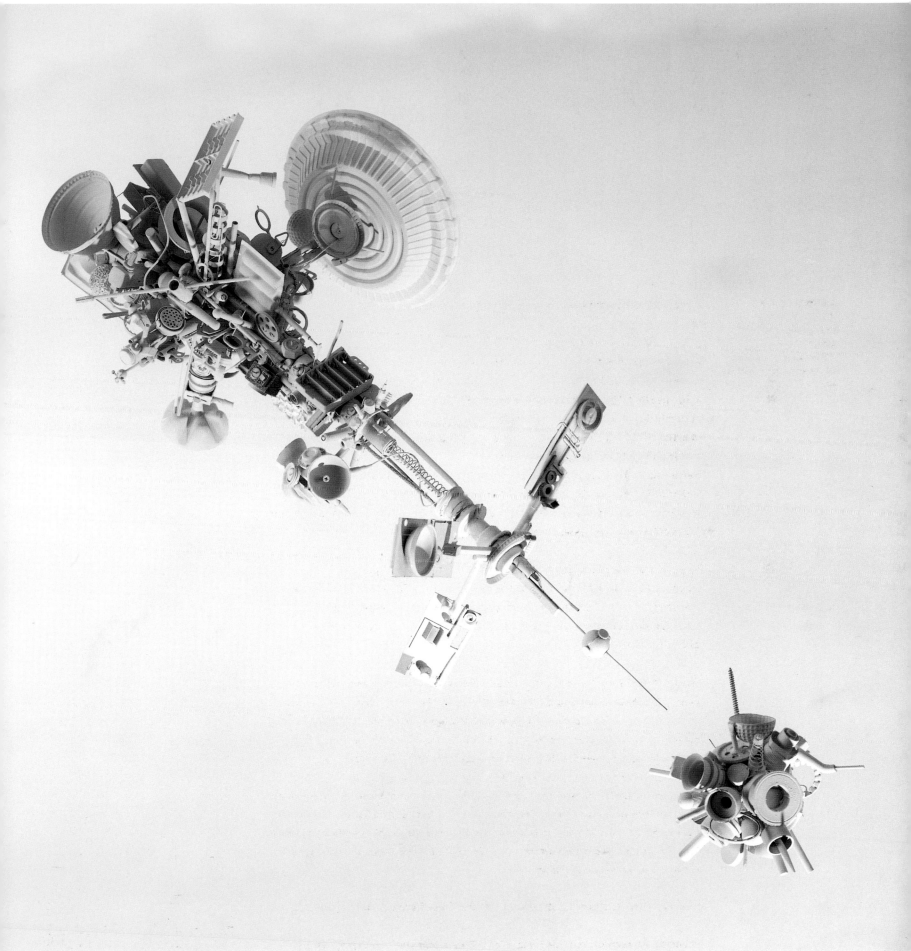

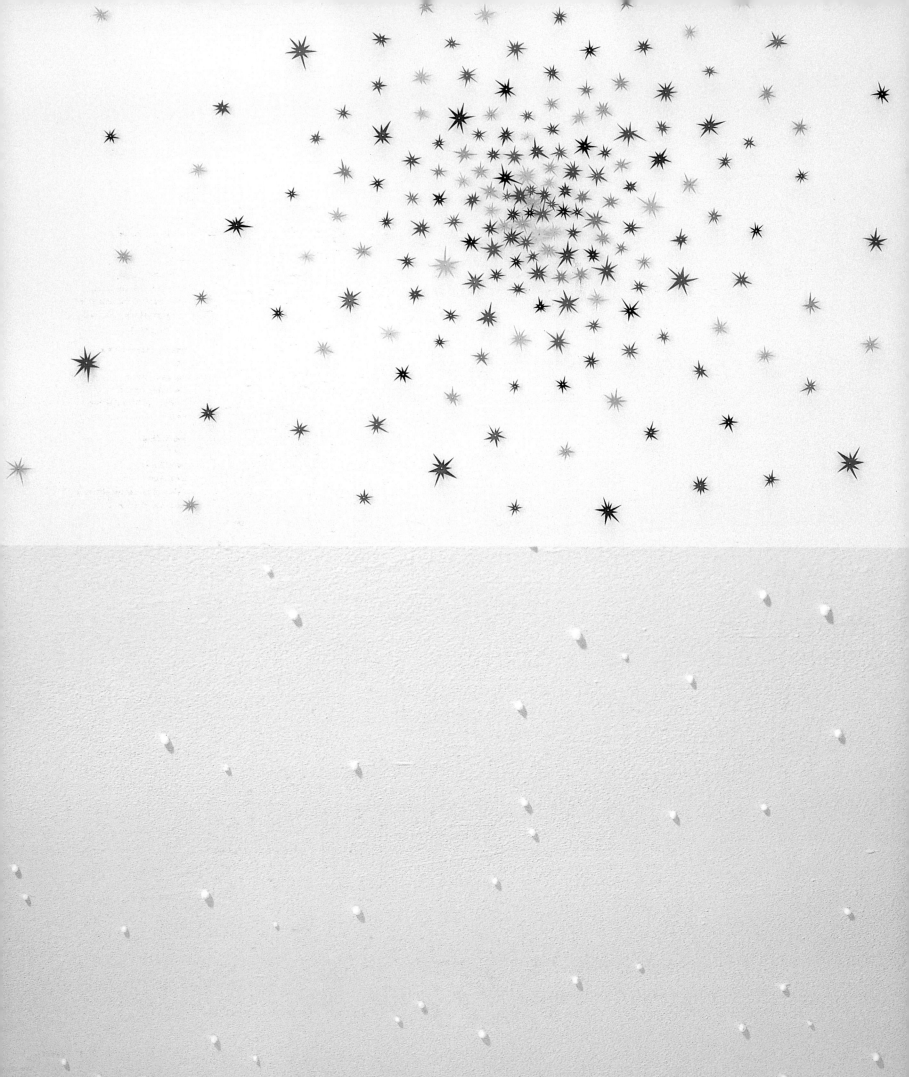

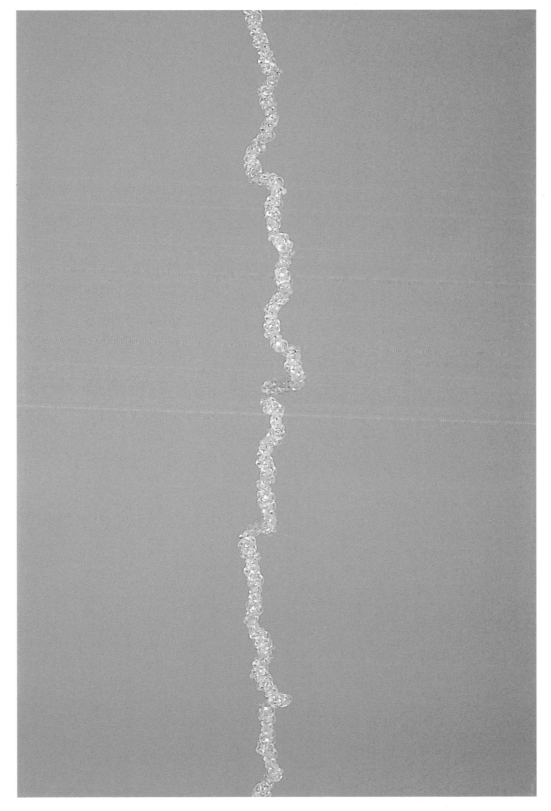

opposite, top, **Untitled**
1996
Paper, pins
Dimensions variable
A wall installation made with
hundreds of stars cut from paper.
Each star is affixed to the wall,
floating by a pin.

opposite, bottom, **Untitled**
1997
Styrofoam on wall
Dimensions variable
Styrofoam pellets affixed to the
wall.

left, **Untitled**
1997
Monofilament
l. 406.5 cm
A chain of knotted monofilament
hangs from the ceiling.

left, top, **A Piece of Paper**
1992
Paper, pedestal
785 × 28 × 21.5 cm
A standard 28 × 21.5 cm piece of
paper sits atop a pedestal the
exact same colour and size as the
paper.

left, bottom, **Untitled**
1992
Torn paper, pin
59.5 × 21 cm
A piece of paper has been torn
down to its last fibre. The fibre
connects the two halves very
tenuously. It hangs on the wall by
a pin.

opposite, **Untitled**
1997
Paper
28 × 21.5 × 1.5 cm
A 21.5 × 28 cm sheet of paper was
cut and curled.

Hudson I wish I could take that answer as silly, but somehow it rings true. Do you think of things in general, from humans to cars to plants or planets, as being made from the happenstance of what's on hand?

Friedman **It's more that I begin with what's on hand, or what I know. I think everyone looks at things based on what they know. Even things that are unfamiliar, they translate them into something they can understand. I like to have a foundation of the familiar to depart from and build onto, which is why I start with the ordinary. This idea or assumption of ordinary tends to be in the form of the material or the representation. Personally, I'm not quite sure what the ordinary is.**

Hudson Exactly. With a little bit of unprejudiced examination, most everything is extraordinary, if not ornate. These new works, in comparison to those of your last few exhibitions, seem richer that way. Your choosing to represent the dragonfly (*Untitled*, 1997) typifies that idea.

Friedman **Especially when it plays off my housefly sculpture (*Untitled*, 1995). For me it's like the fly mutated into the dragonfly.**

Hudson Mutation appears to be one of your growing concerns?

Friedman **In my past work my ideas about change have been more about transformation: the material's transformation from what it is into something different. The ideas surrounding mutation and deviation are interesting to me not only in that they inform the transformation of materials, but also in how they inform a change and departure within each different branch of my investigation. One vantage point I take on my work is to look at it chronologically. Each piece I make has the potential to use that history I've established. If I use a piece of paper, to me it becomes connected to a history: a piece of paper poked by a pin as many times as possible without ripping the paper apart hangs on the wall by the pin that poked it (*Untitled*, 1991); two identically wrinkled pieces of paper (*Untitled*, 1990); a piece of paper ripped in half down to its last fibre (*Untitled*, 1992); *A Piece of Paper* (1992); *In Memory of a Piece of Paper* (1994). My work has always been involved in connecting diverse ideas and forms together. The different ideas that I explore within a body of work range from ideas that opened things up for me, to unifying ideas that connect my disparate branches of investigation.**

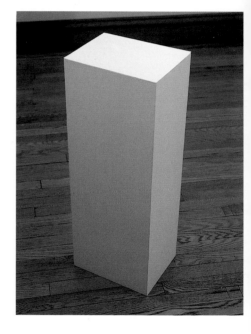

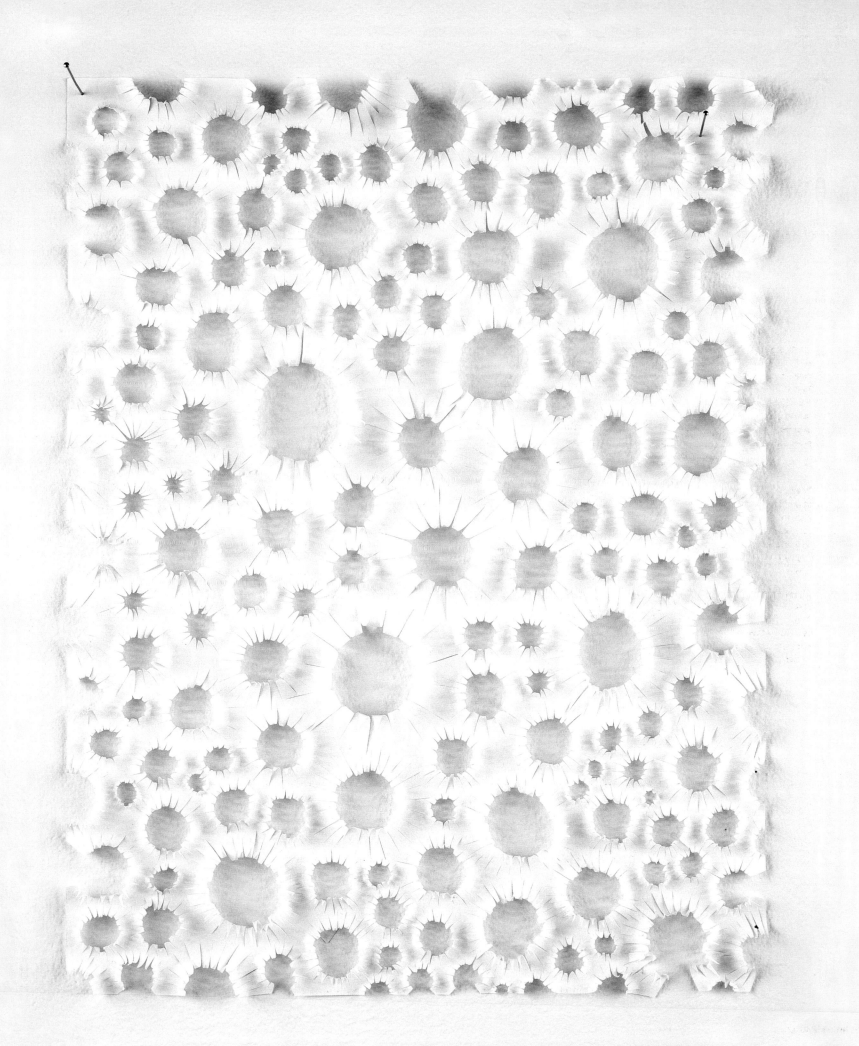

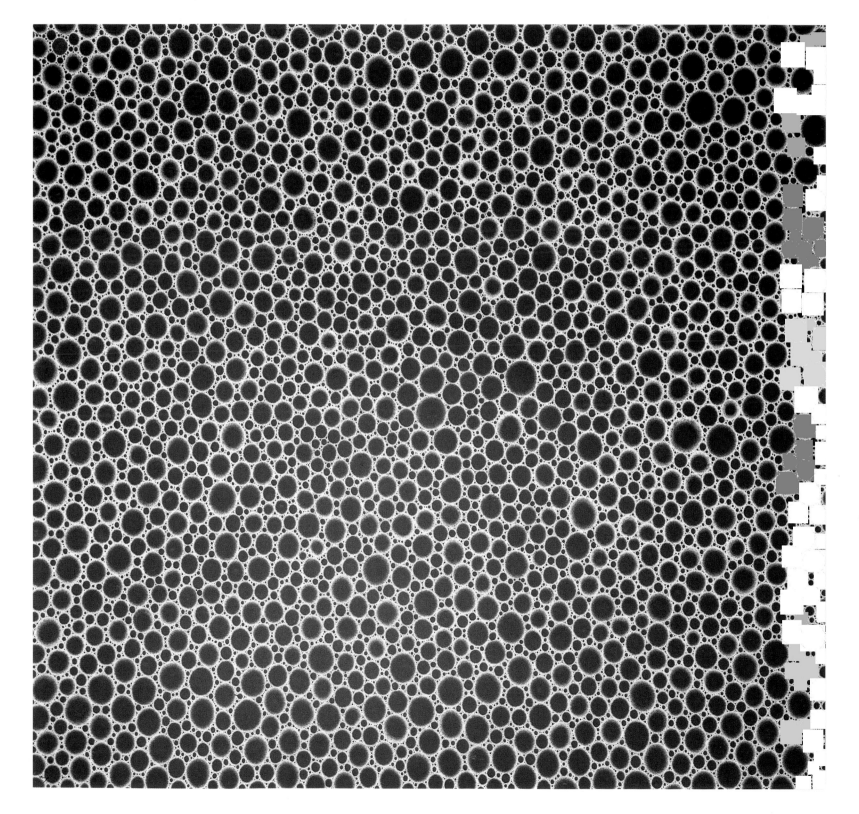

opposite, **Untitled**
1997
Marker on paper
76 × 81.5 cm
A field of varying sized dots made
with a black marker. Each dot is
made by placing a marker on the
paper and allowing it to bleed.
The larger the dot, the longer it
was left on the paper to bleed.

right, **Untitled**
1991
Tennis ball fuzz
⌀ 91.5 cm
Fuzz from a tennis ball is rolled
into fuzzballs and arranged on the
floor.

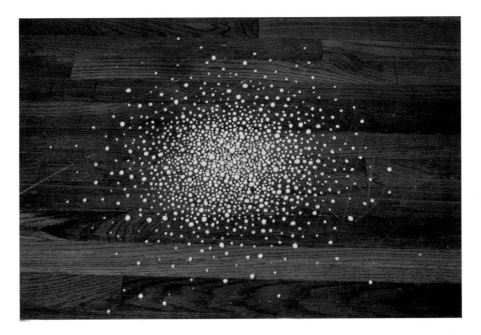

Hudson Many people refer to the obsessive nature of your work, but it seems more about
the way that repetition and classification allow something to transform?

Friedman **Yes. These elements also make it more about a closer and closer investigation
inside of something, like looking into its molecular make-up.**

Hudson Haven't you moved further away from the use of synthetic systems of
organization to more organic or inspired systems?

Friedman **I like the thought of breaking something down further to find its ingredients.
The ingredients are building blocks. Finding that place is like an intersection of
possibilities.**

Hudson And then you begin building?

Friedman **It's hard to say where the building and breaking down happen. Sometimes
they happen simultaneously. They each seem to rely on the other. But I think moving to
more organic systems of organization comes from allowing myself different kinds of
blocks.**

Hudson When you begin working towards an exhibition, do you have a specific vision or
intention in mind?

Friedman **A very general vision.**

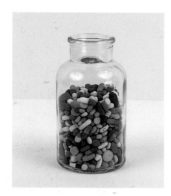

Hudson Conceptually or visually?

Friedman **Conceptually and visually.**

Hudson On a number of occasions you've used the word 'backdrop'. What's its significance?

Friedman **It came from thinking about some deep-seated assumptions. I was using the word 'backdrop' as something that directs one's reality of another thing, like being asked to think of an umbrella politically while standing on your head.**

Hudson Art being a backdrop for ideas?

Friedman **Yes. It's very liberating to think about, and work from, what's most basic.**

Hudson Personal consciousness as landscape?

Friedman **Laboratory and playground. I imagine a collective mental space, where all potential lies in the ability to construct a thought.**

Hudson That brings me to the manners of representation: how art can be a representation – a backdrop – and how representation is cosmology. You frequently use a display of quantity as a way to indicate this, as with this explosion or implosion of pills (*Untitled*, 1997).

Friedman **Each pill is made out of clay using a Physician's Desk Reference manual. I represented the pills to create a bridge between the visual, the physiological and the conceptual. In this piece, I was taking the idea of consuming art, as a metaphor for experiencing art and its ensuing effects, to an extreme. I see this piece being like a demolition ball and a spark plug.**

Hudson What is it you enjoy about those leaps of faith?

Friedman **When I describe things, my vantage point tends to keep shifting on me.**

Tom Friedman, brochure, Feature Inc., New York, 1997

left and opposite, **Untitled**
1997
Play-Doh
Dimensions variable
Pills pictured in the *Physician's Desk Reference* made from Play-Doh.

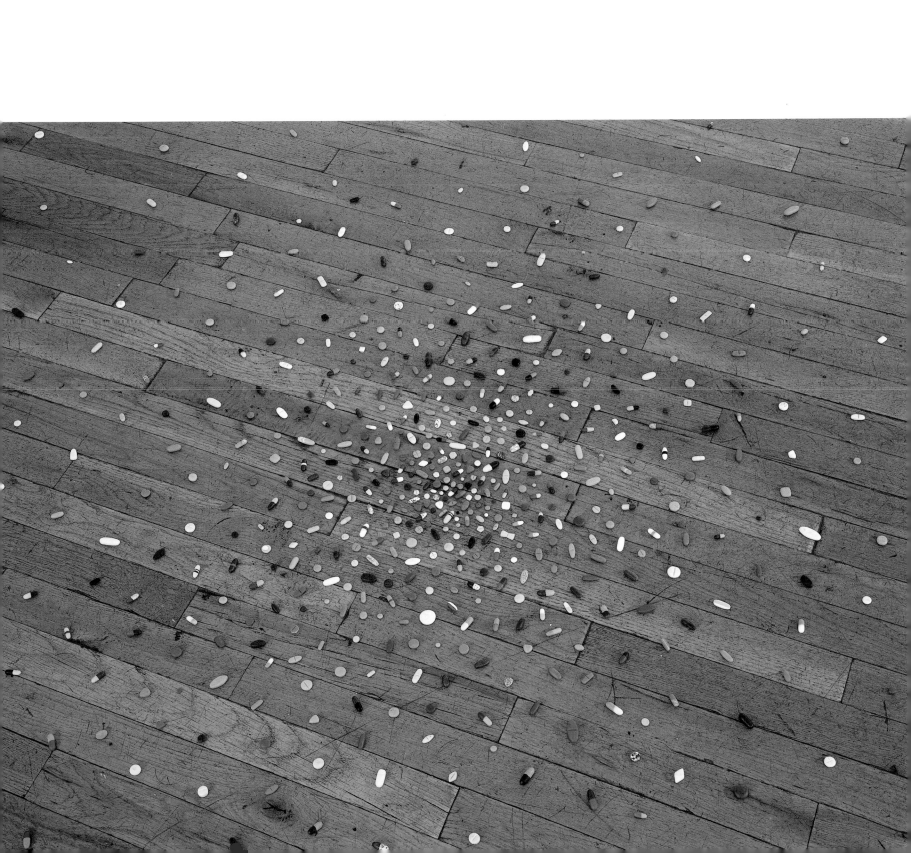

1. faster computer's memory storage. retrieval and processing more efficient.

2. worldwide web increases in volume and complexity. search and navigation through web improves. with faster computers able to store, retrieve and manipulate larger amounts of information, navigation through web becomes more immediate.

3. faster computers enable more immediate and complex 3-D image construction and manipulation. standard commercial computer has processing power to construct, manipulate and navigate through fairly detailed VR (virtual reality) spaces. sites on the web begin to incorporate VR formats. vicinity becomes term for VR-site. city standard web vicinity format.

4. developments in image recognition leads to 3-D scanner technology. 3-D scanners look like hand-held video cameras. 3-D motion scanner.

5. basic manipulation of objects in VR-spaces. technologies directed towards programming and hardware for object manipulation.

6. stereoscopic monitors developed to solve problems of spatial reference in VR spaces.

7. standard commercial computer has processing power to construct, manipulate and navigate through highly detailed VR-spaces, stereoscopic eye ware replaces monitors for internet navigation.

8. technology directed towards constructing virtual presence in VR-space. programs developed that allow customizing of VR-bodies. sensory body suits developed to more accurately manoeuvre VR-bodies. an elaborate array of armatures offer resistances to simulate real space movement and to sustain muscle strength.

9. sensory implants become available; unpopular due to body violation, mostly used by internet cults.

10. technology directed towards extending time spent in VR-space. first person to spend one year in VR-space.

11. science of neuromapping leads to neuroreconstruction and neurocosmetics. artificial enlightenment (enlightenment achieved through neurocosmetics) becomes a fad.

12. sensory explants developed. this technology evolved from the discovery and research into mental wave or m-wave emissions. struggle between technologies of neural violating (brainwashing) devices and neural security systems.

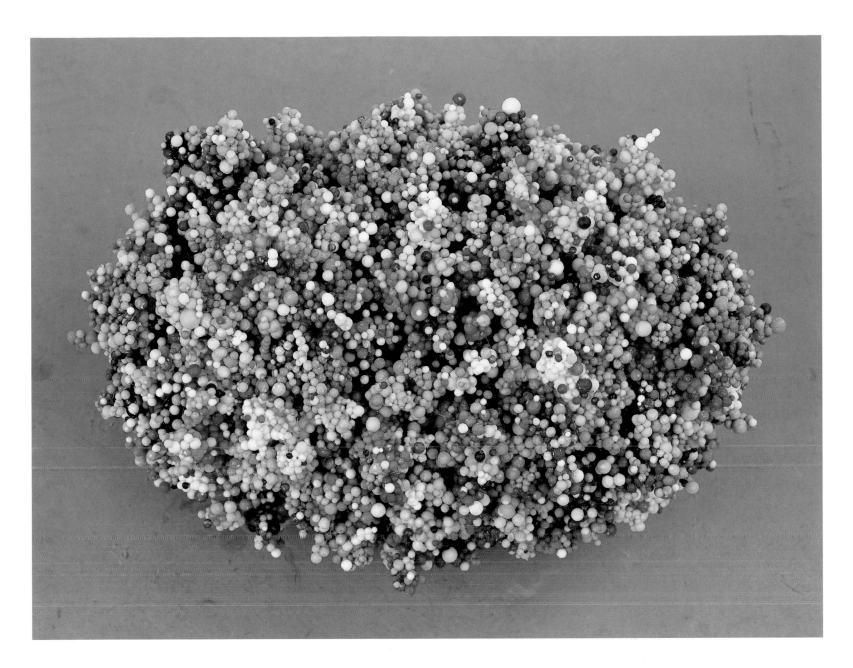

13. VR space achieves seamlessness with reality. first VR-space amusement park. slowly people migrate to a VR-space existence.
14. division and tension between VR-space people and r-space people.
15. assimilation programs develop which translate information for new functions to individual mind base. physiological assimilation programs available. library of experiences opens. public access to files of recorded experiences.
16. neural devices being used over the years have stimulated m-wave emissions in people. perimeter of individual m-wave emission increases to extend outside body shell. telepathy becomes a standard sense.
17. technology directed towards m-wave stimulation devices.
18. slow linking of people in m(mental) space. m-space perimeter increases as more individuals assimilate into m-space. within m-space individuals retain m(personal) space. objects in m-space are constructed by assimilees. as more individuals assimilate into m-space, they contribute to the concretization of object thought form. distance in m-space is measured by the time required to construct the particular relocating thought. first level m-space is communal, containing the union and intersections of m-spaces. sublevel m-spaces are

Untitled (with Julie Lichtenberg)
2000
Styrofoam balls, paint
15 × 23 × 15 cm
A mass made with Styrofoam balls
of many different colours.

Untitled
1997
Coloured pencil and graphite on
paper
Diptych, 104 × 115.5 cm; 105.5 ×
105 cm

constructed for various reasons. each sublevel removed from the first level requires a larger and larger amount of focal energy to sustain. M-space existees fluctuate back and forth from m-space to r(real)-space. places exist in r-space for m-space existees bodies while in m-space. slowly m-space existees separate from their material body. The shedding of physiological constriction to pure mind increases dramatically the fluidity and velocity of thought.

19. first contact with another life form (in m-space). shown new worlds in m-space by new life form. shown the link between m-space and r-space.

20. humans evolve to mr(mind real)-space. individual can fluctuate back and forth between m-space and r-space and the rules for both spaces are interchangeable.

21. q(quantum)-space pockets appear in m-space. q-space is the consciousness of patterns. It is a non-reflexive space, a space of being, as opposed to m-space which is total reflexivity. If a q-space point intersects with the centre of an individual m-wave construction, that individual is assimilated into q-space. in r-space, death is assimilation into q-space. m-wave construction designates vicinity within q-space patterns. if individual m-wave construction is turbulent then it attaches to turbulent q-space vicinity. very turbulent q-space vicinity can dissolve individual m-wave construction (loss of soul). if an m-wave construction is a single point then that m-wave (when assimilated into q-space) attaches to nothing, is drawn to the centre of q-space and is assimilated to a(absolute)-space.

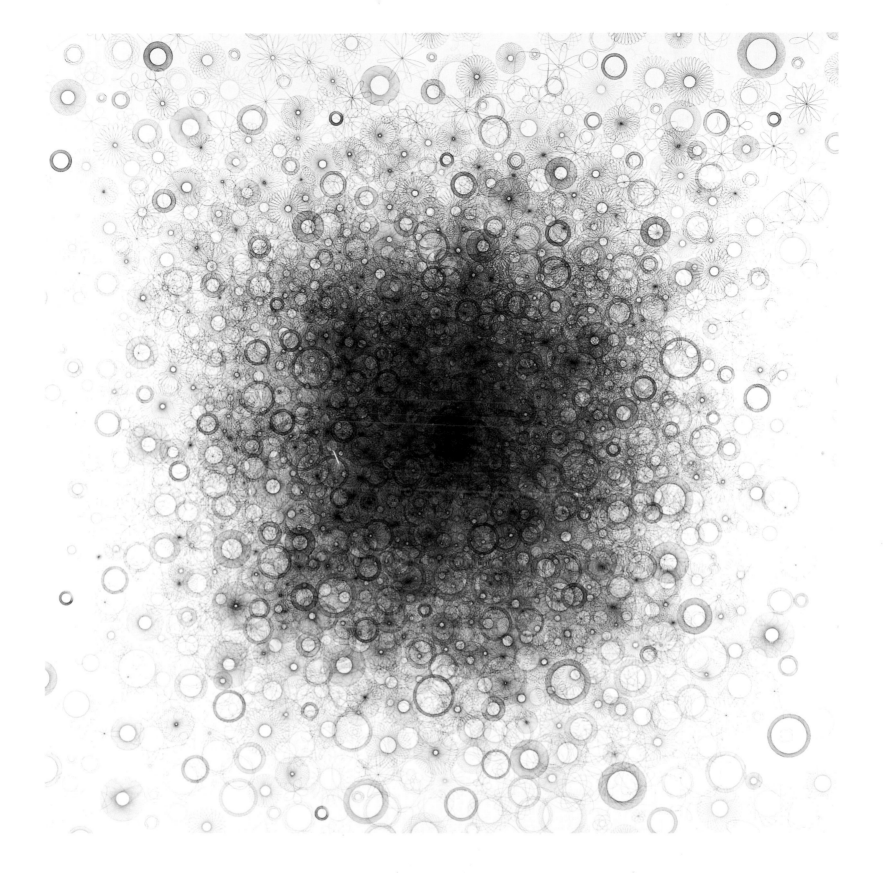

Untitled
1996
Pencil on paper
104 × 104 cm
A drawing made with a Spirograph
kit.

Artist's Writings

Contents

Tom Friedman Born 1965 in Saint Louis, Missouri, lives and works in Conway, Massachusetts

Selected exhibitions and projects
1988–91

Selected articles and interviews
1988–91

1988
Studies, BFA, Graphic Illustration, Washington
University, Saint Louis

1990
Studies, MFA, Sculpture, University of Illinois at
Chicago

Award, Faculty Prize for Graduate Study in Studio Arts,
University of Illinois at Chicago

'Thesis: Tom Friedman, Brian Sikes',
Gallery 400, University of Illinois at Chicago (group)

'The Thing Itself',
Feature Inc., New York (group)

'Minus',
Robbin Lockett Gallery, Chicago (group)

'Godhead',
Feature Inc., New York (group)

'Looking at Labor: What Price Beauty',
Randolph Street Gallery, Chicago (group)

1991
Visiting lecturer, Illinois Wesleyan University,
Bloomington

Rezac Gallery, Chicago (solo)
Cat. *Tom Friedman*, Rezac Gallery, Chicago, text Susan
Snodgrass

'Itch',
N.A.M.E. Gallery, Chicago (group)

Southeastern Center for Contemporary Art, Winston-
Salem, North Carolina (solo)
Cat. *Tom Friedman*, Southeastern Center for
Contemporary Art, Winston-Salem, North Carolina,
text Jeff Fleming

Feature Inc., New York (solo)

'White Bird',
Gallery 400, University of Illinois at Chicago (group)

Tom Friedman • Brian Sikes
T H E S I S
at Gallery 400
University of Illinois at Chicago
400 South Peoria
Chicago, Illinois 60680

May 21 to 27, 1990
Reception May 23, 4–7 p.m.

TOM FRIEDMAN
Untitled, laundry detergent
48"x48" (approx.)

Tom Friedman

new work
reception Wednesday 4 September 1991 6-8 pm

Feature
484 Broome St NY NY 10013
212/941-7077 Tuesday-Saturday 11-6 pm

exhibition continues through 28 September

pictured left to right
Untitled, 1991, Life Savers, 1/2 × 2 1/2"
Untitled, 1991, pillow stuffing, 30" *diameter* × 18"
Untitled, 1990, black and white photograph, 24 × 12"

1990

Harris, Patty, 'Four Summer Art Shows', *Downtown*,
New York, 29 August
Levin, Kim, 'Choices', *Village Voice*, New York, 7 August

1991

Artner, Alan, 'Friedman Debuts with Winning
Simplicity', *Chicago Tribune*, 22 February
Barckert, Lynda, 'The Work of Art', *Chicago Reader*, 1
March
Brunetti, John, 'Tom Friedman: Rezac Gallery', *New
City*, Chicago, 14 March
Hixson, Kathryn, 'Chicago in Review', *Arts Magazine*,
New York, May
McCracken, David, 'Gallery Scene', *Chicago Tribune*, 8
February
Palmer, Laurie, 'Tom Friedman: Rezac Gallery',
Artforum, New York, May

Patterson, Tom, 'Trio of Solos: Thoughts on Three
Current Shows at SECCA', *Winston-Salem Journal*, 1
September

Author unknown, 'Goings on about Town', *New Yorker*,
23 September
Cameron, Dan, 'In Praise of Smallness', *Art & Auction*,
New York, April, 1992
Heartney, Eleanor, 'Tom Friedman: Feature', *Art in
America*, New York, December
Levin, Kim, 'Choices', *Village Voice*, New York, 17
September
Smith, Roberta, 'Art in Review', *New York Times*, 13
September

McCracken, David, 'Gallery Scene', *Chicago Tribune*, 30
August

Tom Friedman
August 24 – October 3, 1991

Southeastern Center for Contemporary Art
Winston-Salem, North Carolina

Selected exhibitions and projects
1991–93

'Bhabha, Tom Friedman, David Shaw and Sally Webster',
Feature Inc., New York (group)

'Casual Ceremony',
White Columns, New York (group)
Cat. *Casual Ceremony*, White Columns, New York, texts Bill Arning, Ben Kinmont

1992
'Healing',
Wooster Gardens, New York; **Rena Bransten Gallery**, San Francisco (group)

'Lying on Top of a Building the Clouds Seemed No Nearer Than When I Was Lying in the Street',
Galerie Monika Sprüth, Cologne (group)

'Misadventures',
Foster Gallery, University of Wisconsin-Eau Claire, Eau Claire (group)
Cat. *Misadventures*, Foster Gallery, University of Wisconsin-Eau Claire, Eau Claire, text Dan Peterman

'The Mud Club, Winchester Cathedral & Lake Nairobi',
Gahlberg Gallery, College of DuPage, Glen Ellyn, Illinois (group)
Cat. *The Mud Club, Winchester Cathedral & Lake Nairobi*, Gahlberg Gallery, College of DuPage, Glen Ellyn Illinois, text Hudson

Bonsack Gallery, Saint Louis (solo)

'Hair',
John Michael Kohler Arts Center, Sheboygan, Wisconsin (group)

l. to r., Julie Lichtenberg, Tom Friedman, 1993

1993
'New Works',
Feigen, Inc., Chicago (group)

'Once upon a Time ... A Loose Form of Narrative',
Gallery A, Chicago (group)
Cat. *Once upon a Time ... A Loose Form of Narrative*, Gallery A, Chicago, texts Kathy Cottong, Norman Dubie

Feature Inc., New York (solo)

Award, Academy Award in Art, American Academy of Arts and Letters, New York

Selected articles and interviews
1991–93

Smith, Roberta, 'Art in Review', *New York Times*, 3 January, 1992
Faust, Gretchen, 'New York in Review', *Arts Magazine*, New York, March, 1992

1992

Bernardi, David, 'News Review', *Flash Art*, Milan, May–June

Marrs, Jennifer, 'Simple Style with a Complex Meaning', *Courier*, Glen Ellyn, Illinois, 2 October

Shepley, Carol Ferring, 'Tom Friedman Shapes Art out of Everyday Things', *St. Louis Post-Dispatch*, 14 February, 1993

Auer, James, 'There's No More Than a Hair's-breadth between Art, Reality in This Exhibit', *Milwaukee Journal*, 17 January, 1993
Flynn, Patrick J.B., 'Hair', *Art Paper*, Toronto, February, 1993
Paine, Janice T., 'Hair Pieces: Exhibition Worth Combing', *Milwaukee Sentinel*, 8 January, 1993

Kahn, Wolf, 'Connecting Incongruities: A Landscape Painter's Observations on the Work of Six Young Sculptors', *Art in America*, New York, November

1993
Artner, Alan, 'Sharp Conceptual Show Dares to be Different', *Chicago Tribune*, 22 January

Tom Friedman
New Work
opening reception Tuesday 9 February 1993

Feature
484 Broome Street NY NY 10013 USA

Tuesday-Saturday 11-6 pm
exhibition continues through 6 March 1993

Blair, Dike, 'Tom Friedman: Feature', *Flash Art*, Milan, November–December
Humphrey, David, 'New York Fax', *Art Issues*, Los Angeles, May–June
Nesbit, Lois, 'Tom Friedman: Feature', *Artforum*, New York, Summer

Selected exhibitions and projects
1993–94

'The American Academy Invitational Exhibition of Painting and Sculpture',
American Academy of Arts and Letters, New York (group)

'Jeanne Dunning, Tom Friedman, Julia Fish: Subject Matters',
Kendall College of Art and Design Art Gallery, Grand Rapids, Michigan (group)

Visiting lecturer, Kendall College of Art and Design, Grand Rapids, Michigan

'Times',
Anderson O'Day Gallery, London (group)

'Mixed Messages: A Survey of Recent Chicago Art',
Forum for Contemporary Art, Saint Louis, Missouri (group)

Ezra and Cecile Zilkha Gallery, Wesleyan University, Middletown, Connecticut (solo)

'Substitute Teachers',
Sadie Bronfman Cultural Center, Montreal, Quebec (group)
Cat. *Substitute Teachers*, Sadie Bronfman Cultural Center, Montreal, Quebec, texts Regine Basha, Stuart Horodner, et al.

Award, The Louis Comfort Tiffany Foundation Awards in Painting, Sculpture, Printmaking, Photography, and Craft Media, New York
Cat. *The Louis Comfort Tiffany Foundation Awards in Painting, Sculpture, Printmaking, Photography, and Craft Media*, Louis Comfort Tiffany Foundation, New York, text author unknown

Award, Individual Artist's Fellowship, Illinois Arts Council, Chicago

1993–95
Visiting artist, Luther Greg Sullivan Visiting Artist, Wesleyan University, Middletown, Connecticut

1994
'Objects: Tom Friedman and Linda Horn',
Evanston Art Center, Illinois (group)
Cat. *Objects: Tom Friedman and Linda Horn*, Evanston Art Center, Illinois, text Michelle Rowe-Sheilds

'Tom Friedman, Jennifer Pastor and Jim Isermann',
Richard Telles Fine Art, Los Angeles (group)

'percept/image/object',
Lannan Foundation, Los Angeles (group)

Selected articles and interviews
1993–94

Levin, Kim, 'Choices: The American Academy Invitational Exhibition of Painting and Sculpture', *Village Voice*, New York, 23 February
Southworth, Linda, 'An Extraordinary Exhibition at Arts and Letters', *Washington Heights Citizen & The Inwood News*, New York, 28 February

Lillington, David, 'Times: Anderson O'Day Gallery', *Time Out*, London, 16 June
Lillington, David, 'Times: Anderson O'Day Gallery, London', *Metropolis M*, Utrecht, Winter

Heartney, Eleanor, 'New York, dans les Galeries', *Art Press*, Paris, October
Mensing, Margo, 'Changing Hands: Renovations in the Domestic Sphere', *Fibrearts*, Asheville, North Carolina, Summer

1994
Connors, Thomas, 'Objects', *New Art Examiner*, Chicago, May

Greene, David, 'Doors of Perception', *Burelle's*, Los Angeles, May
Mollica, Franco, 'percept/image/object', *Tema Celeste*,

Selected exhibitions and projects
1994–95

Galerie Analix, Geneva (solo)

Galleria Raucci e Santamaria, Naples (solo)

Guest lecture, Lannan Foundation, Los Angeles

Galerie Jennifer Flay, Paris (group)

'Rien à Signaler',
Galerie Analix, Geneva (group)
Cat. *Rien à Signaler*, Galerie Analix, Geneva; A&M
Bookstore, Milan, texts Barbara S. Polla, Gianni
Romano, et al.

'Common/Uncommon',
Gahlberg Gallery, College of DuPage, Glen Ellyn,
Illinois (group)

'Critical Mass',
A&A Gallery, Yale University School of Art, New Haven,
Connecticut; **Dallas Artists Research and Exhibition,
McKinney Avenue Contemporary**, Dallas (group)

Artist's project, Gianni Romano, ed., *Postmedia*, Milan,
Autumn

1995
Visiting lecturer, Tyler School of Art, Philadelphia,
Pennsylvania

'Strung into the Apollonian Dream …',
Feature Inc., New York (group)

'I Gaze a Gazely Stare',
Feature Inc., New York (group)

'Projects 50: Tom Friedman',
The Museum of Modern Art, New York (solo)
Cat. *Projects 50: Tom Friedman*, The Museum of Modern
Art, New York, texts Tom Friedman, Robert Storr

Everything, 1992–95, in progress

'Oltre la Normalità Concentrica',
Palazzo da Zara, Padua (group)
Cat. *Oltre la Normalità Concentrica*, Città di Padova,
texts Gianni Romano, Italo Rota

Tom Friedman and Julie Lichtenberg's house, rural
Massachusetts

'Subversive Domesticity',
Edwin A. Ulrich Museum of Art, Wichita State
University, Kansas (group)
Cat. *Subversive Domesticity*, Edwin A. Ulrich Museum of
Art, Wichita State University, Kansas, text Dana Self

Selected articles and interviews
1994–95

Milan, Autumn
Tager, Alisa, 'Emerging Master of Metamorphosis', *Los
Angeles Times*, 3 May

Perretta, Gabriele, 'Tom Friedman: Galleria Raucci e
Santamaria', *Flash Art Italia*, Milan, Summer
Trione, Vincenzo, 'De Soto, Ulisside del Bello', *Il
Mattino*, Naples, 27 May

Mitchell, Charles Dee, '"Critical Mass": More Than
Meets the Eye', *Dallas Morning News*, 3 February, 1995

Romano, Gianni, 'Tom Friedman', *Zoom*, No. 129, Milan
Romano, Gianni, 'In and Out Liquid Architectures
(Through a Few Objects)', *Temporale*, No. 31, Lugano

1995

Cotter, Holland, 'Beneath the Barrage, The Modern's
Little Show', *New York Times*, 7 April
Levin, Kim, 'Choices', *Village Voice*, New York, 2 May
Rich, Charles, 'At MoMA: A "Mad" Muse', *Hartford
Courant*, 1 April
Schjeldahl, Peter, 'Struggle and Flight', *Village Voice*,
New York, 18 April

50

tom friedman
projects

**The Museum of Modern Art
New York**
March 28 – May 16, 1995

Selected exhibitions and projects
1995–96

'Pulp Fictions: Works on Paper',
Gallery A, Chicago (group)

'lo-fi',
Lauren Wittels, New York (group)

'A Collection Sculptures',
The Caldic Collection, Rotterdam (group)
Cat. *A Collection Sculptures*, The Caldic Collection,
Rotterdam, text Yvette Huizing-van Caldenborgh

'b/w photos',
Feature Inc., New York (group)

1996
Book, *Tom Friedman: Work Book*, Feature Inc., New York

Feature Inc., New York (solo)

Julie Lichtenberg and Allen Guiel building the artist's studio

'More Than Real',
Royal Palace, Caserta, Italy (group)
Cat. *More Than Real*, Royal Palace, Caserta, Italy, texts
Jean Baudrillard, Francesco Bonami, Umberto Raucci,
Carlo Santamaria, Massimo Sgroi, Giorgio Verzotti

'Stretch the Truth',
Art: Concept, Nice (group)

'Hero',
Fieldwork/Project Room, Commonwealth Gallery,
Madison, Wisconsin (group)

'Affinities: Chuck Close and Tom Friedman',
Art Institute of Chicago (group)
Cat. *Affinities: Chuck Close and Tom Friedman*, Art
Institute of Chicago, text Madeleine Grynsztejn

Selected articles and interviews
1995–96

Kastner, Jeffery, 'lo-fi: Lauren Wittels, New York',
frieze, London, September–October

Hainley, Bruce, 'Next to Nothing: The Art of Tom
Friedman', *Artforum*, New York, November
Narbutas, Siaurys, 'Modernus Menas Padeda Atlaidziau
Zvelgti I Pasauli', *Lietuvos Rytui*, Lithuania, August

1996

Author unknown, 'Goings on about Town', *New Yorker*,
5 February
Author unknown, 'Goings on about Town', *New Yorker*,
20 January
Canning, Susan M., 'Tom Friedman: Feature Inc.', *New
Art Examiner*, Chicago, April
Ebony, David, 'Tom Friedman at Feature', *NYC Top Ten*,
<http://www.articons.com>, February
Johnson, Ken, 'Friedman's Flea Circus', *Art in America*,
New York, May
Levin, Kim, 'Art Short List', *Village Voice*, New York, 13
February
Mahoney, Robert, 'Tom Friedman: Feature', *Time Out*,
New York, 31 January
Smith, Roberta, 'Art in Review', *New York Times*, 26
January

Alexander, Randy, 'Hero: Commonwealth Gallery', *New
Art Examiner*, Chicago, May

Artner, Alan, 'Work Ethic: Linking Chuck Close and Tom
Friedman', *Chicago Tribune*, 3 May
Author unknown, 'The Aspirin Age', *Chicago Tribune*, 7
June
Camper, Fred, 'Art People: Tom Friedman's Object
Lessons', *Chicago Reader*, 26 April
Grabner, Michelle, 'Chuck Close and Tom Friedman: The
Art Institute of Chicago', *frieze*, London,
September–October
Holg, Garrett, 'Two of a Kind? Exhibit Shows Links in
Method Between Close, Friedman', *Chicago Sun-Times*,
2 June
O'Hara, Delia, 'Unique Artists Find Common Ground',
Chicago Sun-Times, 26 April
Wilk, Deborah, 'Affinities: Chuck Close and Tom

Cover, *Tom Friedman: Work Book*, Feature Inc., New York

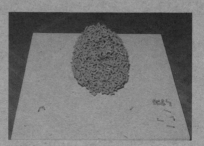

Untitled, 1995, with damage sustained from viewer backing
into the work while looking at Chuck Close's painting of Roy
Lichtenstein at 'Affinities: Chuck Close and Tom Friedman',
Art Institute of Chicago

Selected exhibitions and projects
1996–97

Guest lecture, School of the Art Institute of Chicago

'Universalis: XXIII Bienal Internacional São Paulo',
Pavilhão Ciccillo Matarazzo, Parque do Ibrapuera, São
Paulo (group)
Cat. *Universalis: XXIII Bienal Internacional São Paulo*,
texts Paul Schimmel, et al.

Stephen Friedman Gallery, London (solo)

'Currents in Contemporary Art',
Christie's East, New York (group)

Guest lecture, New York University

1997
Artist's edition, *Zombie*, edition of 15

Artist's edition, **Zombie**, 1997

Christopher Grimes Gallery, Santa Monica (solo)

'Dane County Collects',
Madison Art Center, Wisconsin (group)
Cat. *Dane County Collects*, Madison Art Center,
Wisconsin, texts Sheri Castelnuovo, Stephen
Fleischman, Toby Kamps

Ynglingagatan, Stockholm (solo)

'Frankensteinian',
Caren Golden Fine Art, New York (group)

'Currents 70: Tom Friedman'
Saint Louis Art Museum (solo)
Cat. *Currents 70: Tom Friedman*, Saint Louis Art
Museum, text Rochelle Steiner

Guest lecture, Saint Louis Museum of Art

Selected articles and interviews
1996–97

Friedman: Art Institute of Chicago', *New Art Examiner*,
Chicago, September

Author unknown, 'Tom Friedman: Busca a Arte Total',
Folha de São Paulo, 4 October
Bonami, Francesco, 'Biennials? A View From Brazil',
Flash Art, Milan, March–April, 1997
Cameron, Dan, 'Glocal Warming', *Artforum*, New York,
December, 1997
Canton, Katia, 'Revelação Norte-Americana Virá à
Bienal', *Folha de São Paulo*, 22 June
Damianovic, Maia, 'Futuro Presente Passato
1967–1997 (Speciale Biennale)', *Tema Celeste*, Milan,
May–June, 1997
Gonçalves Filho, Antonio, 'Três Sugestões para o
Visitante', *O Estado de São Paulo*, 3 October

Barrett, David, 'Tom Friedman: Stephen Friedman
Gallery', *Art Monthly*, Vol. 202, London, December–
January
Guha, Tania, 'Tom Friedman: Stephen Friedman
Gallery', *Time Out*, London, 13 November

Author unknown, 'News of the Print World', *Print
Collector's Newsletter*, New York, March–April
Blair, Dike, 'Tom Friedman', *ZAPP Magazine #7* (video
magazine), March
Borruso, Sarah, 'Substance Abuse', *hotwired gallery*,
<http://www.hotwired.com/gallery>, October
Schjeldahl, Peter, 'Hudson's Way', *Village Voice*, New
York, 2 July
Storr, Robert, 'jst', *Grand Street*, No. 57, New York,
Summer
Sugiura, Kunié, 'Interview with Tom Friedman', *BT*,
Tokyo, June

1997

Pagel, David, 'Tom Friedman: Christopher Grimes
Gallery', *Los Angeles Times*, 14 February

Alesia, Tom, 'Who Says Gum Not Good Art?', *Capital
Times*, Madison, Wisconsin, 11 April

Rubin, Birgitta, 'Utan Murar', *Dagens Nyheter*,
Stockholm, 18 March

Rice, Nancy, 'Tom Friedman', *Art Saint Louis*, Summer
Silva, Eddie, 'Present, Accounted', *Riverfront Times*,
Saint Louis, 14 May

Selected exhibitions and projects
1997

'Lovecraft',
Centre for Contemporary Art, Glasgow; **South London
Gallery**, London (group)

'At the Threshold of the Visible: Minuscule and Small-
Scale Art, 1964–1996',
organised by Independent Curators Inc., New York
Johnson Museum of Art, Cornell University, Ithaca
New York; **Meyerhof Galleries**, Maryland Institute of
Art, Baltimore; **Art Gallery of Ontario**, Toronto; **Art
Gallery of Windsor**, Ontario; **Virginia Beach Center
for the Arts**; **Santa Monica Museum of Art**, California;
Edmonton Art Gallery, Alberta (group)
Cat. *At the Threshold of the Visible: Minuscule and Small-
Scale Art, 1964–1996*, Independent Curators Inc., New
York, texts Ralph Rugoff, Susan Stewart

'A Lasting Legacy: Selections from the Lannan
Foundation Gift',
**Geffen Contemporary at Museum of Contemporary
Art**, Los Angeles (group)

'Identity Crisis: Self-Portraiture at the End of the
Century',
Milwaukee Art Museum, Wisconsin; **Aspen Art
Museum**, Colorado (group)
Cat. *Identity Crisis: Self-Portraiture at the End of the
Century*, Milwaukee Art Museum, Wisconsin, texts Dean
Sobel, Marc J. Ackerman

Feature Inc., New York (solo)

TOM FRIEDMAN
New Work

FEATURE, INC.
76 Greene Street
NY, NY 10012
p 212-941-7077
f 212-431-7187

TOM FRIEDMAN
New Work
21 Oct-14 Nov 1997
Tue-Sat 11-6 pm

Guest lecture, University of New Orleans, New Orleans

Guest lecture, Yale University, New Haven,
Connecticut

Guest lecture, University of Southern Maine, Portland

'New Work: Drawings Today',
Museum of Modern Art, San Francisco (group)
Cat. *New Work: Drawings Today*, Museum of Modern Art,
San Francisco, texts Elise S. Haas, Gary Garrels, Janet
Bishop

Selected articles and interviews
1997

Staple, Polly, 'Lovecraft', *Untitled*, London, Summer,
1998

Cotter, Holland, 'A Show That Could Travel in Just a
Carry-on Bag', *New York Times*, 14 December

Porges, Maria, 'San Francisco Fax', *Art Issues*, Los
Angeles, March–April

Author unknown, 'True Obsessions', *Time Out*, New
York, 23 October
Damianovic, Maia, 'Una Stagione di Monstre a New
York', *Tema Celeste*, Milan, July–September, 1998
Greene, David A., 'Captain of Industry', *Village Voice*,
New York, 18 November
Halle, Howard, 'Tom Friedman: Feature Inc.', *Time Out*,
New York, 13 November
Levin, Kim, 'Short List', *Village Voice*, New York, 11
November
Servetar, Stuart, 'New York Fax', *Art Issues*, Los
Angeles, January–February, 1998
Smith, Roberta, 'Art Guide: Feature Inc.', *New York
Times*, 31 October
Smith, Roberta, 'Tiny Objects, Grandiose Statements',
New York Times, 24 October

Aletti, Vince; Levin, Kim, 'Our Biennial', *Village Voice*,
New York, 21 January
Leffingwell, Edward, 'Nationalism and Beyond', *Art in
America*, New York, March
Miller, John, 'Tom Friedman with John Miller', *Index*,
New York, January
Storr, Robert, 'Just Exquisite? The Art of Richard

Selected exhibitions and projects
1997–98

Julie Lichtenberg, Tom Friedman and Oliver

1998

Visiting artist, Fine Arts Work Center, Provincetown, Massachusetts

Visiting artist, San Francisco Art Institute

Institute of Contemporary Art at Maine College of Art, Portland (solo)

Visiting artist, Princeton University, New Jersey

Visiting artist, Rhode Island School of Design, Providence

'Transience and Sentimentality: Boston and Beyond', **Institute of Contemporary Art**, Boston (group)

Visiting artist, School of the Museum of Fine Arts, Boston

Visiting artist, The Cranbrook Academy of Art, Bloomfield Hills, Michigan

'Drawing the Question',
Dorsky Gallery, New York (group)
Cat. *Drawing the Question*, Dorsky Gallery, New York, texts Susan Harris, Jennifer Gross

Tomio Koyama Gallery, Tokyo (solo)

'Pop Surrealism',
Aldrich Museum of Contemporary Art, Ridgefield, Connecticut (group)
Cat. *Pop Surrealism*, Aldrich Museum of Contemporary Art, Ridgefield, Connecticut, texts Richard Klein, Dominique Nahas, Ingrid Schaffner

'Poussière (Dust Memories)',
Fonds Régional d'Art Contemporain de Burgogne, Dijon, France; **Fonds Régional d'Art Contemporain Bretagne; Galerie du Trib**, Rennes, France (group)
Cat. *Poussière (Dust Memories)*, Fonds Régional d'Art Contemporain Bretagne, texts François Dagognet, Catherine Elkar, John Fante, Emmanuel Latreille, Cyril Harpet, Lafcadio Hearn, Raymond Roussel, Bashô

'Bob and Wheel',
dfn gallery, New York (group)

'Humble County',
D'Amelio Terras, New York (group)

'More Pieces for the Puzzle: Recent Additions to the Collection',
The Museum of Modern Art, New York (group)

'Young Americans 2: New American Art at the Saatchi Gallery',
Saatchi Gallery, London (group)
Cat. *Young Americans 2: New American Art at the Saatchi*

Selected articles and interviews
1997–98

Tuttle', *Artforum*, New York, November

1998

Millis, Christopher, 'Hubba Hubba: A Sexy Boston Art Show at the ICA', *Boston Phoenix*, 20 March
Rothkopf, Scott, 'Modernism to Kitsch and Right Back Again', *Harvard Crimson*, Harvard, 6 March

Author unknown, 'Tom Friedman', *Bijutsu Techo*, Tokyo, July
Kaihatsu, Chie, 'Tom Friedman: Tomita Koyama Gallery', *Studio Voice*, Tokyo, June

Cyrot, Laurence, 'Poussière Fertile', *Hors d'œuvre*, France, Autumn

Schjeldahl, Peter, 'No Big Deal', *Village Voice*, New York, 4 August

Author unknown, 'Over-sexed and over Here', *RA Magazine*, London, September
Belle, Tina, 'Young Americans 2', *London LZ East-West*, 7 October

Selected exhibitions and projects
1998–99

Gallery, Saatchi Gallery, London, texts Brooks Adams, Lisa Liebmann

'Dust Breeding',
Fraenkel Gallery, San Francisco (group)
Cat. *Dust Breeding*, Fraenkel Gallery, San Francisco, no text

Visiting artist, Virginia Commonwealth University, Richmond

'Blunt Object',
David and Alfred Smart Museum of Art, University of Chicago (group)
Cat. *Blunt Object*, David and Alfred Smart Museum of Art, University of Chicago, text Coutenay Smith

Stephen Friedman Gallery, London (solo)

'Word Perfect',
Gallery 400, University of Illinois, Chicago (group)

'Hindsight: Recent Work from the Permanent Collection',
Whitney Museum of American Art, New York (group)

'Encyclopedia 1999',
Turner & Runyon, Dallas (group)

1999
'On the Ball: The Sphere in Contemporary Sculpture',
DeCordova Museum and Sculpture Park, Lincoln, Massachusetts (group)

Selected articles and interviews
1998–99

Brown, Hero, 'Party On', *Independent*, London, 13 September
Burton, Jane, 'Made in the USA', *Daily Express*, London, 5 September
Darwent, Charles, 'American Gothic', *New Statesman*, London, 4 September
Dormant, Richard, 'A Brush with Young America', *Daily Telegraph*, London, 26 August
Farel, Zena, 'All the Young Guns', *India Weekly*, London, 11 September
Negrotti, Rosanna, 'States of Mind', *What's On*, London, 7 October
Rayner, Alex, 'The Yanks are Coming!', *i-D*, London, May
Searle, Adrian, 'The Infants Liam and Noel on the Sofa ... Is This What Passes for the New American Dream?', *Guardian*, London, 8 September
Smith, Alyson, 'Bras and Stripes', *The Face*, London, September
Smith, Caroline, 'Young Americans 2', *Attitude*, London, September

Baker, Kenneth, 'Enigmatic Art Revealed at Fraenkel', *San Francisco Chronicle*, 17 September

Austin, Niki, 'Provoked to Sculpt', *London Jewish News*, 28 August
Author unknown, 'In Safe Hands', *i-D*, London, October
Ebner, Jörn, 'Weltenklänge und ihre Körper', *Frankfurter Allgemaine Zeitung*, Frankfurt, 14 November
Hubbard, Sue, 'Tom Friedman: Stephen Friedman', *Time Out*, London, 18 November

Author unknown, 'Rope on a Soap', *Esquire*, London, October
Cameron, Dan, 'Tom Friedman', *cream: contemporary art in culture*, Phaidon Press, London
Goodman, Jonathan, 'Small Wonders', *World Art*, New York, Autumn

1999
Temin, Christine, 'DeCordova Show Proves Art Is Not Always Square', *Boston Globe*, 24 January
Van Siclen, Bill, '"On the Ball" Artists Explore the Sphere's Possibilities', *Providence Journal*, Boston, 22 January

Selected exhibitions and projects
1999–2000

'Holding Court',
Entwistle, London (group)

Galleria Gian Enzo Sperone, Rome (solo)

'Collectors Collect Contemporary Art: 1990–1999',
Institute of Contemporary Art, Boston (group)
Cat. *Collectors Collect Contemporary Art: 1990–1999*,
Institute of Contemporary Art, Boston, text Jessica
Morgan

Galeria Foksal, Warsaw (solo)
Cat. *Tom Friedman*, Galeria Foksal, Warsaw/Feature
Inc., New York, no text

'Waste Management',
Art Gallery of Ontario, Toronto (group)
Cat. *Waste Management*, Art Gallery of Ontario,
Toronto, text Christina Ritchie

'Stuff',
TBA Exhibition Space, Chicago (group)

'Sometimes Warm and Fuzzy: Childhood and
Contemporary Art',
Des Moines Art Center, Iowa (group)
Cat. *Sometimes Warm and Fuzzy: Childhood and
Contemporary Art*, Des Moines Art Center, Iowa, texts
Susan Lubowsky Talbott, Lea Rosson DeLong

Artists residence, John Eastman, Jr. Endowed Chair,
Skowhegan School of Painting and Sculpture,
Skowhegan, Maine

'Ideas in Things',
Irvine Fine Arts Center, California (group)

'Zero-G: When Gravity Becomes Form',
Whitney Museum of American Art at Champion,
Stamford (group)
Cat. *Zero-G: When Gravity Becomes Form*, Whitney
Museum of American Art, New York, texts Eva Diaz,
Ko'an Jeff Baysa, Michelle-Lee White

2000
'Vanitas Personae: An Exploration of the Self and Other
Related Characters',
Robert Miller Gallery, New York (group)

Selected articles and interviews
1999–2000

Tom Friedman and son, Oliver, at exhibition opening,
Galleria Gian Enzo Sperone, Rome

Gorczyca, Lukasz, 'Energie Skumulowane', *Sztuka
Ploska i Antyki*, Warsaw, May
Kuc, Monica, 'Zmiana Skali', *Gazeta Wyborcza*, Warsaw,
9 July
Sarzynski, Piotr, 'W Galerii', *Polityka*, Warsaw, 1 May
Szablowski, Stach, 'W Innych Wymiarach', *City
Magazine*, Warsaw, 6 July

Bil, Laura, '"Waste Management" Rules', *Varsity*,
Toronto, 13 April
Chu, Ingrid, 'A Time of Waste', *National Post*, Toronto, 8
April
Dault, Gary Michael, 'Think Most Modern Art is Trash?
This Show's for You', *Globe and Mail*, Toronto, 17 April
Peñaloza, Si Si, 'World of Waste Can Be a Wonderful
Thing', *NOW Magazine*, Toronto, April

Grabner, Michelle, 'Stuff', *frieze*, London,
September–October
Hawkins, Margaret, 'Worthwhile Notions', *Chicago Sun-
Times*, 23 April

Berdan, Kathy, 'A "Warm and Fuzzy" Guide for Kids',
Des Moines Register, 13 September
Holms, Karin, 'Not all Warm, Fuzzy: That's About the
Size of It', *Des Moines Register*, 26 September

Schulman, Daniel; Strick, Jeremy, *Museum Studies*,
Vol.25, No. 1, Modern and Contemporary Art: The
Lannan Collection at the Art Institute of Chicago; The
Art Institute of Chicago
West, Aurora, 'Tom Friedman's Art is Like a Spinning
Fried Egg in Space', *Museo*, Vol. 2, Columbia University,
New York, Spring

2000

Selected exhibitions and projects
2000

Feature Inc., New York (solo)

Invitation card, Feature Inc., New York

'The Greenhouse Effect',
Serpentine Gallery, London (group)
Cat. *The Greenhouse Effect*, Serpentine Gallery,
London, texts Lisa Corrin, Ralph Rugoff

'The Visionary Landscape',
Christopher Grimes Gallery, Santa Monica (group)

Museum of Contemporary Art, Chicago; **Yerba Buena
Center for the Arts**, San Francisco; **New Museum of
Contemporary Art**, New York; **Southeastern Center for
Contemporary Art**, Winston-Salem, North Carolina;
Aspen Art Museum, Colorado (solo)
Cat. *Tom Friedman*, Southeastern Center for
Contemporary Art, Winston-Salem, North Carolina,
text Ron Platt

'Domestic Bliss',
South London Gallery, London (group)

Nominated for Hugo Boss Prize, New York

Serpentine Gallery
Programme

Admission free
Open daily 10am — 6pm

The Greenhouse Effect
4 April — 21 May 2000

Sponsored by
BMW Financial Services Group

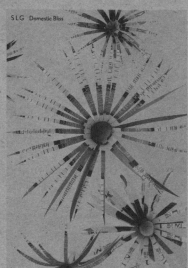

SLG Domestic Bliss

Selected articles and interviews
2000

Cotter, Holland, 'Art in Review', *New York Times*, 31
March
Doran, Anne, 'Tom Friedman: Feature Inc.', *Time Out*,
New York, 6 April
Frankel, David, 'X-Acto Science', *Artforum*, New York,
Summer
Quinones, Paul, 'Tom Friedman: Feature Inc.', *Flash
Art*, Milan, May–June
Saltz, Jerry, 'Anything Goes', *Village Voice*, New York,
11 April

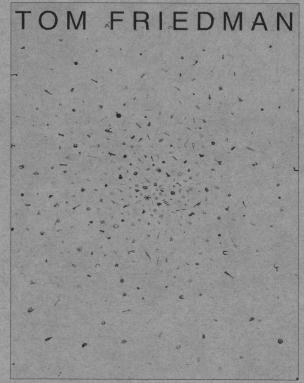

Cover, *Tom Friedman*, Southeastern Center for Contemporary Art, Winston-Salem, North
Carolina

Ackerman, Marc J., *Identity Crisis: Self-Portraiture at the End of the Century*, Milwaukee Art Museum, Wisconsin, 1997

Adams, Brooks, *Young Americans 2: New American Art at the Saatchi Gallery*, Saatchi Gallery, London, 1998

Alesia, Tom, 'Who Says Gum Not Good Art?', *Capital Times*, Madison, Wisconsin, 11 April, 1997

Aletti, Vince; Levin, Kim, 'Our Biennial', *Village Voice*, New York, 21 January, 1997

Alexander, Randy, 'Hero: Commonwealth Gallery', *New Art Examiner*, Chicago, May, 1996

Arning, Bill, *Casual Ceremony*, White Columns, New York, 1991

Artner, Alan, 'Friedman Debuts With Winning Simplicity', *Chicago Tribune*, 22 February, 1991

Artner, Alan, 'Sharp Conceptual Show Dares to be Different', *Chicago Tribune*, 22 January, 1993

Artner, Alan, 'Work Ethic: Linking Chuck Close and Tom Friedman', *Chicago Tribune*, 3 May, 1996

Auer, James, 'There's No More Than a Hair's-breadth between Art, Reality in This Exhibit', *Milwaukee Journal*, 17 January, 1993

Austin, Niki, 'Provoked to Sculpt', *London Jewish News*, 28 August, 1998

Author unknown, 'Goings on about Town', *New Yorker*, 23 September, 1991

Author unknown, *The Louis Comfort Tiffany Foundation Awards in Painting, Sculpture, Printmaking, Photography, and Craft Media*, Louis Comfort Tiffany Foundation, New York, 1993

Author unknown, 'Goings on about Town', *New Yorker*, 20 January, 1996

Author unknown, 'Goings on about Town', *New Yorker*, 5 February, 1996

Author unknown, 'News of the Print World', *Print Collector's Newsletter*, New York, March–April, 1996

Author unknown, 'The Aspirin Age', *Chicago Tribune*, 7 June, 1996

Author unknown, 'Tom Friedman: Busca a Arte Total', *Folha de São Paulo*, 4 October, 1996

Author unknown, 'True Obsessions', *Time Out*, New York, 23 October, 1997

Author unknown, 'Tom Friedman', *Bijutsu Techo*, Tokyo, July, 1998

Author unknown, 'Over-sexed and over Here', *RA Magazine*, London, September, 1998

Author unknown, 'In Safe Hands', *i-D*, London, October, 1998

Author unknown, 'Rope on a Soap', *Esquire*, London, October, 1998

Baker, Kenneth, 'Enigmatic Art Revealed at Fraenkel', *San Francisco Chronicle*, 17 September, 1998

Barckert, Lynda, 'The Work of Art', *Chicago Reader*, 1 March, 1991

Barrett, David, 'Tom Friedman: Stephen Friedman Gallery', *Art Monthly*, Vol. 202, London, December–January, 1996

Basha, Regine, *Substitute Teachers*, Sadie Bronfman Cultural Center, Montreal, Quebec, 1993

Bashô, *Poussière (Dust Memories)*, Fonds Régional d'Art Contemporain Bretagne, 1998

Baudrillard, Jean, *More Than Real*, Royal Palace, Caserta, Italy, 1996

Baysa, Ko'an Jeff, *Zero-G: When Gravity Becomes Form*, Whitney Museum of American Art, New York, 1999

Belle, Tina, 'Young Americans 2', *London LZ East-West*, 7 October, 1998

Berdan, Kathy, 'A "Warm and Fuzzy" Guide for Kids', *Des Moines Register*, 13 September, 1999

Bernardi, David, 'News Review', *Flash Art*, Milan, May–June, 1992

Bil, Laura, '"Waste Management" Rules', *Varsity*, Toronto, 13 April, 1999

Bishop, Janet, *New Work: Drawings Today*, Museum of Modern Art, San Francisco, 1997

Blair, Dike, 'Tom Friedman: Feature', *Flash Art*, Milan, November–December, 1993

Blair, Dike, 'Tom Friedman', *ZAPP Magazine #7* (video magazine), March, 1996

Bonami, Francesco, *More Than Real*, Royal Palace, Caserta, Italy, 1996

Bonami, Francesco, 'Biennials? A View From Brazil', *Flash Art*, Milan, March–April, 1997

Borruso, Sarah, 'Substance Abuse', *hotwired gallery*, <www.hotwired.com/gallery>, October, 1996

Brown, Hero, 'Party On', *Independent*, London, 13 September, 1998

Brunetti, John, 'Tom Friedman: Rezac Gallery', *New City*, Chicago, 14 March, 1991

Burton, Jane, 'Made in the USA', *Daily Express*, London, 5 September, 1998

Cameron, Dan, 'In Praise of Smallness', *Art & Auction*, New York, April, 1992

Cameron, Dan, 'Glocal Warming', *Artforum*, New York, December, 1997

Cameron, Dan, 'Tom Friedman', *cream: contemporary art in culture*, Phaidon Press, London, 1998

Camper, Fred, 'Art People: Tom Friedman's Object Lessons', *Chicago Reader*, 26 April, 1996

Canning, Susan M., 'Tom Friedman: Feature Inc.', *New Art Examiner*, Chicago, April, 1996

Canton, Katia, 'Revelação Norte-Americana Virá à Bienal', *Folha de São Paulo*, 22 June, 1996

Castelnuovo, Sheri, *Dane County Collects*, Madison Art Center, Wisconsin, 1997

Chu, Ingrid, 'A Time of Waste', *National Post*, Toronto, 8 April, 1999

Connors, Thomas, 'Objects', *New Art Examiner*, Chicago, May, 1994

Corrin, Lisa, *The Greenhouse Effect*, Serpentine Gallery, London, 2000

Cotter, Holland, 'Beneath the Barrage, The Modern's Little Show', *New York Times*, 7 April, 1995

Cotter, Holland, 'A Show That Could Travel in Just a Carry-on Bag', *New York Times*, 14 December, 1997

Cotter, Holland, 'Art in Review', *New York Times*, 31 March, 2000

Cottong, Kathy, *Once Upon a Time … A Loose Form of Narrative*, Gallery A, Chicago, 1993

Coutenay, Smith, *Blunt Object*, David and Alfred Smart Museum of Art, University of Chicago, 1998

Cyrot, Laurence, 'Poussière Fertile', *Hors d'œuvre*, France, Autumn, 1998

Dagognet, François, *Poussière (Dust Memories)*, Fonds Régional d'Art Contemporain Bretagne, 1998

Damianovic, Maia, 'Futuro Presente Passato 1967–1997 (Speciale Biennale)', *Tema Celeste*, Milan, May–June, 1997

Damianovic, Maia, 'Una Stagione di Monstre a New York', *Tema Celeste*, Milan, July–September, 1998

Darwent, Charles, 'American Gothic', *New Statesman*, London, 4 September, 1998

Dault, Gary Michael, 'Think Most Modern Art is Trash? This Show's for You', *Globe and Mail*, Toronto, 17 April, 1999

Diaz, Eva, *Zero-G: When Gravity Becomes Form*, Whitney Museum of American Art, New York, 1999

Doran, Anne, 'Tom Friedman: Freature Inc.', *Time Out*, New York, 6 April, 2000

Dormant, Richard, 'A Brush with Young America', *Daily Telegraph*, London, 26 August, 1998

Dubie, Norman, *Once Upon a Time … A Loose Form of Narrative*, Gallery A, Chicago, 1993

Ebner, Jörn, 'Weltenklänge und ihre Körper', *Frankfurter Allgemeine Zeitung*, Frankfurt, 14 November, 1998

Ebony, David, 'Tom Friedman at Feature', *NYC Top Ten*, <http://www.articons.com>, February, 1996

Elkar, Catherine, *Poussière (Dust Memories)*, Fonds Régional d'Art Contemporain Bretagne, 1998

Fante, John, *Poussière (Dust Memories)*, Fonds Régional d'Art Contemporain Bretagne, 1998

Farel, Zena, 'All the Young Guns', *India Weekly*, London, 11 September, 1998

Faust, Gretchen, 'New York in Review', *Arts Magazine*, New York, March, 1992

Fleischman, Stephen, *Dane County Collects*, Madison Art Center, Wisconsin, 1997

Fleming, Jeff, *Tom Friedman*, Southeastern Center for Contemporary Art, Winston-Salem, North Carolina, 1991

Flynn, Patrick J.B., 'Hair', *Art Paper*, Toronto, February, 1993

Frankel, David, 'X-Acto Science', *Artforum*, New York, Summer, 2000

Friedman, Tom, *Projects 50: Tom Friedman*, The Museum of Modern Art, New York, 1995

Friedman, Tom, *Tom Friedman: Work Book*, Feature Inc., New York, 1996

Friedman, Tom, *Tom Friedman*, Galeria Foksal, Warsaw/Feature Inc., New York, 1999

Garrels, Gary, *New Work: Drawings Today*, Museum of Modern Art, San Francisco, 1997

Gonçalves Filho, Antonio, 'Três Sugestões para o Visitante', *O Estado de São Paulo*, 3 October, 1996

Goodman, Jonathan, 'Small Wonders', *World Art*, New York, Autumn, 1998

Gorczyca, Lukasz, 'Energie Skumulowane', *Sztuka Ploska i Antyki*, Warsaw, May, 1999

Grabner, Michelle, 'Chuck Close and Tom Friedman: The Art Institute of Chicago', *frieze*, London, September–October, 1996

Grabner, Michelle, 'Stuff', *frieze*, London, September–October, 1999

Greene, David, 'Doors of Perception', *Burelle's*, Los Angeles, May, 1994

Greene, David, 'Captain of Industry', *Village Voice*, New York, 18 November, 1997

Gross, Jennifer, *Drawing the Question*, Dorsky Gallery, New York, 1998

Grynsztejn, Madeleine, *Affinities: Chuck Close and Tom Friedman*, Art Institute of Chicago, 1996

Guha, Tania, 'Tom Friedman: Stephen Friedman Gallery', *Time Out*, London, 13 November, 1996

Haas, Elise S., *New Work: Drawings Today*, Museum of Modern Art, San Francisco, 1997

Hainley, Bruce, 'Next to Nothing: The Art of Tom Friedman', *Artforum*, New York, November, 1995

Halle, Howard, 'Tom Friedman: Feature', *Time Out*, New York, 13 November, 1997

Harpet, Cyril, *Poussière (Dust Memories)*, Fonds Régional d'Art Contemporain Bretagne, 1998

Harris, Patty, 'Four Summer Art Shows', *Downtown*, New York, 29 August, 1990

Harris, Susan, *Drawing the Question*, Dorsky Gallery, New York, 1998

Hawkins, Margaret, 'Worthwhile Notions', *Chicago Sun-Times*, 23 April, 1999

Hearn, Lafcadio, *Poussière (Dust Memories)*, Fonds Régional d'Art Contemporain Bretagne, 1998

Heartney, Eleanor, 'Tom Friedman: Feature', *Art in America*, New York, December, 1991

Heartney, Eleanor, 'New York, dans les Galeries', *Art Press*, Paris, October, 1993

Hixson, Kathryn, 'Chicago in Review', *Arts Magazine*, New York, May, 1991

Holg, Garrell, 'Two of a Kind? Exhibit Shows Links in Method Between Close, Friedman', *Chicago Sun-Times*, 2 June, 1996

Holms, Karin, 'Not all Warm, Fuzzy: That's About the Size of It', *Des Moines Register*, 26 September, 1999

Horodner, Stuart, *Substitute Teachers*, Sadie Bronfman Cultural Center, Montreal, Quebec, 1993

Hubbard, Sue, 'Tom Friedman: Stephen Friedman', *Time Out*, London, 18 November, 1998

Hudson, *The Mud Club, Winchester Cathedral & Lake Nairobi*, Gahlberg Gallery, College of DuPage, Glen Ellyn Ilinois, 1992

Huizing-van Caldenborgh, Yvette, *A Collection Sculptures*, The Caldic Collection, Rotterdam, 1995

Humphrey, David, 'New York Fax', *Art Issues*, Los Angeles, May–June, 1993

Johnson, Ken, 'Friedman's Flea Circus', *Art in America*, New York, May, 1996

Kahn, Wolf, 'Connecting Incongruities: A Landscape Painter's Observations on the Work of Six Young Sculptors', *Art in America*, New York, November, 1992

Kaihatsu, Chie, 'Tom Friedman: Tomia Koyama Gallery', *Studio Voice*, Tokyo, June, 1998

Kamps, Toby, *Dane County Collects*, Madison Art Center, Wisconsin, 1997

Kastner, Jeffery, 'lo-fi: Lauren Wittels, New York', *frieze*, London, September–October, 1995

Kinmont, Ben, *Casual Ceremony*, White Columns, New York, 1991

Klein, Richard, *Pop Surrealism*, Aldrich Museum of Contemporary Art, Ridgefield, Connecticut, 1998

Kuc, Monica, 'Zmiana Skali', *Gazeta Wyborcza*, Warsaw, 9 July, 1999

Latreille, Emmanuel, *Poussière (Dust Memories)*, Fonds Régional d'Art Contemporain Bretagne, 1998

Leffingwell, Edward, 'Nationalism and Beyond', *Art in America*, New York, March, 1997

Levin, Kim, 'Choices', *Village Voice*, New York, 7 August, 1990

Levin, Kim, 'Choices', *Village Voice*, New York, 17 September, 1991

Levin, Kim, 'Choices', *Village Voice*, New York, 23 February, 1993

Levin, Kim, 'Choices', *Village Voice*, New York, 2 May, 1995

Levin, Kim, 'Art Short List', *Village Voice*, New York, 13 February, 1996

Levin, Kim; Aletti, Vince, 'Our Biennial', *Village Voice*, New York, 21 January, 1997

Levin, Kim, 'Short List', *Village Voice*, New York, 11 November, 1997

Lillington, David, 'Times: Anderson O'Day Gallery', *Time Out*, London, 16 June, 1993

Lillington, David, 'Times: Anderson O'Day Gallery, London', *Metropolis M*, Utrecht, Winter, 1993

Lisa, Liebmann, *Young Americans 2: New American Art at the Saatchi Gallery*, Saatchi Gallery, London, 1998

Lubowsky Talbott, Susan, *Sometimes Warm and Fuzzy: Childhood and Contemporary Art*, Des Moines Art Center, Iowa, 1999

Mahoney, Robert, 'Tom Friedman: Feature', *Time Out*, New York, 31 January, 1996

Marrs, Jennifer, 'Simple Style with a Complex Meaning', *Courier*, Glen Ellyn, Illinois, 2 October, 1992

McCracken, David, 'Gallery Scene', *Chicago Tribune*, 8 February, 1991

McCracken, David, 'Gallery Scene', *Chicago Tribune*, 30 August, 1991

Mensing, Margo, 'Changing Hands: Renovations in the Domestic Sphere', *Fibrearts*, Asheville, North Carolina, Summer, 1993

Miller, John, 'Tom Friedman with John Miller', *Index*, New York, January, 1997

Millis, Christopher, 'Hubba Hubba: A Sexy Boston Art Show at the ICA', *Boston Phoenix*, 20 March, 1998

Mitchell, Charles Dee, '"Critical Mass": More Than Meets the Eye', *Dallas Morning News*, 3 February, 1995

Mollica, Franco, 'percept/image/object', *Tema Celeste*, Milan, Autumn, 1994

Morgan, Jessica, *Collectors Collect Contemporary Art: 1990–1999*, Institute of Contemporary Art, Boston, 1999

Nahas, Dominique, *Pop Surrealism*, Aldrich Museum of Contemporary Art, Ridgefield, Connecticut, 1998

Narbutas, Siaurys, 'Modernus Menas Padeda Atlaidžiau Zvelgti I Pasauli', *Lietuvos Rytui*, Lithuania, August, 1995

Negrotti, Rosanna, 'States of Mind', *What's On*, London, 7 October, 1998

Nesbit, Lois, 'Tom Friedman: Feature', *Artforum*, New York, Summer, 1993

O'Hara, Delia, 'Unique Artists Find Common Ground', *Chicago Sun-Times*, 26 April, 1996

Pagel, David, 'Tom Friedman: Christopher Grimes Gallery', *Los Angeles Times*, 14 February, 1997

Paine, Janice T., 'Hair Pieces: Exhibition Worth Combing', *Milwaukee Sentinel*, 8 January, 1993

Palmer, Laurie, 'Tom Friedman: Rezac Gallery', *Artforum*, New York, May, 1991

Patterson, Tom, 'Trio of Solos: Thoughts on Three Current Shows at SECCA', *Winston-Salem Journal*, 1 September, 1991

Peñaloza, Si Si, 'World of Waste Can Be a Wonderful Thing', *NOW Magazine*, Toronto, April, 1999

Perretta, Gabriele, 'Tom Friedman: Galleria Raucci e Santamaria', *Flash Art Italia*, Milan, Summer, 1994

Peterman, Dan, *Misadventures*, Foster Gallery, University of Wisconsin-Eau Claire, Eau Claire, 1992

Platt, Ron, *Tom Friedman*, Ron Platt, Winston-Salem, North Carolina, 2000

Polla, Barbara S., *Rien à Signaler*, Galerie Analix, Geneva; A&M Bookstore, Milan, 1994

Porges, Maria, 'San Francisco Fax', *Art Issues*, Los Angeles, March–April, 1997

Quinones, Paul, 'Tom Friedman: Feature Inc.', *Flash Art*, Milan, May–June, 2000

Rayner, Alex, 'The Yanks are Coming!', *i–D*, London, May, 1998

Rice, Nancy, 'Tom Friedman', *Art Saint Louis*, Summer, 1997

Rich, Charles, 'At MoMA: A "Mad" Muse', *Hartford Courant*, 1 April, 1995

Ritchie, Christina, *Waste Management*, Art Gallery of Ontario, Toronto, 1999

Romano, Gianni, 'Tom Friedman', *Zoom*, No. 129, Milan, 1994

Romano, Gianni, *Rien à Signaler*, Galerie Analix, Geneva; A&M Bookstore, Milan, 1994

Romano, Gianni, ed., *Postmedia*, Milan, Autumn, 1994

Romano, Gianni, 'In and Out Liquid Architectures (Through a Few Objects)', *Temporale*, No. 31, Lugano, 1994

Romano, Gianni, *Oltre la Normalità Concentrica*, Città di Padova, 1995

Rosson DeLong, Lea, *Sometimes Warm and Fuzzy: Childhood and Contemporary Art*, Des Moines Art Center, Iowa, 1999

Rota, Italo, *Oltre la Normalità Concentrica*, Città di Padova, 1995

Rothkopf, Scott, 'Modernism to Kitsch and Right Back Again', *Harvard Crimson*, Harvard, 6 March, 1998

Roussel, Raymond, *Poussière (Dust Memories)*, Fonds Régional d'Art Contemporain Bretagne, 1998

Rowe-Sheilds, Michelle, *Objects: Tom Friedman and Linda Horn*, Evanston Art Center, Illinois, 1994

Rubin, Birgitta, 'Utan Murar', *Dagens Nyheter*, Stockholm, 18 March, 1997

Rugoff, Ralph, *At the Threshold of the Visible: Minuscule and Small-Scale Art, 1964–1996*, Independent Curators Inc., New York, 1997

Rugoff, Ralph, *The Greenhouse Effect*, Serpentine Gallery, London, 2000

Saltz, Jerry, 'Anything Goes', *Village Voice*, New York, 11 April, 2000

Sarzynski, Piotr, 'W Galerii', *Polityka*, Warsaw, 1 May, 1999

Schaffner, Ingrid, *Pop Surrealism*, Aldrich Museum of Contemporary Art, Ridgefield, Connecticut, 1998

Schimmel, Paul, *Universalis: XXIII Bienal Internacional São Paulo*, 1996

Schjeldahl, Peter, 'Struggle and Flight', *Village Voice*, New York, 18 April, 1995

Schjeldahl, Peter, 'Hudson's Way', *Village Voice*, New York, 2 July, 1996

Schjeldahl, Peter, 'No Big Deal', *Village Voice*, New York, 4 August, 1998

Schulman, Daniel; Strick, Jeremy, *Museum Studies*, Vol.25, No. 1, Modern and Contemporary Art: The Lannan Collection at the Art Institute of Chicago; The Art Institute of Chicago, 1999

Searle, Adrian, 'The Infants Liam and Noel on the Sofa ... Is This What Passes for the New American Dream?', *Guardian*, London, 8 September, 1998

Self, Dana, *Subversive Domesticity*, Edwin A. Ulrich Museum of Art, Wichita State University, Kansas, 1995

Servetar, Stuart, 'New York Fax', *Art Issues*, No. 51, Los Angeles, January–February, 1998

Shepley, Carol Ferring, 'Tom Friedman Shapes Art out of Everyday Things', *St. Louis Post-Dispatch*, 14 February, 1993

Silva, Eddie, 'Present, Accounted', *Riverfront Times*, Saint Louis, 14 May, 1997

Smith, Alyson, 'Bras and Stripes', *The Face*, London, September, 1998

Smith, Caroline, 'Young Americans 2', *Attitude*, London, September, 1998

Smith, Roberta, 'Art in Review', *New York Times*, 13 September, 1991

Smith, Roberta, 'Art in Review', *New York Times*, 3 January, 1992

Smith, Roberta, 'Art in Review', *New York Times*, 26 January, 1996

Smith, Roberta, 'Tiny Objects, Grandiose Statements', *New York Times*, 24 October, 1997

Smith, Roberta, 'Art Guide', *New York Times*, 31 October, 1997

Snodgrass, Susan, *Tom Friedman*, Rezac Gallery, Chicago, 1991

Sobel, Dean, *Identity Crisis: Self-Portraiture at the End of the Century*, Milwaukee Art Museum, Wisconsin, 1997

Southworth, Linda, 'An Extraordinary Exhibition at Arts and Letters', *Washington Heights Citizen & The Inwood News*, New York, 28 February, 1993

Steiner, Rochelle, *Currents 70: Tom Friedman*, Saint Louis Art Museum, 1997

Stewart, Susan, *At the Threshold of the Visible: Minuscule and Small-Scale Art, 1964–1996*, Independent Curators Inc., New York, 1997

Storr, Robert, *Projects 50: Tom Friedman*, The Museum of Modern Art, New York, 1995

Storr, Robert, 'jst', *Grand Street*, No. 57, New York, Summer, 1996

Storr, Robert, 'Just Exquisite? The Art of Richard Tuttle', *Artforum*, New York, November, 1997

Strick, Jeremy; Schulman, Daniel, *Museum Studies*, Vol.25, No. 1, Modern and Contemporary Art: The Art Institute of Chicago, 1999

Sugiura, Kunié, 'Interview with Tom Friedman', *BT*, Tokyo, June, 1996

Szablowski, Stach, 'W Innych Wymiarach', *City Magazine*, Warsaw, 6 July, 1999

Tager, Alisa, 'Emerging Master of Metamorphosis', *Los Angeles Times*, 3 May, 1994

Temin, Christine, 'DeCordova Show Proves Art Is Not Always Square', *Boston Globe*, 24 January, 1999

Van Siclen, Bill, '"On the Ball" Artists Explore the Sphere's Possibilities', *Providence Journal*, Boston, 22 January, 1999

West, Aurora, 'Tom Friedman's Art is Like a Spinning Fried Egg in Space', *Museo*, Vol. 2, Columbia University, New York, Spring, 1999

White, Michelle-Lee, *Zero-G: When Gravity Becomes Form*, Whitney Museum of American Art, New York, 1999

Wilk, Deborah, 'Affinities: Chuck Close and Tom Friedman: Art Institute of Chicago', *New Art Examiner*, Chicago, September, 1996

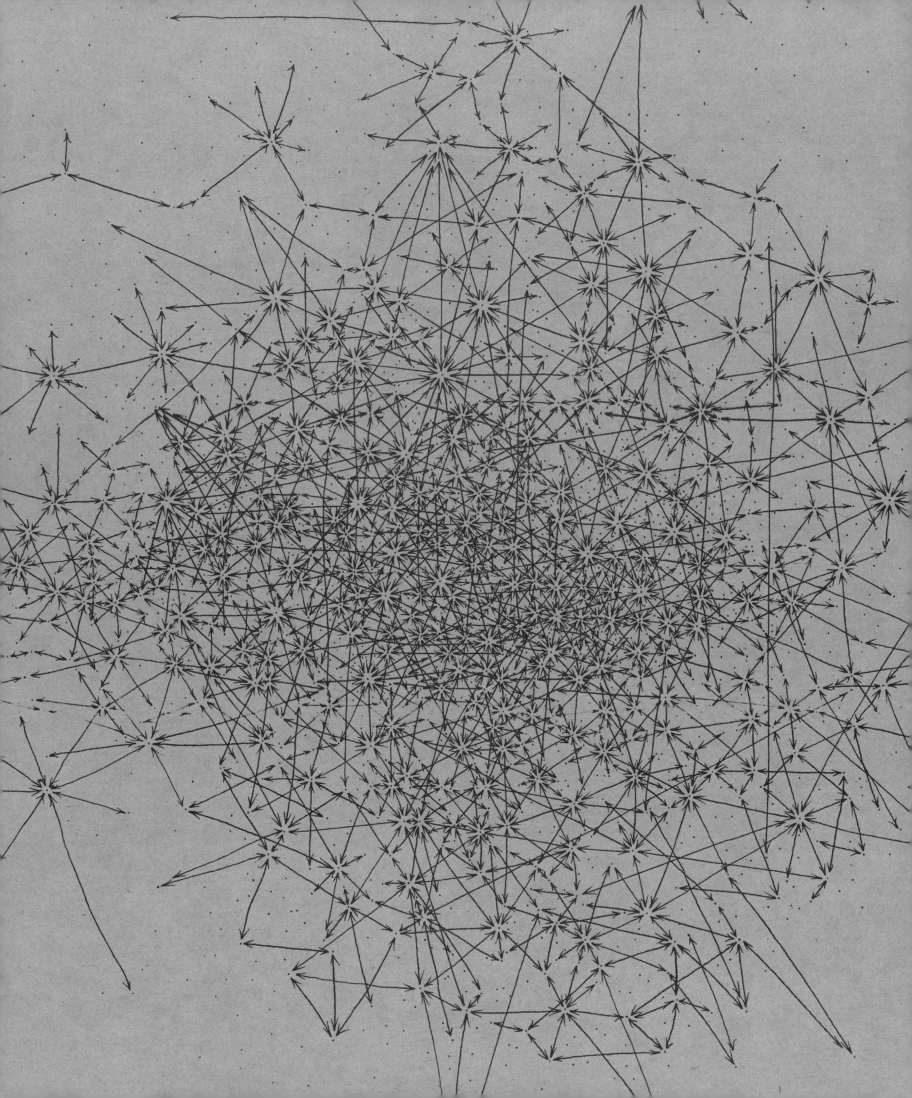